ILLINOIS WILDS

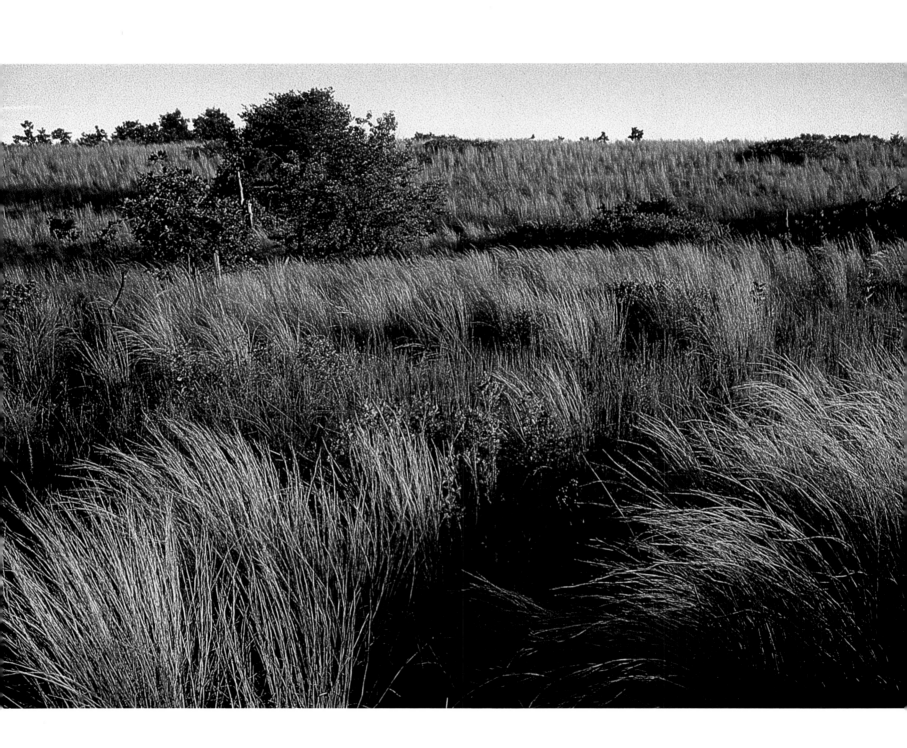

ILLINOIS
Wilds

Text and photographs by

Michael R. Jeffords, Susan L. Post, and Kenneth R. Robertson

PHOENIX PUBLISHING
URBANA, ILLINOIS

To my father, who unknowingly gave me a love of Nature
MJ

*To Grandma Babe, who never failed to take us to the woods, and
to my parents for dealing with the treasures we brought back*
SP

*To Arlene and Amanda, who have shared with me the beauty
of many wild places in Illinois*
KR

Printed on acid-free, recycled paper.
Manufactured in the United States of America.
10 9 8 7 6 5 4 3 2 1

ISBN 1-886154-04-X

Design by Debra Bolgla

Phoenix Publishing
300 West Main Street
Urbana, Illinois 61801

TABLE OF CONTENTS

FOREWORD

THE VERY FIRST PEOPLE TO INHABIT WHAT IS NOW ILLINOIS must have found it to their liking, for artifactual evidence of their presence includes seasonal encampments, villages, and permanent "towns" found scattered throughout the state. An abundance of fish and game was available as well as areas suitable for the cultivation of crops. The region was blessed with numerous rivers and streams that served as the first highways for indigenous peoples and later for European immigrants. Trails existed, but these did not become truly efficient until after Europeans introduced the horse. The trails eventually became roads and finally yielded to the superhighways and railroads of today.

There is increasing evidence that the large animal population of North America was seriously affected by indigenous peoples' hunting activity. This impact, however, was miniscule compared to what was to come with the arrival of Europeans. As the tide of immigrants moved westward, permanent settlements, trade, and commerce were established. Illinois' distinctive geology set the scene for it to become one of the great agricultural areas of the world—simultaneously a blessing and a curse—for with the introduction of the moldboard plow and field tiling systems, the prairie land was converted for agriculture and the wetlands drained.

In crossing much of Illinois, the highway traveler is exposed to a relentless panorama of corn and soybeans. There is another part of the state, however, masked from casual view and unknown to most citizens. It is that part to which *Illinois Wilds* is dedicated. Illinois is blessed with an array of landscapes, richly diverse in plant and animal life, partly due to the state's long north/south axis, which embraces both northern and southern climates.

This book is arranged by various kinds of landscapes, some are extensive in size while others are relatively small. These jewels of nature are sometimes remote and flourish only for limited periods of time; most people are far too occupied with daily commitments to ferret them out and visit them during the various seasons of the year. The authors have assembled this material over the course of many years and are now able to present a coherent overview of some of our exceptional landscapes. They possess outstanding photographic skills, the requisite technical training, and a deft use of language. They developed this book to cultivate a new understanding, appreciation, and support for our wildlands so that these places will remain available to be enjoyed today and secured for future tomorrows.

Lorin I. Nevling
Chief, Illinois Natural History Survey

Introduction

First impressions are often lasting impressions and Illinois now appears to be little more than flat plains covered with corn and soybean fields, dotted with occasional cities and villages—at best a pit stop on the way to somewhere else. Unfortunately, present and future generations will never see Illinois as it was before European settlers began the inexorable process of development. Historical accounts of Illinois spoke of huge trees, vast grasslands, and extensive wetlands. The seemingly endless prairies possessed a great diversity of many-hued plants; a traveler could go from central Illinois to Wisconsin and encounter few trees. Although there was human solitude aplenty, the prairies were teeming with life—passenger pigeons by the millions, snakes basking along the dusty trail, a myriad of grasshoppers shooting through the air like arrows from a medieval army. Yet not everyone appreciated the beauty of the prairie. When Charles Dickens visited Illinois in 1842, he found Looking Glass Prairie "lonely, wild and oppressive in its barren monotony." As Dickens continued his journey, he saw the land near the Mississippi River only as "unwholesome, steaming earth."

On the prairie were woodlands, often miles in extent, that stood like islands in the wild sea of grass and flowers. On the eastern border of Illinois stood the last outlier of the great deciduous forest that covered much of eastern North America. The virgin forest was so dense that trees had to grow straight up to reach the sunlight; wild grape and poison ivy vines hung from branches like huge suspension cables. Wet places were found in both the woods and prairies. Chicago, in 1833, was described as "a healthy place even though in the wet season the city was surrounded by water and you had to wade several miles from town to gain dry prairie." Areas of southern Illinois were described only as "drowned land, a cheerless miserable place."

Illinois was chiefly a combination of flat, moderately moist to "marshy" prairies and forested hilly country. Prairies occupied 21.6 million acres (60% of the state) and forest 13.8 million acres (39% of the state). In northern Illinois, these habitats were interspersed with sand dunes, bogs, fens, sedge meadows, and marshes. Magnificent cliffs, often capped by hill prairies, towered over the Mississippi and Illinois rivers. Canyons, with cliffs of limestone and sandstone, and bald cypress and tupelo swamps dominated far southern Illinois.

Landscapes have many components, including differences in topography, glacial history, soils, plants and animals. Illinois is no exception. Its borders are mostly defined by irregularly-shaped bodies of water and it is easily discernible on any satellite image of North America. The western border follows the Mississippi River, the southern and much of the eastern borders are formed by the Ohio and Wabash rivers and the northeastern boundary by the shoreline of Lake Michigan. Illinois is a long state from north to south; the distance is over 400 miles. Its northern border is at about the same latitude as Boston, Massachusetts, while Cairo, Illinois, at the southern tip, has the same latitude as Newport, Virginia. Illinois is also wider than it appears at first glance. Quincy is some 50 miles *west* of the "gateway to the west," St. Louis, Missouri.

Illinois is a prairie plain. Compared with other nearby states, it presents few notable physiographic contrasts. The state has the lowest overall elevation of the North Central states, with the average elevation 600 feet above sea level. The highest point, Charles Mound in Jo Daviess County, is 1,235 feet above sea level; the lowest point, 279 feet, is the level of the Mississippi River in Alexander County. The central part of Illinois is extremely flat with moraines forming the only topographical relief. Moraines are linear hills made by an accumulation of earth and stones that mark the leading edges of glacial ice fronts. They are more abundant around Chicago and in western Illinois, which accounts for the more rolling terrain there. The Mississippi, Ohio, and Wabash rivers and their tributaries have deeply entrenched themselves into the prairie plain, exposing a variety of rock formations in the steep valley slopes.

The land that we know as Illinois was radically different in the past: burning under a tropical, equatorial sun, deluged beneath a warm sea, sweltering in a coastal swamp and, most recently, buried under hundreds of feet of ice. During the past million years, an interval of time called the "Pleistocene Epoch," most of the Northern Hemisphere above the 50th parallel has been repeatedly covered by glacial ice. Lying between the Rocky Mountains and the Appalachians, Illinois occupies a unique position; it stands at the crossroads of North American Pleistocene glaciation. Here deposits left by the glaciers that invaded from the northeast overlap deposits made by glaciers from the northwest. In addition, Illinois contains the area of southernmost advance of the continental glaciers in the Northern Hemisphere. The outwash drainageways from the northeast, north, and northwest converged in Illinois on their way to the Gulf of Mexico, and the state has held the largest number of individual advances of continental glaciers.

The Pleistocene glaciers and their meltwaters forever changed the Illinois landscape. Nearly 90% of the state was covered by one or more sheets of glacial ice. When the last of the glaciers began to melt from Illinois, about 14,000 years ago, the country that emerged looked far different from the preglacial landscape. The glaciers had scraped and smeared the landforms they overrode, leveling and filling many of the minor valleys and even some of the larger ones. The moving ice carried colossal amounts of rock and earth. Continual floods released by the melting ice created new drainage ways, deepened old ones, and then partly refilled both with great quantities of rock and earth that were carried beyond the glacier fronts. The glacial and meltwater deposits created the flatter landforms now typical of the prairies. Over most of the region lay a deep mantle of unconsolidated glacial drift—earth and rock materials moved by a glacier and deposited in the area.

This glacial history has played an important role in shaping the Illinois topography. Except for the unglaciated regions, the topography can be characterized as a dissected plain of glacial till. During the glacial period there were several major advances of ice sheets into Illinois: the pre-Illinoian, Illinoian, and Wisconsinan glaciers. Only three areas of the state remained untouched: the seven southernmost counties of the state, an area between the Mississippi and the Illinois rivers in Calhoun County and, in the northwestern corner of the state, Jo Daviess County and a small portion of Carroll County. Not surprisingly, these correspond to the more rugged parts of Illinois.

The most abundant glacial deposits in Illinois were left by the last two of the ice advances. When the Illinoian glaciation was at its maximum, nearly 90% of the state was covered by ice. The ice reached as far as the higher northern slope of the Shawnee Hills in southern Illinois and was the southernmost extent of continental glaciation in the Northern Hemisphere. The landscape left by the Illinoian glacier can be compared to that of a dry lake plain; it is flat. This flatness is attributed to three factors: the fast movement and uniformity of the ice sheet, the leveling action of sheet erosion, and the low-lying nature of the preglacial Illinois Basin. The later Wisconsinan glacier penetrated only into the northeastern quarter of the state. Here the glacier developed a succession of moraines, 50 to 100 feet high and 50 to 100 miles long. This most recent glacier left an impressive legacy: Lake Michigan and the other Great Lakes, the fertile till plains of mid-America, and the serrated landscape of the western Rocky Mountains.

The richest Illinois soils have been developing for a relatively short time, only about 14,000 years, since the last continental glaciers began melting away. Parent materials for the soils in most of the state are windblown silt (loess) occurring at various thicknesses over glacial till. The loess was deposited during periods of glacial retreat. Tremendous floods of meltwater poured down major river valleys and deposited massive amounts of sediment on the floodplains. During the dry arctic-like winters while the ice was present, these sediments, deposited by summer meltwater streams, dried out. Strong winds blowing across the sediment-choked bottomlands of the major river systems gathered up clouds of dust that

blanketed the tundra-like land with the silty, loess deposits. Some areas have as much as 50 feet of loess on the surface. Loess, and other materials exposed at the land surface, are the parent materials from which the state's rich soils were formed.

Because it lies at the junction of the eastern forest, western great plains, southern coastal plain, Ozark uplift, and northern forest biomes, Illinois has an extremely rich diversity of native species. The state is a melting pot for life forms that are characteristic of these different geographical areas and habitats. Illinois is host to over 54,000 species of native organisms. The largest groups are the insects, with about 17,000 species, and the fungi, with approximately 20,000 species. The "charismatic megafauna," made up of reptiles, amphibians, fishes, birds, and mammals, includes 646 species.

The biodiversity of Illinois is more readily appreciated when it is compared to that of other regions. The LaRue–Pine Hills Ecological Area of southwestern Illinois contains limestone cliffs like those of the Missouri Ozarks, swampland that mimics parts of Louisiana, and densely wooded coves reminiscent of the Appalachians. It is the most diverse natural area of its size in the midwest, possessing 35% of Illinois' known native species. LaRue–Pine Hills, covering 4,000 acres, contains approximately 1,000 native plant species. Conversely, Great Smoky Mountain National Park, an area 130 times larger, contains only 1,500 native plant species. This same region of southwestern Illinois also has more amphibian and reptile species (61) than are found in any region of comparable size in the United States. Perhaps equally surprising, one-fourth of all the species of freshwater fishes and mussels which inhabit North America north of Mexico are found in Illinois.

Although we no longer have the luxury of standing on a hillock or an old glacial moraine and viewing a limitless expanse of prairie or forest, we do have the opportunity to experience the essence of these places. That is what we have attempted to document in this work. We have tried to identify the most distinguishing feature of various Illinois habitats—whether the vegetation is predominantly trees, grasses or forbs, the soil a deep loess, sand or gravel, or the ground surface dry or covered by water. Emphasis is given to plant life because the most visible expression of a natural terrestrial habitat is usually the vegetation. As noted by Charles Darwin: "A traveler should be a botanist, for in all views plants form the chief embellishment. Group masses of naked rock, even in the wildest forms, may for a while afford a sublime spectacle, but they will soon grow monotonous. Paint them with bright and varied colors and they become fantastic, clothe them with vegetation and they must form a decent, if not beautiful, picture."

Animals, especially mammals, may appear conspicuously absent, but this has occurred for a reason. Large or small mammals are difficult to find in most natural habitats without the use of mist nets or various other traps. Even a pair of keen, observant eyes will still overlook most mammals. Only the most dedicated naturalist and scientist can feasibly define habitats in Illinois by their mammals. Over half of our native wildlife are widely distributed around the state, highly mobile, and nocturnal (active only at night). Also, due to

habitat destruction, many species have adapted to a wide variety of areas and most can be found throughout the state. Some species like the white-tailed deer are everywhere, from the backyards of suburbia to the runways of O'Hare Airport. Unlike Yellowstone National Park, where bison, elk, marmots, and moose can be viewed with regularity, a sighting of any but the most common mammals in Illinois is unusual and should be counted as an exceptional pleasure to be added to the enjoyment of Illinois' wilds.

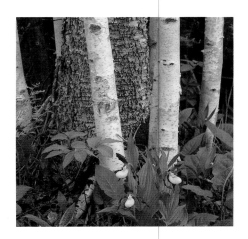

Thus, the majority of the photographs in this book are of plants and animals that can be seen by the casual visitor and also can be used to characterize a habitat.

As expected, shockingly little of our state's rich natural heritage remains—Illinois ranks an unenviable 49th of the 50 states in the percentage of natural areas surviving (only Iowa is lower). Of the 13.2 million acres of forest in 1820, about 4.2 million acres remained in 1980. Only 13,500 acres, however, are relatively undisturbed forest. The decline of prairies is even more extreme. Only 2,300 of 21.6 million acres of prairie survive, or less than 0.045%. Many of our wetlands have been, and continue to be, drained before they can be biologically inventoried and have their value determined. Our streams are polluted and increasingly degraded by the influx of soil from surrounding farmland. On the other hand, given the agricultural and urban development of the state, we are fortunate that fragments of nearly all habitat types found in presettlement times remain. These remnants, preserved by law or by individuals who cared enough to save these fragile habitats for future generations, provide at least a glimpse of what was once the landscape of Illinois.

Illinois is a leader among states in preserving natural areas, perhaps because so much of its native landscape has already been lost. Dedicated environmentalists and scientists were able to convince the General Assembly to pass into law a means whereby samples of the natural environment would be protected in perpetuity. In 1963, The Illinois Nature Preserves Commission became the first state system of nature preserves to be established in the United States. At the time of this writing, over 200 official nature preserves, encompassing more than 30,000 acres, have been dedicated. Throughout this book we have mentioned selected nature preserves as examples of Illinois' distinct and irreplaceable habitats. Even though the wilderness that was Illinois has long since departed, some wildness yet remains. Illinois' wilds may be as simple as a few violets growing in a lawn—a remnant of an ancient prairie grove—or as complex as hundreds of acres of cypress-tupelo swamp in southern Illinois. Regardless of the size, wildness is important. As the distinguished biologist and educator E.O. Wilson has said, "those with the foresight to preserve and treasure even a small part of this heritage will be remembered far longer than those who destroy the rest."

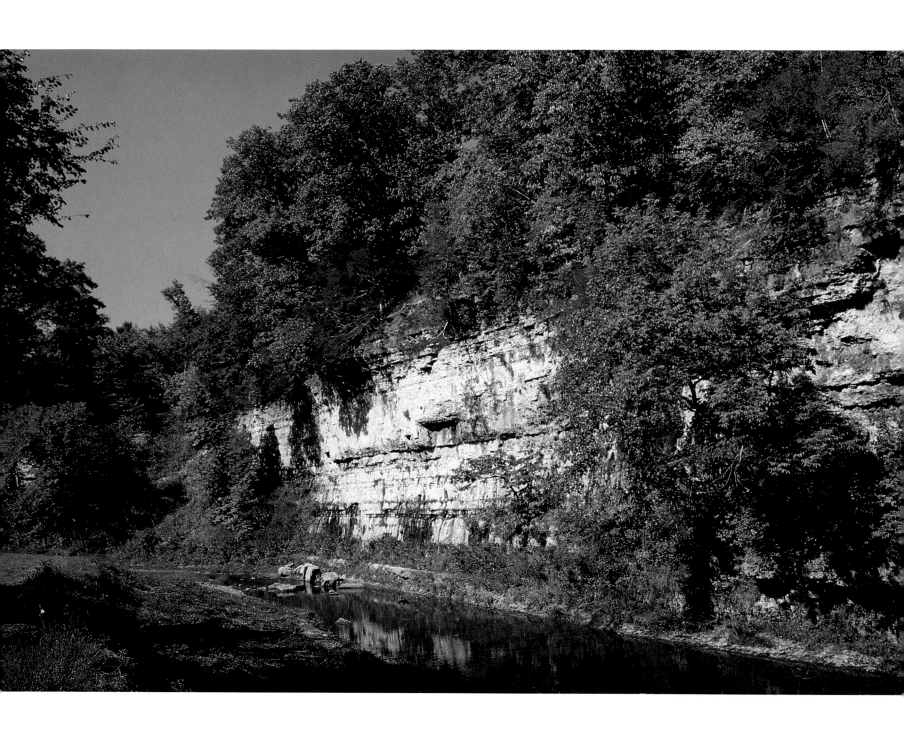

1

UNGLACIATED WOODS

Michael R. Jefferds

An attractive woody vine, mountain clematis grows in the cool, mossy environment of an algific slope. MJ

Apple River Canyon becomes clothed with vegetation during midsummer. KR

AN EARLY UNIVERSITY OF PENNSYLVANIA GEOLOGIST, W.H. Keating, noted in 1823 that portions of northwestern Illinois lacked the large granite boulders so characteristic of much of the glaciated Midwest. The topography of this area of Illinois, remarkable for the complexity and completeness of its drainage patterns, was also strikingly different from areas to the immediate south and west. Literally dozens of streams entered the Mississippi River within a relatively short distance. These and their tributaries formed an intricate web, separated by ridges and valleys of varying heights and widths that were thickly carpeted with forests. Ravines and valleys crisscrossed the land in every direction, and slopes formed the dominant feature of the landscape. Few lakes and ponds existed. All these features belied a glacial heritage.

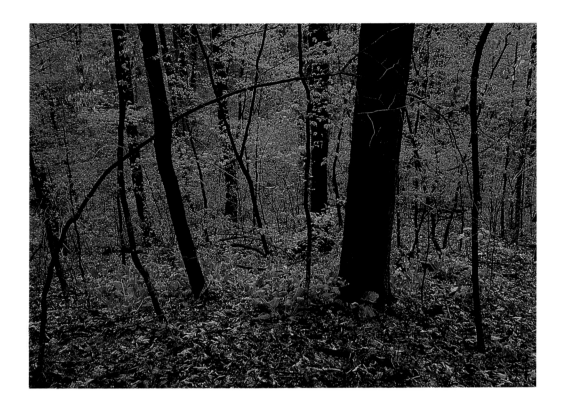

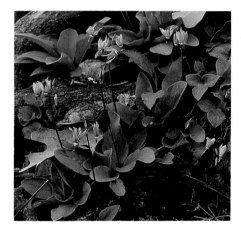

With time, this area of Illinois—primarily Jo Daviess and part of Carroll County—along with portions of Wisconsin, Minnesota, and Iowa, became known as the "Driftless Area," an island that had escaped the great continental glaciers of the Pleistocene. At various times, vast fingers of ice advanced and retreated, somehow avoiding this particular 15,000 square miles in the upper Midwest. Though this area may be envisioned as an island in a sea of ice, it was never completely isolated from unglaciated regions, and avenues of migration were open to plants and animals. In fact, dozens of plant species managed to survive the Pleistocene in the Driftless Area while their neighbors were driven to extinction. Today, these survivors can be singled out as species that are absent from surrounding regions or those which are intermittently distributed. Examples include the paper birch and bird's-eye primrose, both boreal relics of glacial times.

Because of its location, nearly 1,000 miles from the nearest ocean, the Driftless Area has a typical continental climate with bitterly cold winters—Jo Daviess is the coldest county in Illinois—hot summers, and abundant rainfall. The soils are composed mostly of wind-blown loess, disintegrated rock, and, along valley floors, flood-deposited soil (alluvium). This climate and these soils have produced a number of

The jeweled shooting-star requires a particular soil found on river bluffs and occurs in Illinois either near the edges of the old continental glaciers or in unglaciated areas along the lower Illinois and Upper Mississippi rivers. In early May the bluff trails in Mississippi Palisades State Park are covered with these brilliant pink blossoms and their fragrance fills the air. SP

Forested slopes were once the dominant feature of the unglaciated northwest corner of Illinois. At one time nearly all of Jo Daviess County was continuous forest. Today much of the forest has been converted to pastureland. MJ

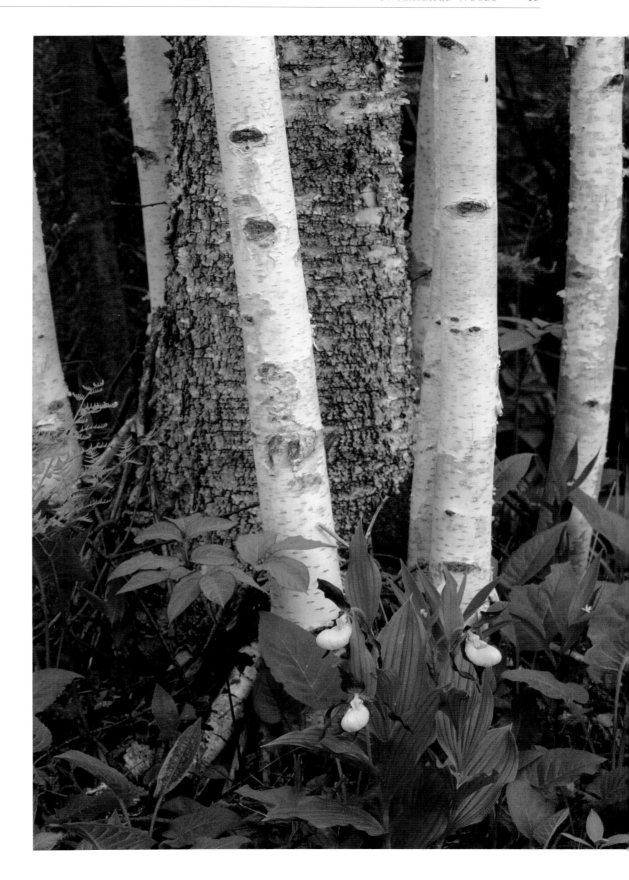

Although commonly planted as an ornamental throughout the northern half of Illinois, the white birch is native in only a few northern counties. The small yellow lady's-slipper was once common, but habitat destruction, picking, and digging by gardeners have severely reduced its numbers. MJ

habitat types that support diverse plant associations. A notable feature of the flora is the curious mingling of northern and southern species, though the greatest proportion find their origins in the north. Rich, moist ravine forests of sycamore, elm, and maple contain turtlehead and cardinal-flower. Wet to dry upland forests of various oaks support jeweled shooting-star, showy orchis, yellow lady's-slipper, wake robin, and twinleaf. Spring seeps retain the northern shinleaf and lesser twayblade orchid, and vertical cliff faces are asylums for other rare species like sullivantia and muskroot.

Nearly all the streams that drain Jo Daviess County are bordered somewhere along their general southwest course by limestone cliffs of the Galena and Niagara formations. Some can be peered over while standing upright, but others are lofty, vertical precipices such as those found in Apple River Canyon. Depending on their orientation, the cliffs can be dry as dust, exposed to the full blast of the northwest wind. Others that are sheltered from temperature extremes drip cool, clear limewater and never see the sun. The plants that inhabit these vertical surfaces are broadly classified into "xerophytic," those tolerating extremely dry conditions, or "hydrophytic," those thriving under extremely moist situations. These latter plants are mostly bog species which occupy only the cliff faces because of the reduced competition there from other species.

The dripping cliffs almost without exception face to the north and east. They are towering, massive affairs with a pronounced overhang. Mosses and liverworts clothe them in green mats that remain all year. The limestone has many chert seams with constant water seepage. As a result, the bird's-eye primrose can survive far south of its normal range because its roots are kept cool in summer by the dripping limewater. In winter the cliff faces are kept from freezing by the ice cascades that cover them, and the roots and crowns of the primrose are protected. After the primrose blooms in late April, the whorled loosestrife forms stunning arrangements against the moist limestone during midsummer.

Crustaceous lichens cover the dry, exposed southern cliffs, interspersed with occasional patches of cliffbrake fern, harebells, and the eastern red cedar. Compared to their moister north-facing counterparts, these cliffs are barren, appearing devoid of life for long stretches.

Several of the streams, instead of being edged with vertical cliffs, are bordered by steep, north-facing limestone talus (rock fragments) slopes. These slopes are generally covered with a thick carpet of moss, and ice persists beneath the surface throughout most of the summer, creating a cool microclimate on the surface of

Bird's-eye primrose is a glacial relict found in Illinois only on the dolomite cliffs of Apple River Canyon, far south of its normal range. Herman Pepoon in 1909 described this plant as "tinting the bare rock a lavender purple with the multitudes of its blossoms." SP

The limestone cliffs of the Apple River constantly drip cool limewater and provide a habitat in the cracks and crevices for the northern bird's-eye primrose. MJ

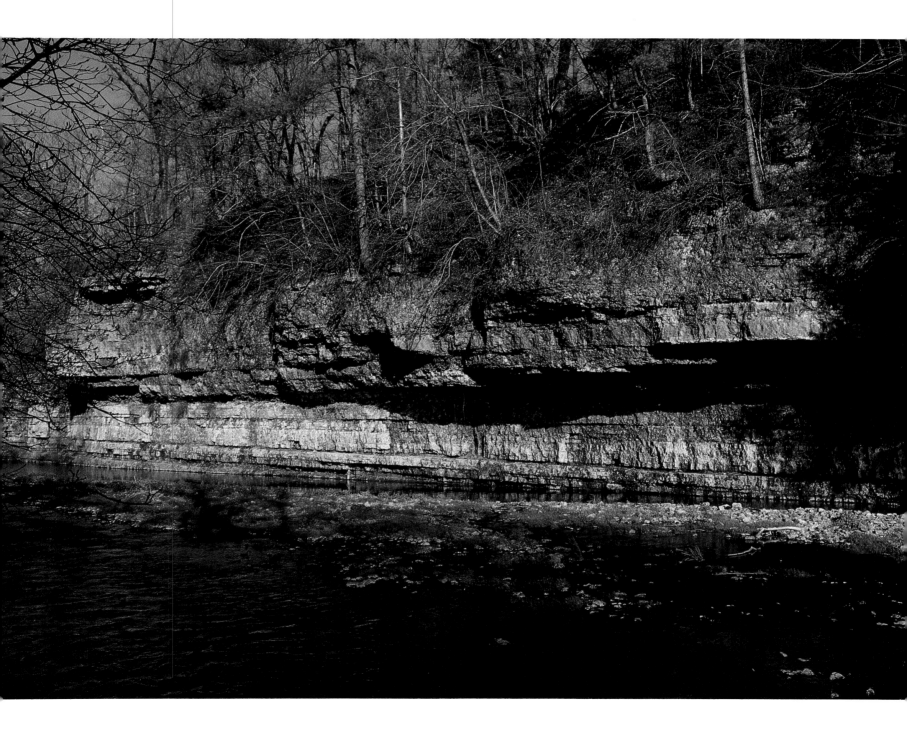

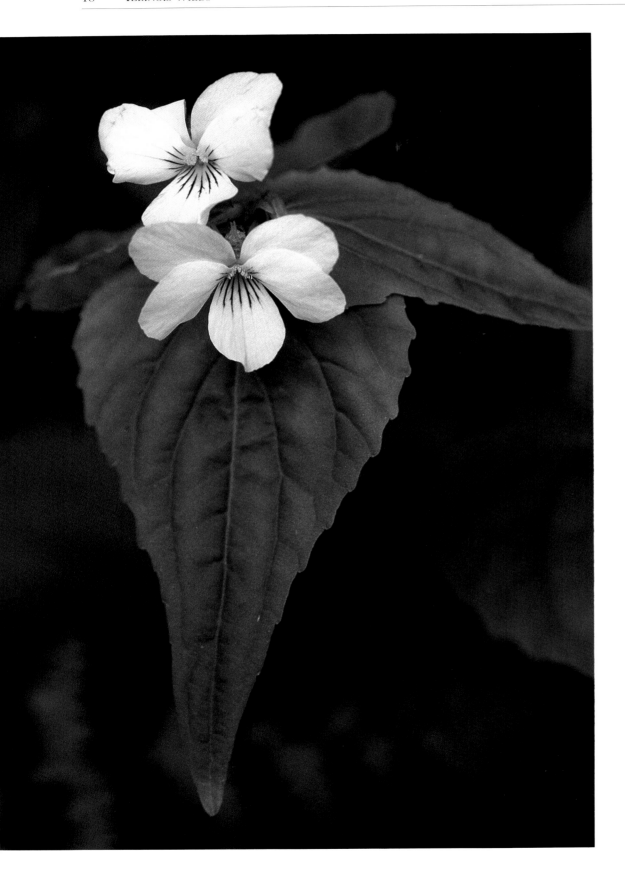

Canada violet grows mainly in southern Canada and the northern United States or in the mountains further south, but is commonly found on algific slopes in northwest Illinois. MJ

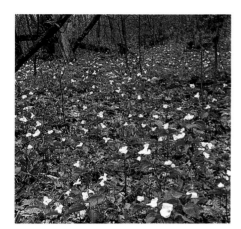

the slope. Cold air flows down the slope in a layer 6 to 8 inches deep, thereby creating a habitat suitable for such northern species as star-flower, Canada violet, and mountain clematis. The cold may also change the physical structure of individual plants, causing them to assume odd growth habits and alter their flowering times. Herbs that normally bloom in the spring may be in flower until autumn. The slopes are dominated by herbs and mosses because the temperatures are too cold for most tree roots.

Of the original 300,000 acres of forest cover in the Driftless Area of Jo Daviess County, accounting for approximately 80% of the land cover, only about 78,000 acres remain. Vast tracts have been lost to farming, grazing, and home sites. Fortunately for us, many early descriptions of this area were published by Herman Pepoon, a medical doctor and a botanist who grew up near Apple River Canyon. His writings provide remarkable glimpses into the past. Nature preserves and natural areas such as Hanover Bluff and Apple River Canyon preserve the heritage of this unique area. Undisturbed examples of wet to dry upland forest, spring seeps, limestone cliffs, and hill prairies with their attendant flora still exist and are protected.

Great white trilliums, the state's largest trillium species, occur abundantly in May in select wooded ravines in Mississippi Palisades State Park. The flowers are sensitive to light and may track the daily path of the sun. As the flowers age, they turn pink, a phenomenon that originally led botanists to classify the aging flowers as a different species. SP

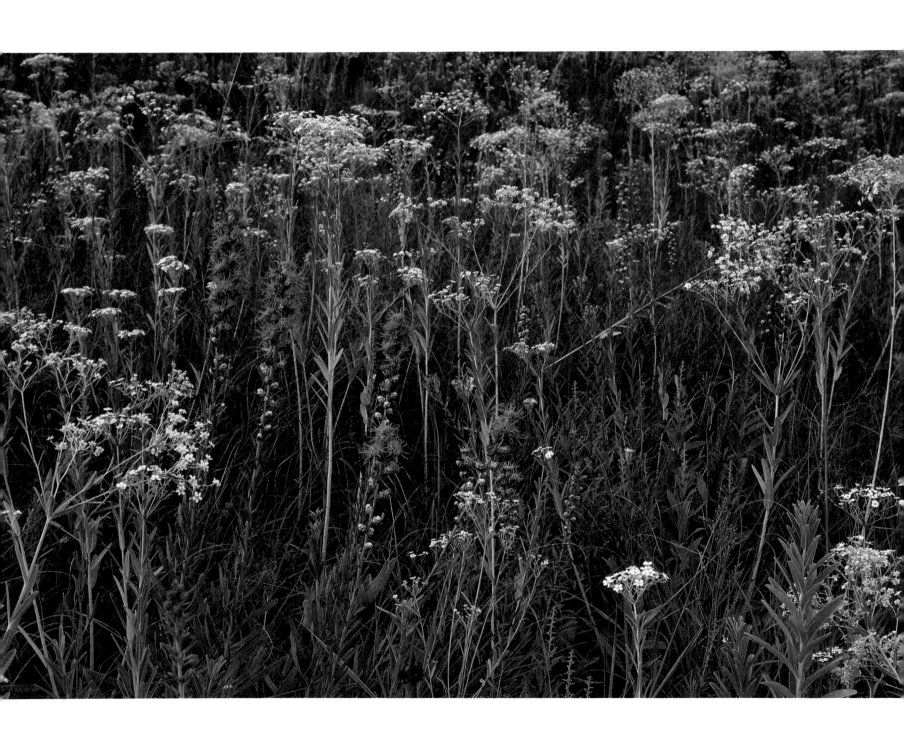

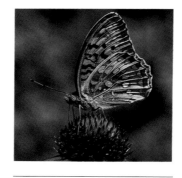

2

GRAVEL AND DOLOMITE PRAIRIES

Kenneth R. Robertson

Great-spangled fritillaries, perched atop purple coneflowers, catch the eye during summer on Illinois prairies. The larvae of this fritillary are secretive, hiding during the day and feeding at night on various species of violets. SP

The most imposing plants on prairies in late summer are the pink blazing-stars, members of the sunflower family. Rough blazing-star is the species most often found growing in dry conditions. SP

MOST PEOPLE AVOID A PRAIRIE IN EARLY SPRING when the brisk, raw winds are chilling, and the drizzle could easily change to sleet or snow. There is ordinarily nothing to see. Yet those few who do brave the elements to visit a northern Illinois gravel prairie are richly rewarded by several unique plants that grow there in abundance during early spring, plants that are otherwise rare or absent in Illinois. From the parking lot at Harlem Hills Nature Preserve near Rockford, visitors can follow the trail to the crest of the nearest hill and stand amid thousands of pasque flowers. The diminutive lilac blossoms of these flowers hug the ground, having forced their way through the brown latticework of dry grasses. In early morning or late afternoon, the sun highlights the hairy stems and leaves producing a striking effect. Nearby, prairie smoke is just beginning to bloom, its rose-pink clusters nodding above a

rosette of featherlike leaves. The attentive observer may also discover a few glossy yellow flowers of the rare prairie buttercup, a threatened species in Illinois. As spring progresses, the plumelike fruits of the pasque flower and prairie smoke form and are soon shed to the wind. The prairie smoke is aptly named; its fruits could be an ephemeral wisp of smoke from a miniature prairie fire.

Gravel prairies were once found in much of northern Illinois. This region was not covered by the deep layer of wind-blown loess that followed the retreat of the Wisconsinan glacier in other parts of the state. The topography is marked by exposed bedrock and prominent moraines, kames, and eskers. The glacial till and "outwash," a mixture of sand, limestone gravel, and dolomite, are at or near the surface, covered by only a thin layer of soil. Conditions are often bone dry due to the well-drained soil and the slope of the land that usually faces south or west. Gravel prairies are seen mostly in the morainal area of northeastern Illinois in Winnebago, Ogle, and Stephenson counties, with a few occurring eastward to the outer edge of the greater Chicago area and southwestward along the major rivers.

At Harlem Hills and other gravel prairies, wildflowers emerge one by one after the pasque flower and prairie smoke have set fruit: the cream flowers of the downy painted cup, the yellow heart-leaved meadow parsnip, and the large flowers of the bird's-foot violet, to name only a few. The pale yellow wood betony is worth a second look to admire the corkscrew arrangement of its flowers. Perhaps the largest plant at this time of the year is the cream false indigo, forming graceful mounds of gray-green foliage that support clusters of drooping, pealike flowers. More typical tallgrass prairie plants follow as summer moves leisurely toward fall: coneflowers, often crowned with great spangled fritillary butterflies, prairie clovers, and blazing-stars, a major late-season nectar source for migratory monarchs. Among the more unusual plants are silky aster, stiff white aster, and wooly milkweed. The vegetation of these prairies is noteworthy because of the curious mix of plants commonly found in northern and western states along with plants typical of midwestern tallgrass prairies.

Unfortunately, most gravel prairies have been destroyed by urban sprawl or gravel mining. In addition to Harlem Hills, several examples are preserved as part of the system of Illinois Nature Preserves: Spring Hill Farm Fen, Bluff Spring Fen, Cary Prairie, Bicentennial Prairie, and Shoe Factory Road Prairie. Each has its unique assortment of plants.

In a few places in northern Illinois, a unique type of prairie occurs on fairly flat areas with outcrops of flagstones and dolomite bedrock. Most of these

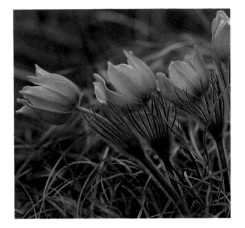

Certainly the first flowers found in dry gravely prairies each spring, blooming as early as mid-March, are the pasque flowers. MJ

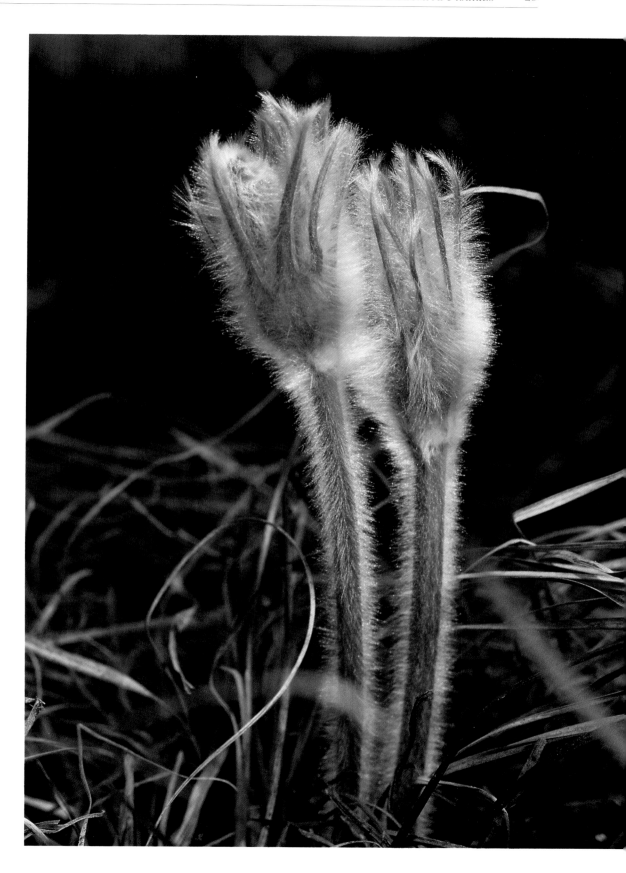

The entire pasque flower plant has a kittenlike covering of soft hairs. Pasque flowers in bloom are best viewed from ground level. SP

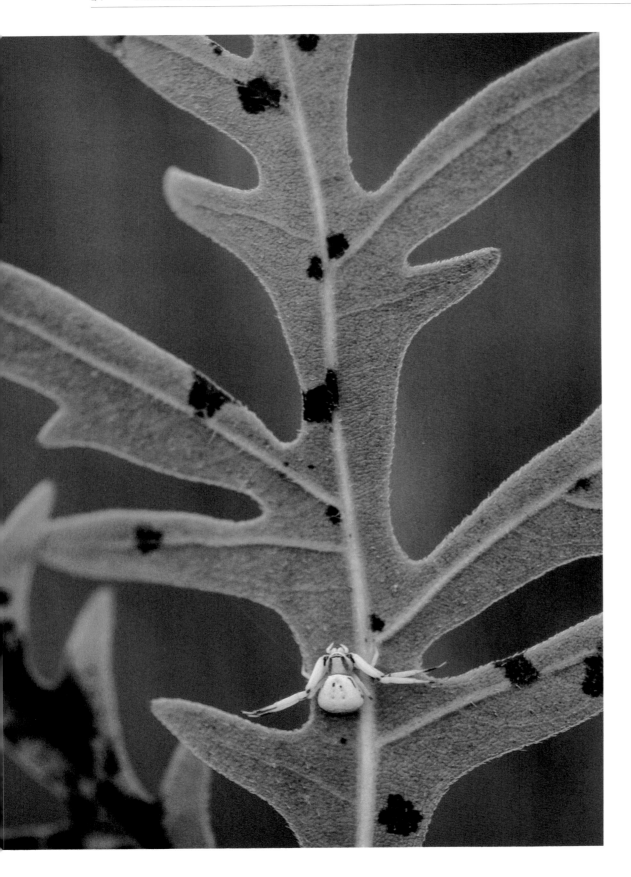

A lethal predator to most insects, this diminutive crab spider is dwarfed by the great, coarse leaves of a compass plant. Compass plants stand like beacons among the relatively short grasses of northern prairies. MJ

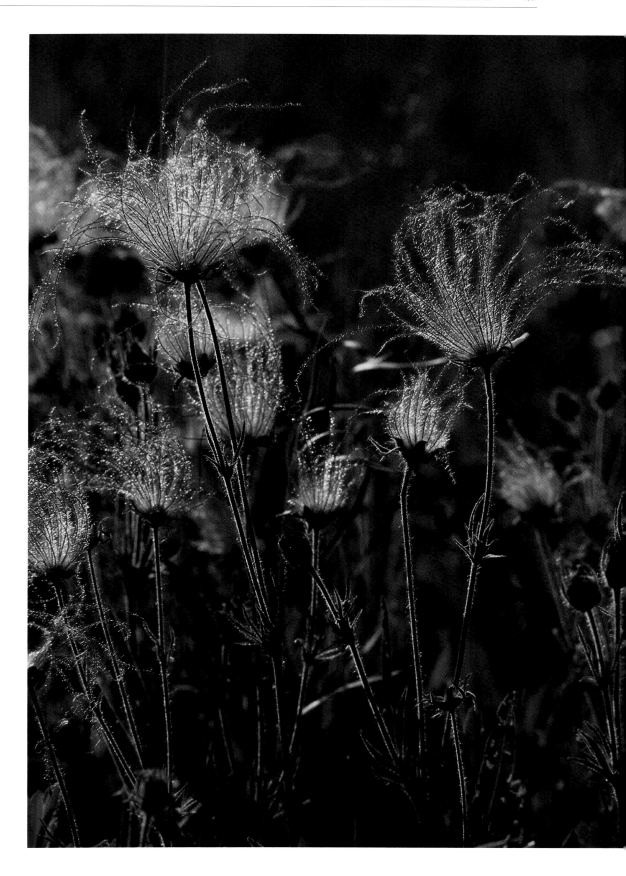

The plumelike fruits found in late spring account for the common names of this northern plains species: "prairie smoke" and "old man's whiskers." MJ

outcroppings appear along the Des Plaines River as it flows southwestward from Chicago; others are found near Rockford and Freeport. The soil is shallow and usually dry, although moist conditions can exist when dolomite outcrops occur in a river floodplain. Lockport Prairie and Romeoville Prairie in Will County are notable examples. The extremely alkaline conditions resulting from the dolomite limit the kinds of plants that will grow, and even those that tolerate the high pH are smaller in size than usual. On the drier areas, side-oats grama and little bluestem are common; big bluestem, Indian grass, and prairie cord grass appear as moisture increases.

The lakeside daisy, a rare member of the sunflower family, was once found on dry gravel and dolomite prairies, but the last remaining natural population in Illinois was accidentally destroyed in 1981. A few Illinois plants survived in a private garden, but did not set seed because only a single mating type was preserved. Recently, these survivors were crossed with plants from Ohio and Ontario to produce fertile offspring, and some of these hybrids have been introduced at several Illinois sites. One of the rarest plants in North America, the leafy prairie clover, persists in two moist dolomite prairies southwest of Chicago. Elsewhere this plant occurs only on the limestone cedar glades of Tennessee and Alabama. Other unusual plants of dolomite prairies are false pennyroyal, rock jasmine, and marbleseed, well-named for the hard, shiny white "seeds" (actually fruits).

The nodding wild onion grows abundantly on dolomite and many other kinds of prairies in northeastern Illinois. Because of its onion/garlic odor and its prevalence where the Chicago River now flows into Lake Michigan, the Potawatomi Indians called the area *Checagou*, which means "stinking." The word was later modified by the European settlers to "Chicago."

Freeport Prairie in Stephenson County is a dry dolomite prairie but has much of the same appearance as a gravel prairie. It slopes steeply and reveals in spring the same northern and western plants found in gravel prairies. Part of Bicentennial Prairie in Ogle County is also a dolomite prairie and has a good show of cream wild indigo and the silver-leaved, lavender-pink flowered silky aster.

While gravel and dolomite prairies are certainly not major habitat types in Illinois, they are intriguing and certainly add to the surprising diversity of the state. Even during the raw days of early spring, the spectacular show of wildflowers on the gravel prairies merits a visit to a favorite spot, and the uncommon plants of the rare dolomite prairies draw their own share of devotees.

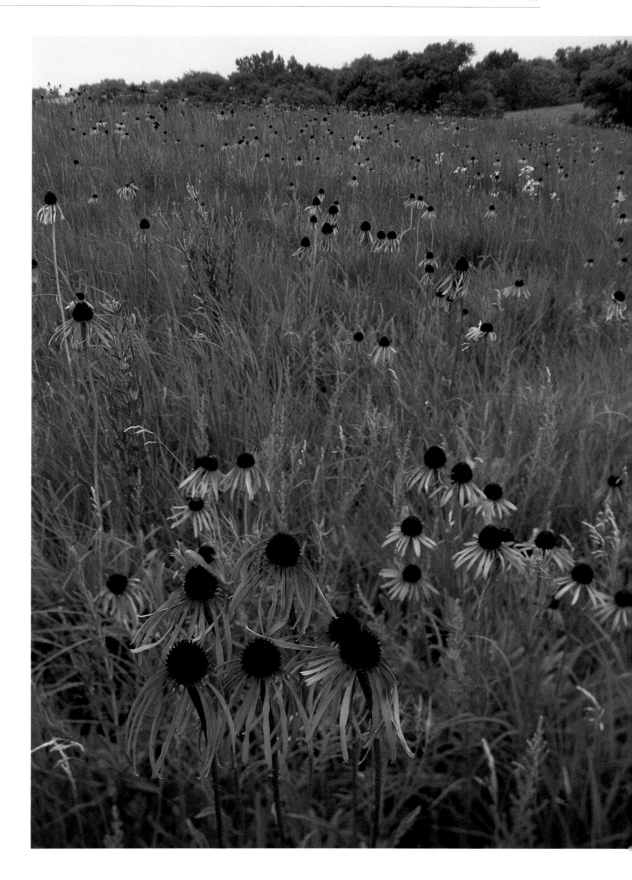

Purple coneflowers bloom in great masses during June on the gravel terrace prairies of northern Illinois. The species has numerous real or supposed medicinal qualities and was used as a cure for everything from sore throat to syphilis. MJ

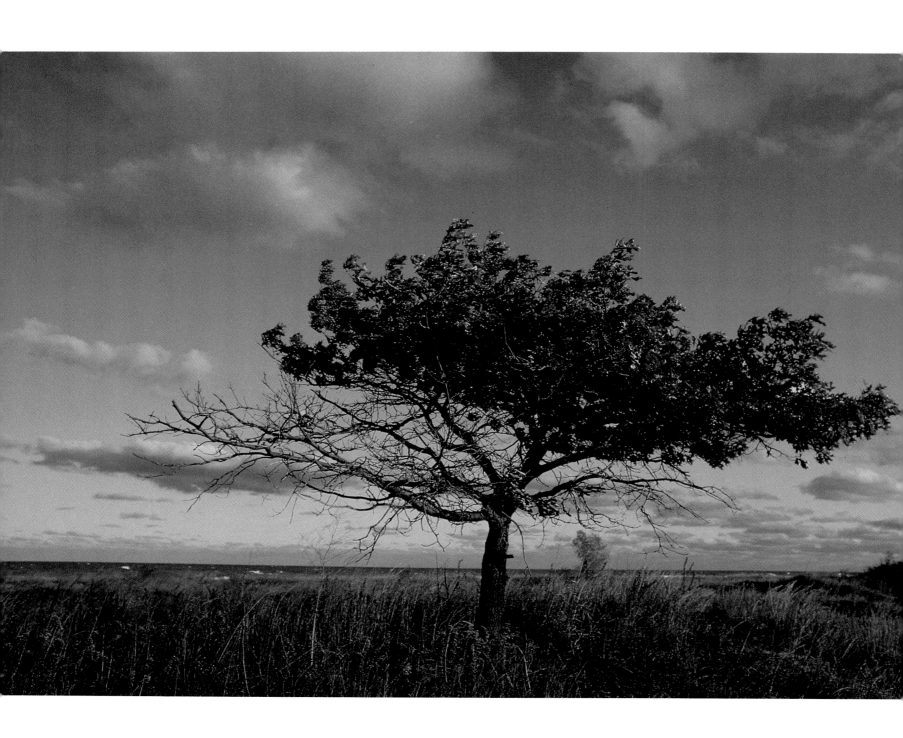

3

LAKE SHORE

Michael R. Jeffords

STROLLING ALONG THIS SANDY BEACH, one sees not the seaweeds, shells, and various crustacea typical of the Atlantic coast, but rather fragments of sticks and logs, quantities of rounded pebbles, and the inevitable dead smelt. A glance to the east reveals a vast freshwater sea. Looking west, one sees ridges of coarse, pebbly sand, interspersed with moist swales or sloughs, backed by an extensive marsh. The north is dominated by the imposing towers of a nuclear power plant, the south by the equally impressive Chicago skyline.

Variously dubbed the "Waukegan moorlands," "Waukegan flats," or more simply, the "Dunesland," this remarkable area bordering Lake Michigan in Lake County is home to over 650 species of plants and uncounted species of insects and other animals. The geology, climate, and location of the Dunesland undoubtedly

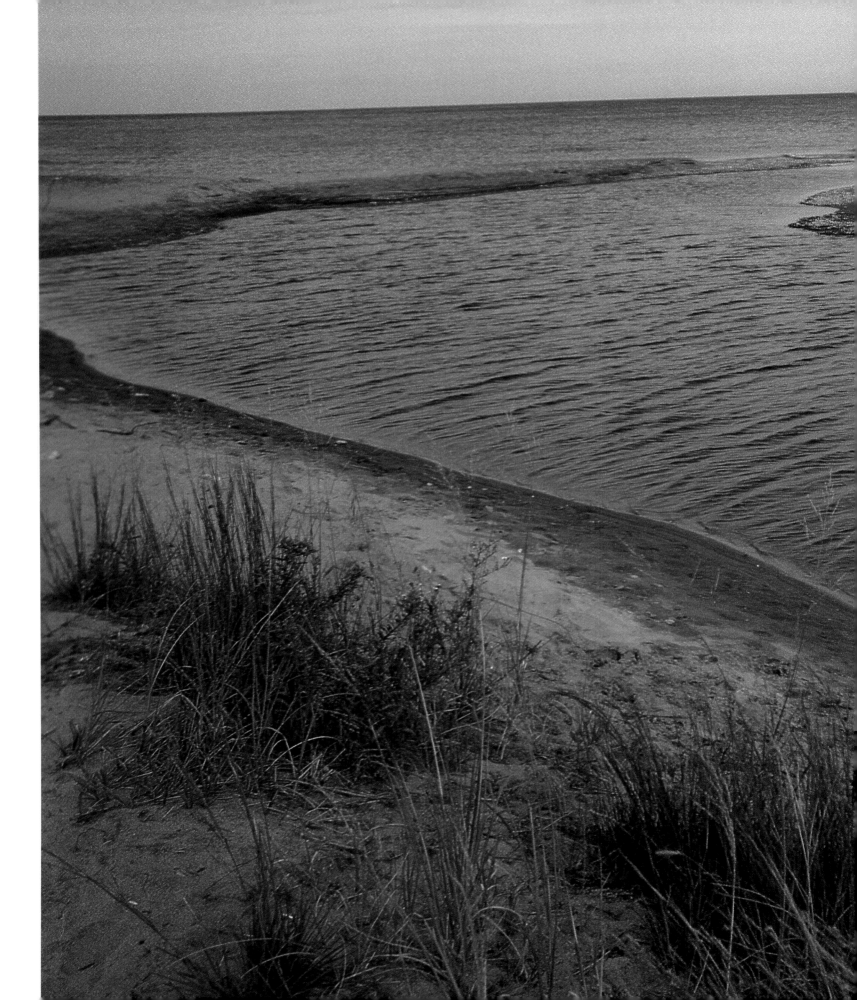

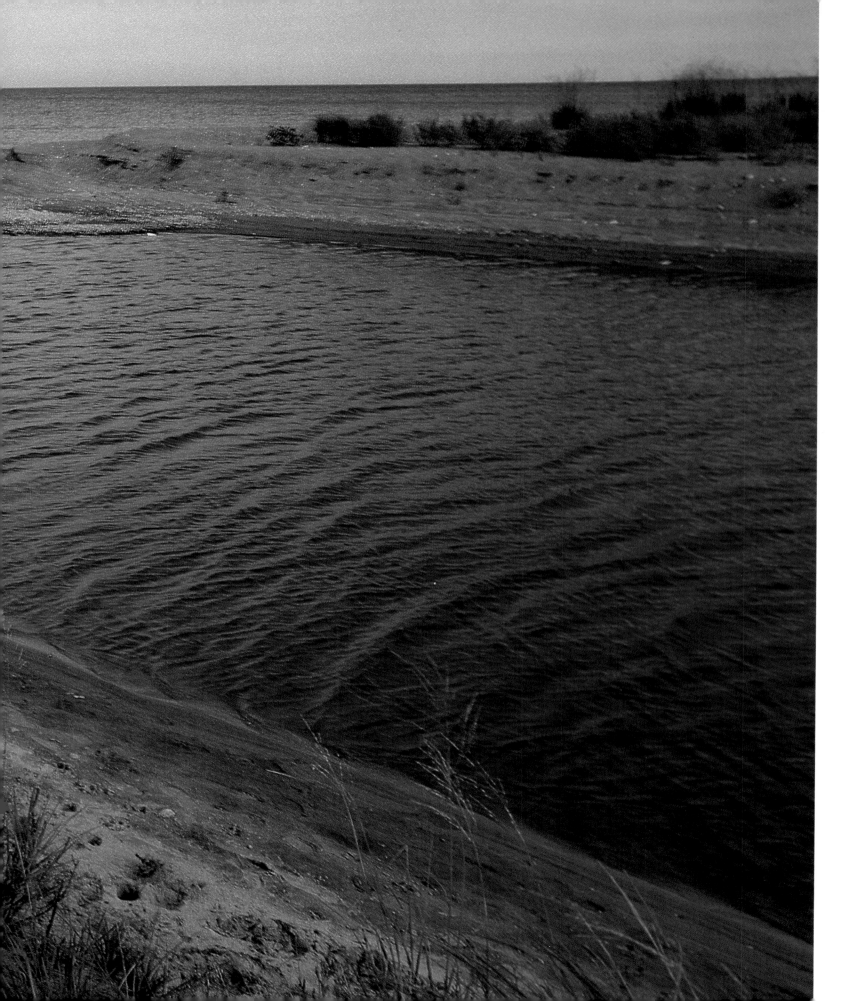

account for the enormous diversity of life found here. Within very short distances occur beaches, sand dunes, marshes, chalky swales, sand prairies, savannas, and oak forests. The climate is intense, with subzero winter temperatures and hot, humid summers. The soils are derived not from windblown loess but from glacial drift. Here the southwestern desert prickly pear cactus casually mingles with the bearberry and the tough, creeping juniper of the far north; southeastern blazing-stars cohabit with the northern fringed gentians. These northern plants are relicts of the postglacial spruce-fir forest that once widely covered this area. Much of the Dunesland's diverse plant life was influenced by the rich, deciduous forest to the south and the tallgrass prairie spreading to the west.

Because of its location, this area of Illinois was the most recently glaciated, covered by a thousand feet of ice. The Wisconsinan glacier had a profound effect on the Dunesland and was ultimately responsible for its formation. When the glacial ice was melting, 8,000 to 12,000 years ago, what is now Lake Michigan was much larger. This ancestral "Lake Chicago" reached a level some 60 feet higher than the present level of Lake Michigan. As the glacier receded farther and farther north, the water level fell in stages as the lake found new avenues of drainage to the south and west. Each level lasted for several hundred years and resulted in characteristic beach ridges that can still be seen today. The final stage, the "Toleston Stage," found the lake only 25 feet higher than its present level and was the most important stage in forming the current Dunesland landscape. The final drop was very gradual, and the ridges that resulted are not very high. They alternate with swales or sloughs that normally stay wet the entire year.

The Dunesland is a study in succession. The lower beach is alternately exposed to washing by the waves and drying by the sun and is almost devoid of life. The middle beach, reached only by the most severe winter waves, has a small flora of such arid-loving annuals as sea rocket. The upper beach is above the wave action and plants occur here that can tolerate continual covering and uncovering by blowing sand. Dunes form around the plants. These are not the giant sand dunes found on the southern shore of Lake Michigan. Because the prevailing winds are westerly and the sand produced from the lake comes from the east, the formation of large dunes is prevented.

Even though sand dunes are extremely xerophytic (dry), they are not dry throughout. The sand is moist to within a few inches of the surface, insulated by a layer of dry sand. This enables plants to take root. The first or "pioneering" plants

Three varieties of dogwood—silky, gray, and red osier—are important understory components of the black oak savannas of the Dunesland. MJ

Overleaf: The Dead River, a short river or a long pond, extends 1.5 kilometers to the shore of Lake Michigan. Lake currents plug the river mouth with sand, stopping the flow and allowing the river to fill with rain water. Contrary to its name, the river is not dead but contains a variety of animal and plant life common to most ponds. MJ

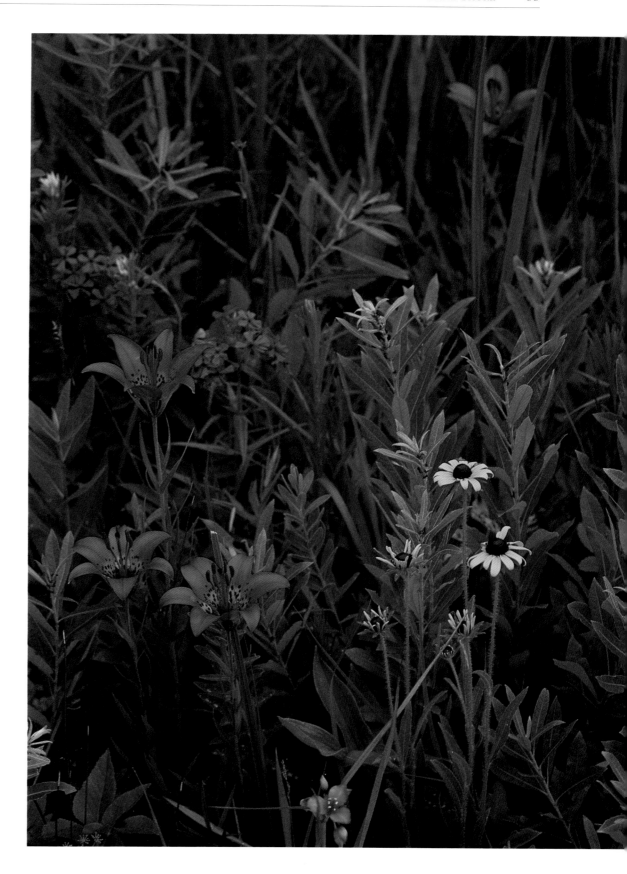

A great diversity of plant species grow in profusion in a small area. Wood lilies, phlox, and black-eyed Susans intermingle with sedges and rushes in the moist sand. MJ

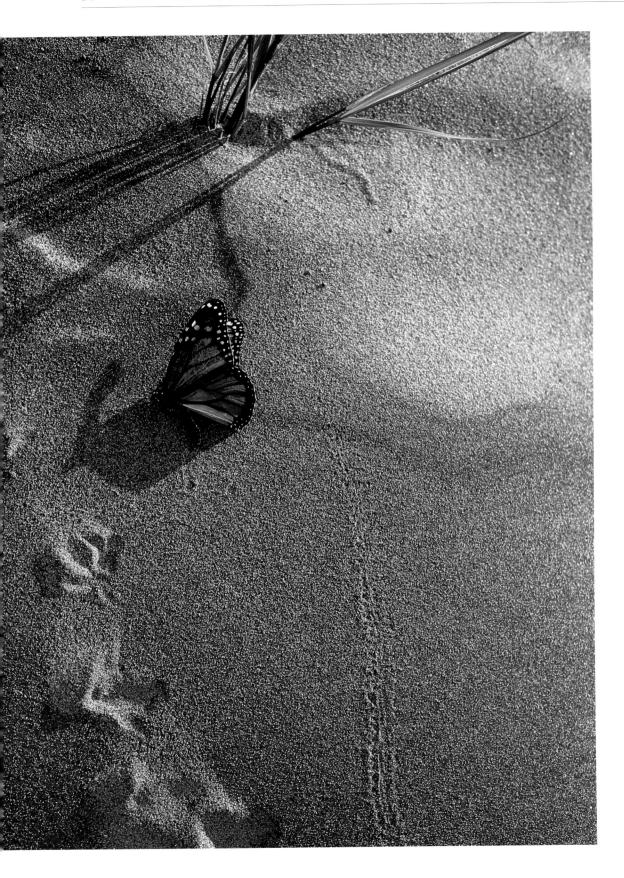

Sand-binding grasses represent the first stage in dune stabilization. These grasses are highly resistant to water loss and their roots hold firm against the wind. A lone monarch becomes part of the lake's flotsam. MJ

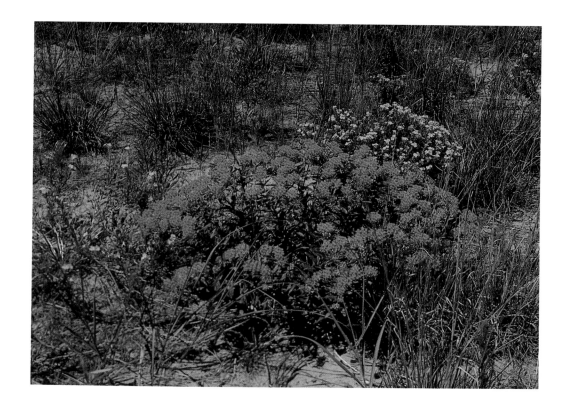

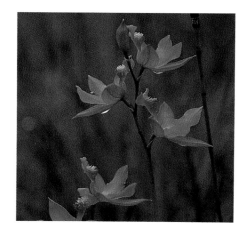

Grass pink orchids grow abundantly along the shores of the Great Lakes in moist swales. Populations of the plant fluctuate, however, and where it was dominant one year it may subsequently be rare. MJ

Butterfly milkweeds form cushionlike mounds of showy flowers. An extremely long taproot allows the plant to reach moisture far below the dry soil surface. KR

found growing on the newly created dunes that front the beach are sand-binding grasses—marram, sand reed, and little bluestem. Dune-binding shrubs include sand cherry, cottonwood, and creeping and upright juniper, their tough, ropy roots going deep into the loose sand and holding against the force of the wind. Some dune plants are capable of producing roots along the stem (adventitious roots) when they are buried by shifting sand, and each stem may eventually become a separate plant. Any combination of these plants may build up a dune and eventually stabilize it. On sand dunes, the greatest vegetational changes occur within the first few hundred years.

When these pioneering plants have stabilized the dune and contributed an adequate amount of humus to the sand, the northern bearberry, which prefers to live on the slopes rather than the crests of dunes, and certain of the bunch grasses appear. As more humus accumulates and enriches the sand, other species colonize until a sand prairie dominated by big bluestem, little bluestem, and blazing-star is formed. Originally, approximately 60% of the Dunesland was prairie.

Dunesland swales have a succession of plants far different from that of the ridges. Though the soil of the swales seems to be mucky, it is nevertheless composed chiefly of sand and dominated by sedges, rushes, and marsh grasses. Swales

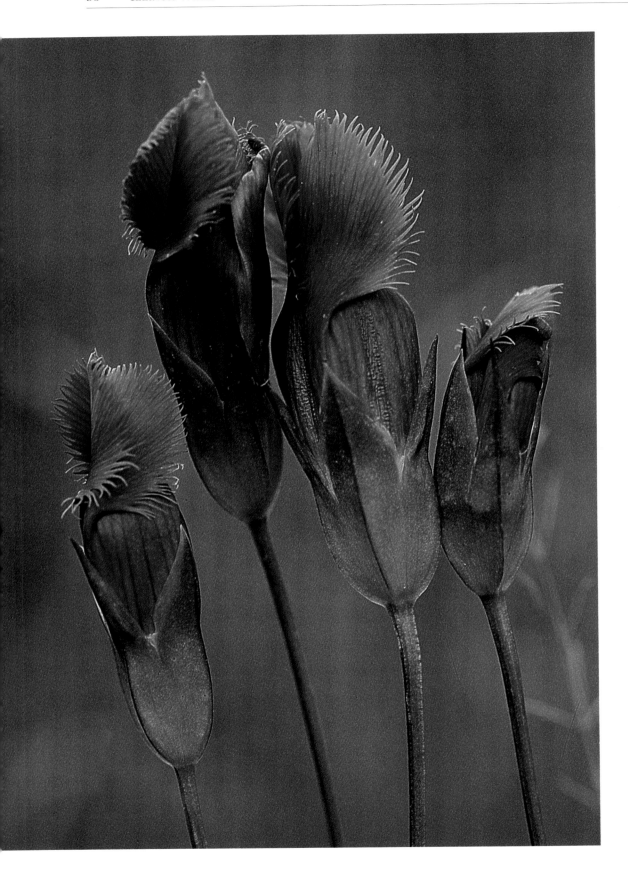

Large fringed gentians are one of the last wild-flowers to bloom in the sandy swales in fall. The flowers open with the morning sun and close by late afternoon. The fringes on the flower are thought to keep marauding insects from getting into the delicate inner portions of the plant. MJ

are alkaline and the plants they attract are much like those found in a bog or marsh. Late spring through autumn brings a profusion of ever-changing pinks, purples, yellows, and reds. Here grow northern orchids, wood lilies, gentians, Indian paintbrushes, and the occasional carnivorous sundew.

Here also, located in one of the swales, lies the Dead River. Characterized as either a very short river (when its mouth is open to Lake Michigan) or a very long pond (when its mouth is closed by a ridge of sand deposited by the north-to-south current), the Dead River is lined with white water lilies, arrowhead, and gerardia and is home to numerous species of waterfowl and wading birds.

Moist swales, like the dunes, are ever-changing. They eventually fill up with humus, become better drained, and are invaded by species from the deciduous forest. Forest succession ultimately results in a savanna-like scrub oak forest dominated by black oak with an understory that includes poison ivy, starry false Solomon's seal, coreopsis, blazing-star, and butterfly weed. The open parklike setting is maintained by periodic fires, but the trees persist because their thick corklike bark insulates them against the intense heat. The prairie plants survive because most of their parts lie buried, well insulated in the sand.

Few places in Illinois have the remarkable diversity of life found in the Dunesland. The peculiar combinations of plants and animals that occur here have resulted from events that took place in remote times. To unravel the unique circumstances that led to the formation of the current landscape, one must go back into the earth's history for many millions of years, into the interaction of climate, soil, and glaciation. To the casual observer, however, the Dunesland remains a puzzle. That life exists here at all is surprising; that plants appear to have won a battle, at least in part, against the harsh, shifting sands of the dunes is even more amazing.

Cottonwoods are important in stabilizing dunes so that other plants can become established. MJ

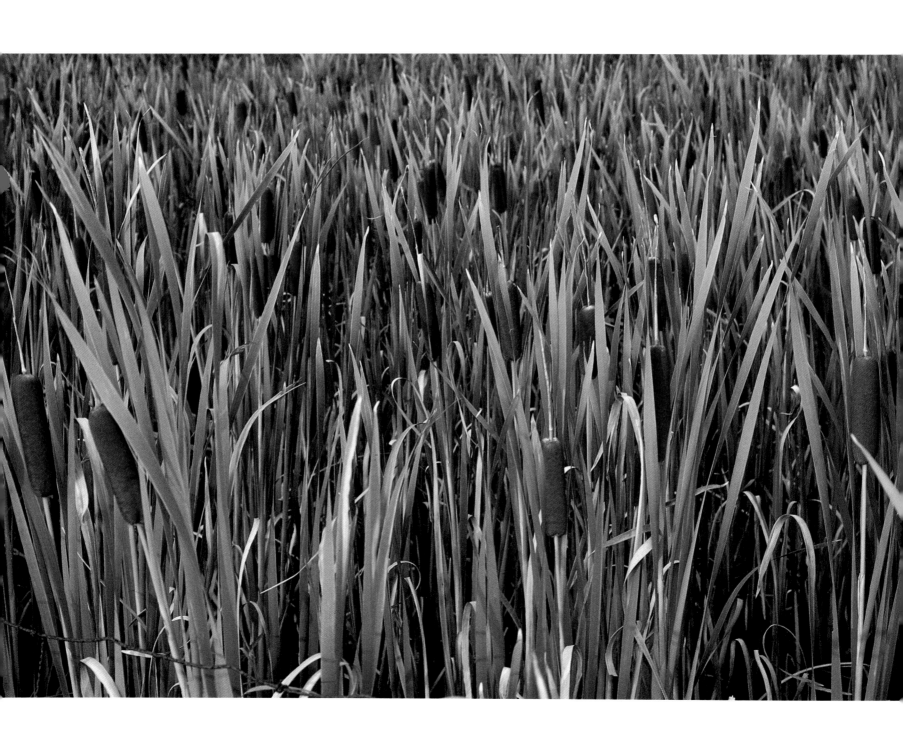

4

Clumps of grass, the size of my hat, are also sprinkled around. 'Twas by the help of these clumps that we crossed these mud holes, as the carriage sank so deep we were all obliged to get out to enable the horses to drag it through.

Chandler Gilman during a stagecoach ride from Chicago to Ottawa, 1835

Marshes and Fens

Kenneth R. Robertson and Michael R. Jeffords

Blue flag irises are nearly universal inhabitants of wet places. The bladelike leaves and flower stalk rise from a large underground rhizome buried in the muck. SP

Cattails are undoubtedly the most familiar inhabitants of wetlands in Illinois, from roadside ditches to bogs. With roots that creep underground, this perennial forms dense stands that exclude most other species. MJ

WHILE MOST CURRENT RESIDENTS do not consider Illinois a very wet state, the early settlers would have had a very different impression. The legacy of the Pleistocene glaciers and a well-developed stream system with a variety of associated wet areas saw to that. Northeastern Illinois was a mosaic of many different wetland habitats, while central Illinois was covered by a montage of wet prairies and marshes. These same early settlers considered wetlands to be a mere hindrance. The tile shop was one of the first businesses to open its doors in areas of new settlement to manufacture and sell drainage tiles that made the land fit for agriculture. In the early 1900s these tamed wetlands were viewed as a godsend. A citizen from Green County wrote, "Land that once overflowed, land that was a riot of rushes and gigantic grass, now produces corn with ears like stovewood." Today, the importance of these

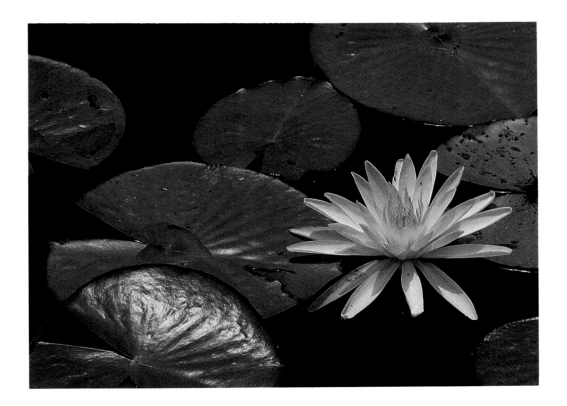

wetlands is only now being realized—they store run-off after major rains and slowly release it, they filter silt and pollutants from water, and they are tremendously productive with a great diversity of plants and wildlife.

The most common types of wetlands in northern Illinois are marshes, sedge meadows, and fens. Marshes are found throughout Illinois and form where the surface of the soil is covered by water for all or most of the year—along the margins of ponds, lakes, or rivers—in places sheltered from strong currents and waves. Many marshes in northeastern Illinois are in depressions underlain by peat (partially decayed plant remains), an indication that these areas were once lake basins. Water depth in marshes usually ranges from zero (saturated soil) to perhaps six feet. A wide variety of birds make their homes in the marshes, from migrating waterfowl to perching birds, including the red-winged blackbird and the yellow-headed blackbird, which is an endangered species in Illinois. Muskrats, the most abundant mammal, build their houses of marsh vegetation and eat starchy rootstocks, stems, and seeds found in the marsh.

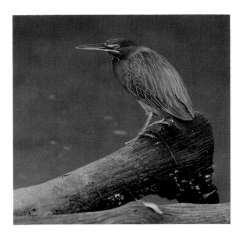

Little green herons are commonly seen in many Illinois wetlands, usually hunting near the water's edge. MJ

Water lilies are found in quiet ponds and the glacial lakes of northern Illinois. MJ

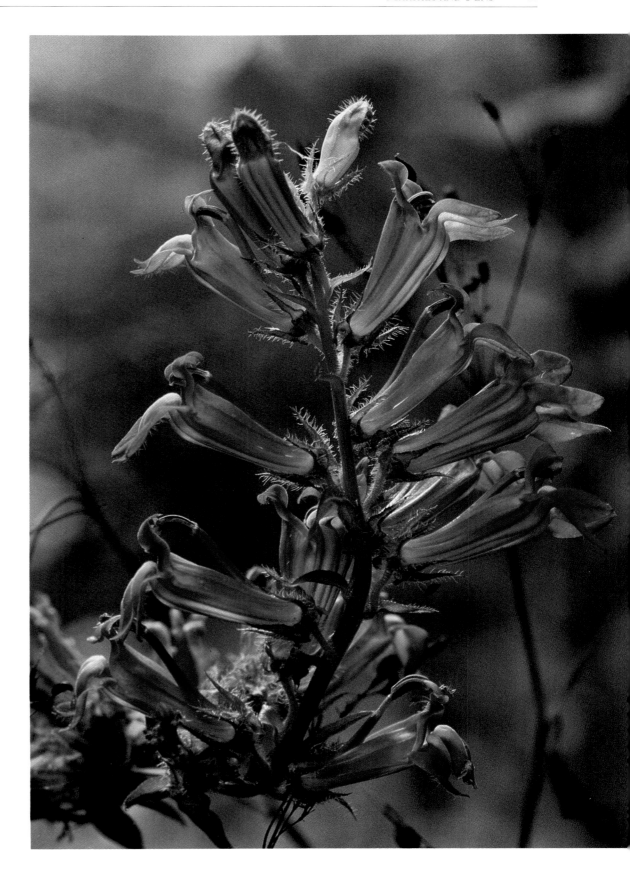

A common inhabitant of wet woods and a-long woodland streams is the great blue lobelia. This species was once thought to be a cure for syphilis. MJ

The most brilliantly colored flower in Illinois is assuredly the cardinal flower. Its chief pollinator is the ruby-throated hummingbird. Most insects simply cannot negotiate the long-tubed flowers. MJ

While natural marshes have a relatively large number of plant species, disturbed marshes have little diversity and are usually dominated by cattails. Most marsh plants are grasslike perennials and can be quite tall. Typical marsh plants include the ubiquitous cattails and various bulrushes, reeds, grasses, and sedges. Marshes are not known for mass displays of wildflowers, but a number of attractive plants are found, including spotted Joe-Pye-weed, tufted loosestrife, swamp milkweed, and blue flag iris.

Sedge meadows are usually associated with fens but also occur with marshes and other calcareous wet places in northeastern Illinois. The water level is near or just below the surface for most of the year, and this habitat often merges into marshes as the water depth increases. Sedge meadows are diabolical to walk through. The gently undulating surface of the vegetation hides countless tussocks formed by the tussock sedge. These tussocks vary from a few inches to over a foot in height—to walk on top of these soft, unstable humps is nearly impossible; to walk between them results in wet feet. When a sedge meadow has been burned in late fall or early spring, a management practice necessary to keep out unwanted shrubs and other vegetation, the abundance and size of the tussocks can be readily appreciated. The tussock sedge is the dominant plant, but other sedges, white turtlehead, and marsh fern also frequent sedge meadows.

Fens are often confused with bogs. In general, bogs are acidic and poor in minerals; most of their water comes from rainfall and surface run-off, and peat is formed from decaying sphagnum moss. Fens range from slightly acidic to alkaline and are rich in minerals. Much of their water comes from groundwater that has percolated through calcareous bedrock or gravel. The peat in fens is produced primarily by sedges and grasses.

In Illinois, fens are more common than bogs and most abundant in the Fox River valley of Lake, McHenry, Cook, and Kane counties and along the Des Plaines River in Cook and Will counties. A few fens are also found southwestward along the Illinois River valley to Tazewell County. Certain types of fens occur in depressions surrounded by gravel moraine ridges, creating a constant, year-round supply of artesian groundwater (water under pressure) that moves through the fen and maintains alkaline conditions. This water enables the peat to accumulate above the level of the surrounding area, forming a raised fen. If open water is present, floating

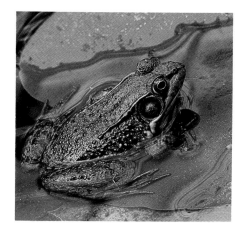

The green frog is widespread in eastern North America and occurs in most Illinois wetlands. Although this species is primarily nocturnal, it is not as wary as many other frogs and will allow close approach before it hops away. MJ

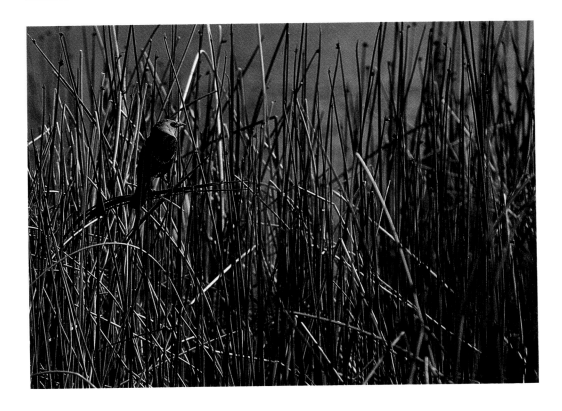

calcareous mats often form around the margins. These floating mats undulate and are fascinating, but often treacherous, to walk across. Unsuspecting visitors may find themselves hip deep, or worse, while examining plants too near the thin outer edge. At times, pieces of the floating mat even break loose to form islands that drift about the pond.

Not all fens, though, are in depressions, and large expanses of sloping fen vegetation develop at the edges of moraines where alkaline ground water seeps out. Often no obvious boundaries can be seen between such fens and seeps. In addition, photosynthesis by algae removes dissolved carbon dioxide from the water and causes deposits of calcium carbonate, called "marl," to form. Extensive marl flats can develop in fens and these are mostly barren because few plants can tolerate the extreme conditions.

Fen vegetation is a marvelous mix of species. Most fens have an abundance of tallgrass prairie grasses, especially big bluestem, little bluestem, Indian grass, and northern prairie dropseed. Wiry panic grass is virtually restricted to fens. Several sedges are common, along with a wide variety of prairie forbs: prairie dock, black-eyed Susan, New England aster, smooth phlox, false dragonhead, and marsh

Yellow-headed blackbirds are rare inhabitants of several northern Illinois marshes, often occurring in unlikely areas where heavy industry abounds. MJ

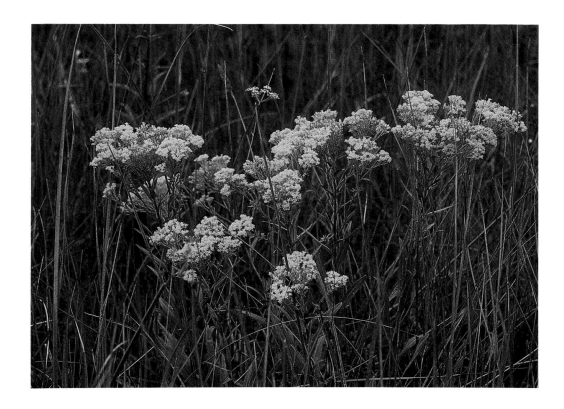

This eyed-elater click beetle, while not directly associated with wetlands, is using the platform-like leaves of American lotus for sunning. MJ

Ohio goldenrod, with its distinctive, flat-topped flowers, is confined to alkaline soil conditions and often denotes a fen. MJ

blazing-star. Other common prairie forbs like compass plant, rattlesnake master, puccoons, and wild quinine are conspicuously absent from fens. Especially striking is the lack of prairie legumes: wild indigo, white and purple prairie clover, and leadplant. Because of the prevalence of prairie species, fires are important in maintaining fen vegetation. Although the soil is wet throughout the year, the aboveground parts of plants die and dry out each fall, allowing fires to spread across the surface. When fires are suppressed, as has happened in the past hundred years, shrubs become more abundant.

Only three wildflowers are primarily restricted to fens and fenlike seeps in Illinois—Ohio goldenrod, swamp thistle, and small-fringed gentian. The Ohio goldenrod is one of the most graceful of all the goldenrods. Its bright yellow flowers appear in early fall and are produced in a broad, flat-topped cluster. Like goldenrods, thistles are also generally thought of as weeds and are abundant in vacant lots and abandoned fields. The swamp thistle, however, can usually be found only in fens. A biennial plant (living for two years), the swamp thistle has a rather coarse appearance with many spiny leaves and several clusters of lavender-pink flowers in late summer. Many kinds of gentians can be found in Illinois, but to see the small-fringed gentian

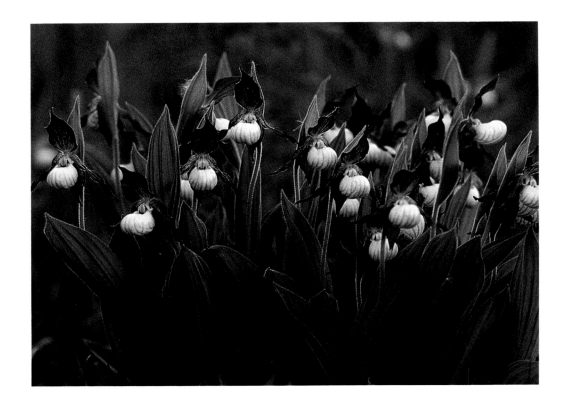

in flower, one must visit fens during September or early October, when the plants can be found growing among the sedges and grasses, often in the wettest part of the fen and on floating mats.

Fens were once rather common in northeastern Illinois, but today they are quite rare due to urbanization and the destruction of habitat which usually follows. Fortunately, a number have been designated Illinois nature preserves. Even this classification does not ensure that they will survive for future generations to enjoy because many fens verge on or are surrounded by industrial and housing developments, and the groundwater on which they depend is being contaminated or lowered. As in marshes, non-native plants also pose a serious problem, especially purple loosestrife and glossy buckthorn. They invade, outcompete, and eventually replace the native vegetation.

Unfortunately, most of the original wetlands in Illinois have been destroyed by human development. Wetlands are not popular places and are often perceived as uncomfortable and even unhealthy or dangerous. Fortunately, enough examples remain and are protected in Illinois nature preserves, state parks, and by private owners to allow one to experience these fragile, yet fascinating watery worlds.

A burned sedge meadow in Lockport Prairie shows numerous hummocks typical of the habitat. KR

The small white lady's-slipper and the small yellow lady's-slipper often grow in close proximity. Sometimes hybrids, with characteristics of both, are produced. Drainage, cultivation of habitat, and extensive picking for the floral industry during the early part of this century now limit both species to the immediate region. SP

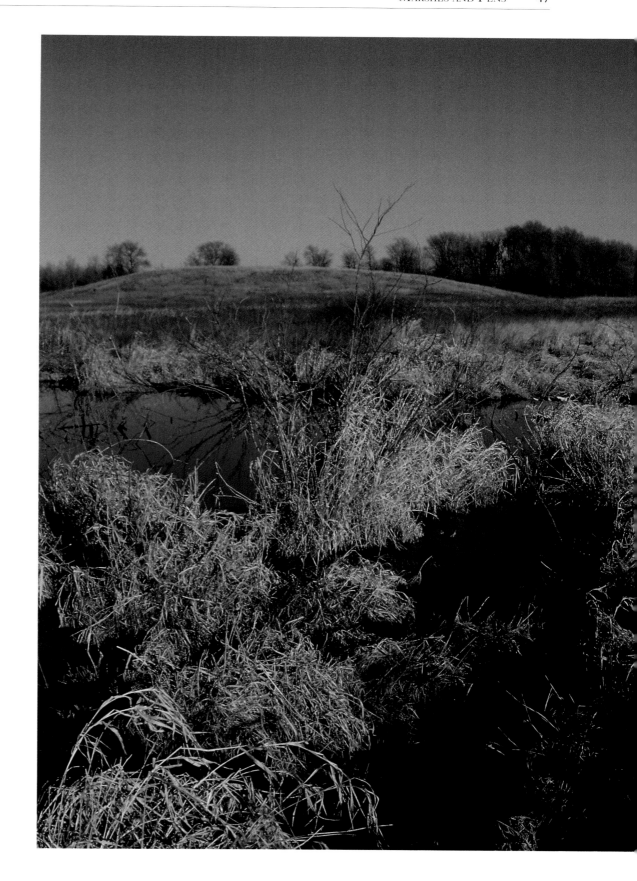

Queen-of-the-prairie, a wild spirea, prefers the alkaline conditions of fens and some marshes. The plant is tall enough to reach above the green blanket of midsummer grasses. SP

Open water exists in fens where calcareous groundwater is forced to the surface. The hill in the background is a glacial kame. KR

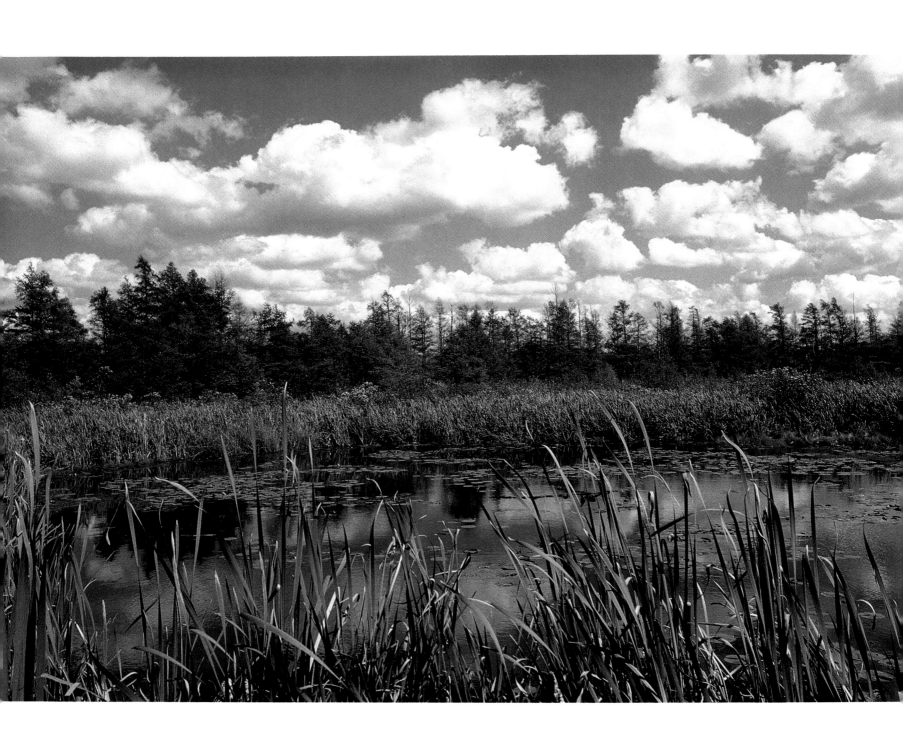

5

BOGS

Susan L. Post

IN THE EARLY TWENTIETH CENTURY Cedar Lake Bog, located in northern Lake County, was an immature bog. At that time it was a quaking mat made up of the roots of dwarf birch, cranberry, and blueberry, with a filling of sphagnum moss. Shrubs and trees were only beginning to appear. Cranberries grew abundantly on the floating mat, yet local people were afraid to go out on the mat of this young bog to harvest them. The word bog comes from the ancient Celtic language and means "something soft that bends or sinks." Bogs were thought of as gloomy places where sinister events were likely to happen. The people of Cedar Lake had a right to be fearful. At least one cow and one horse had wandered onto the bog only to disappear—perhaps fallen victim to the bogey-man. The legend of the bogey-man began in early European times and told of criminals who hid from the law in bogs, hence the origin of the

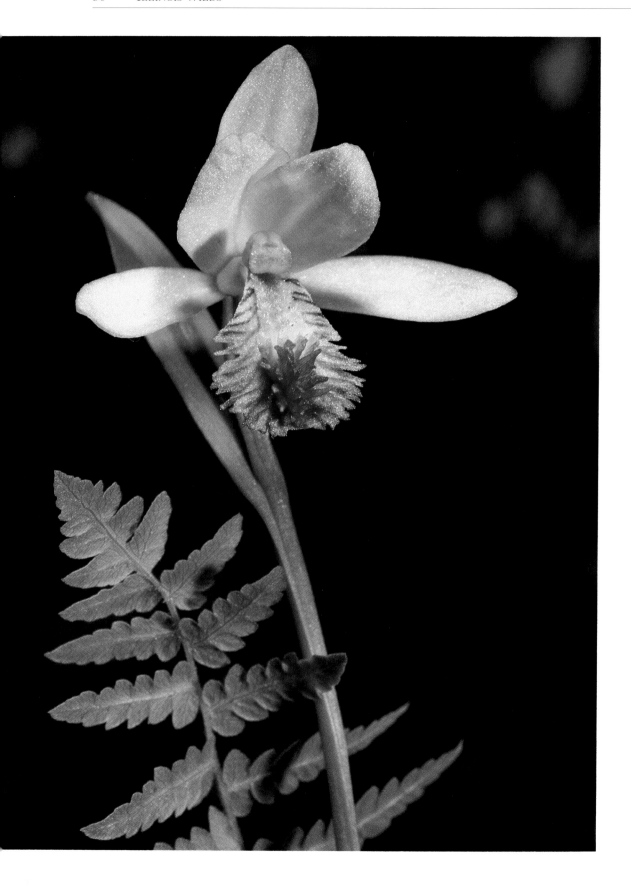

The rose pogonia orchid blooms abundantly in mid-June in the sphagnum of Volo Bog. The slender stems bear a single leaf and the plant prefers sterile, acid soil. MJ

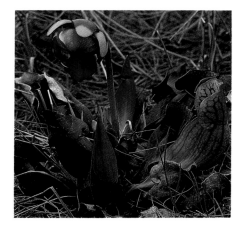

Unlike the sundew, pitcher-plants trap insects passively in leaves modified to hold water. The colorful leaf rosettes give the appearance of flowers and special nectar glands near the pitcher's mouth complete the illusion. The actual flower of the pitcher-plant is oddly shaped and can be pollinated only by insects large enough to force entrance into its interior. MJ

Sphagnum is the building material of the bog. With its alternating small and large cells, it is capable of holding up to eighteen times its weight in water. Up until World War I, sphagnum was used for surgical dressings because its acidity made it naturally sterile. MJ

name. Few people would risk their lives on the treacherous soils in search of them. When European settlers came to America, they brought the legend of the bogeymen with them.

In Illinois, a few scattered bogs can be found in northern Lake and McHenry counties. They are the only remaining examples of a plant community common in most northeastern states and abundant further north. Illinois bogs are located in a single geologic region, the late Wisconsinan drift, which is composed of sediments left by the melting glacier. During the Pleistocene Epoch, when the glaciers retreated, small basins or depressions called "kettles" were gouged from the ground or formed where blocks of ice broke free from the receding glacier and remained buried in the clay, sand, gravel, and boulders that make up the glacial till. Most of these depressions drain into two local river systems, the Des Plaines and the Fox. There is, however, a narrow section on the edge of these drainage basins which remains wet. Here are the bogs, wetlands made unique by lack of drainage. Bogs have no inflowing or outflowing streams. Therefore, carbon dioxide accumulates in the water and inhibits the growth of microscopic plants and bacteria, the decomposer organisms so important for decay. Decomposition is almost nonexisistent in a bog, and large quantities of dead plant life accumulate in ever-thickening layers to form peat. Bog water has a low nutrient content, and the process of peat formation causes both the water and soil to become highly acidic. The organic acids in bog water are nature's best embalming fluid and act as a preservative on any dead plant or animal that falls into a bog pond.

Bog soils and water are reminiscent of their glacial heritage. They thaw slowly because they are well insulated and occupy a low, cool area. Ice often persists below the first several inches of water late into the month of May. Although the bog appears to be able to support little plant life, a uniquely adapted flora finds refuge there. These hardy plants are members of the heath family—leatherleaf, blueberry, and cranberry. Their woody stems and thick, leathery, elliptical leaves are characteristic of plants adapted to dry conditions, for though water is abundant, it is highly acidic and plant roots cannot readily absorb it. The thick, tough leaves protect against excessive water loss and wilting.

Orchids, along with the heaths, thrive in bogs because of a remarkable relationship that exists between their roots and specialized "acid-loving" soil fungi called mycorrhizae. The fungi live symbiotically upon or within the feeding roots of the orchids and heaths, decomposing organic materials in the acid soil and sharing the

food with their hosts in exchange for a "home." Bogs are often the only undisturbed refuges left for many acid-loving species of orchids, including rose pogonia, grass pink, and the pink lady's-slipper.

Carnivorous pitcher-plants and sundews also make the bog their home. The leaves of *Sarracenia*, the pitcher-plant, are modified into a rolled tube which is open at the top to trap rain and dew. A digestive enzyme is secreted into this trapped fluid and efficiently dissolves any unfortunate insect that happens to fall into the pitcher and drown. Pitcher-plant lips are murderously slick and possess numerous backward-directed hairs that send insect prey to their doom. One insect, the pitcher-plant mosquito, has turned the tables and uses the pitcher as a home. Mosquito larvae may be found during any season, even winter, and are apparently able to withstand the freezing and thawing of liquid within the leaves.

Unlike the passive trap of the pitcher-plant, the sundew employs an active trap similar to flypaper. Sundews possess a small rosette of spoon-shaped leaves completely covered with stiff, red hairs. Topping each hair is a gland that secretes a globule of sticky, translucent material. Any relatively small insect that lands on the glistening droplet is promptly snared. The hairs, reacting to the insect's weight, operate like tentacles and slowly curl around the prey, smothering it against the leaf surface where it is digested and absorbed by the plant. Because the bog soil is nitrogen deficient, the raw materials for the sundew's growth come from the bodies of insects, which are nitrogen rich. Since the leaves take in the nutrients required for the plant's food production, the root systems of these carnivorous plants are weak and poorly developed and function only as an anchor.

Bogs are areas in transition. During the gradual succession of one plant community by another, the water basin fills with peat. A classic bog has an "eye" of open water with floating aquatic plants, such as fragrant water lily and yellow pond lily, rimmed by herbs at the water's edge. These plants are intermixed with the dominant plant, sphagnum moss, and mark the initial stage of bog succession, a floating mat. The water is cold and brown, colored by tannins and acids, the products of the slow decay of sphagnum. The established sphagnum ring around the pond grows steadily inward to form an unstable, quaking mat that is held together and strengthened by interlaced roots of herbs and small shrubs. Sphagnum is made up of a network of alternating small and large cells, an arrangement that permits the plant to hold up to 18 times its weight in water. Sphagnum moss grows from the top, dying away below. The lake gradually fills in from the bottom, and the sphagnum mat slowly

Poison sumac contains a poison more potent than that of poison ivy. All parts of the plant—leaves, stems, and the characteristic white berries—are poisonous throughout the year. SP

Round-leaved sundews grow in dense mats on the sphagnum. In full sun the plant sparkles, forming a lethal beacon for many small gnats, midges, mosquitoes, and damselflies. MJ

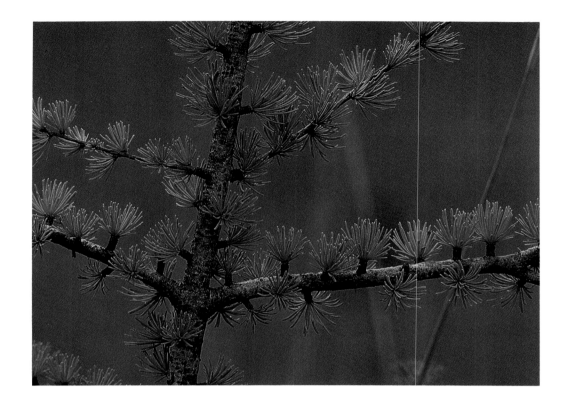

sinks as its weight increases. The weight of the water and the mossy mass on top compresses the decomposing material below to create peat. Further from the open water the sphagnum accumulates around the bases of shrubs to form hummocks. Tamaracks, conifers that lose their needles in winter, grow on the hummocks. Their roots add strength to the ever-increasing sphagnum mat and provide support for other plants that grow above the water line. Their fallen needles help to keep the water and soil acidic by releasing tannic acid as they decompose. Within a century or two, the bog will no longer quake and the "eye" will be filled in. The land will be built up high enough for proper drainage and grasses will move in, preparing the way for new meadows and forests. Volo Bog Nature Preserve, in western Lake County, is an excellent example of a successional bog. All stages are present, including a cattail marsh that surrounds it, separating it from the upland forest.

Bogs are unique communities of wild orchids, pitcher-plants, sundews, and quaking mats. They are defined in many ways: as acidic areas vegetated by a flora in which peat-forming plants are particularly abundant, as wet spongy ground with a characteristic flora, or simply as an acid area, rich in plant residues. Perhaps, however, the bog is defined best as simply "a place where heavy bodies are likely to sink."

Tamaracks are evergreens that lose their needles in winter. The soft green needles cover the plant in sparse tufts, earning the tree the distinction of giving the least shade. Though they grow equally well in other environments, tamaracks are commonly found in bogs, where competition from other tree species is less rigorous. MJ

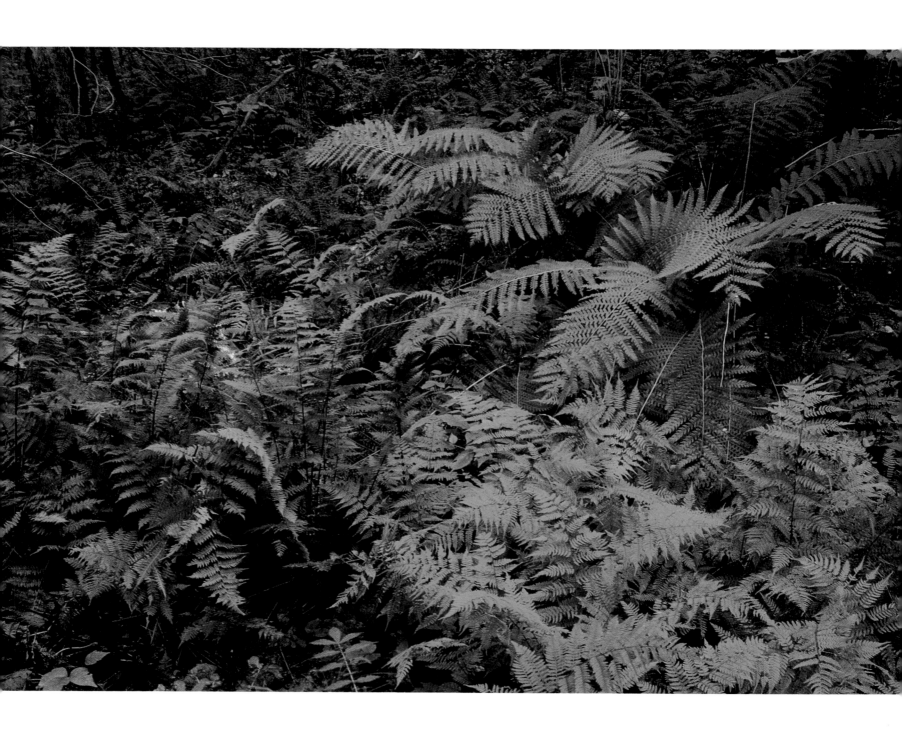

6

SEEP SPRINGS

Susan L. Post

EXTREME SOUTHEASTERN ILLINOIS has regions where ferns grow as tall as a person, often surrounded by a variety of orchids. In central Illinois, marsh marigold and skunk cabbage, uncommon plants this far south, are found among rare deposits of tufa, a soft, porous rock deposited by water. In far northern Illinois, alkaline marl flats support minimal vegetation. Different as these areas are, they share enough in common to be classified as seeps—wet, soggy habitats much like a bog or a swamp.

Usually smaller than half an acre, seeps are most common along the lower slopes of ravines, terraces, and glacial moraines. Seeps typically have soil saturated to varying degrees by groundwater flowing to the surface of the area in a diffuse rather than a concentrated manner. Occasionally water may collect and run in small streams across the face of the seep. Seeps form in the following way: groundwater

that has percolated down through porous sand and gravel reaches a layer of impermeable limestone or sandstone bedrock. When the downward-moving water meets a nonporous rock or clay layer, it tends to flow horizontally. During its horizontal journey, this water takes on the characteristics of the materials it encounters. Eventually, it comes to the edge of a bluff or ravine and flows out, forming seeps that vary from very alkaline to highly acidic.

In extreme southern Illinois an area of low hills and gravel extends in a narrow band from the Mississippi to the Ohio River. These are the Cretaceous Hills, an isolated remnant of the more broadly spread Cretaceous deposits in Kentucky and Tennessee. When the Ohio River changed its course during the glaciation of the late Pleistocene Epoch, that part of the Cretaceous Hills which is in Illinois was separated from deposits to the south and east. Most of these hills are low and gravelly with many seeps. On the eastern edge of the hills, lying on either side of the Pope-Massac county line, are over 50 seep springs. The majority are near the forested northern slopes where gravelly Cretaceous deposits meet underlying bedrock near the ground surface. Groundwater percolates down through the gravel and then out to the surface along the top of the sandstone. The soil varies from wet sand to muck and is strongly acidic.

Upland growth here consists of hardwood forests on the ridges and steeper slopes and a few small prairie remnants. The forests are dominated by maple and oaks: blackjack, white, post, and pin. Flowering dogwood is the common small tree. Southern herbs such as dwarf crested iris and fairy wand occur here. The most intriguing vegetation, however, is found in the seeps. Ferns, orchids, and even sphagnum moss—plants typically found in an acidic northern bog—grow in profusion. Southern lady fern, royal fern, and cinnamon fern, with fronds as tall as seven feet, blanket the seeps luxuriously. A few sites support colonies of the uncommon marsh fern, the rare netted chain fern, and New York fern. Orchids are as diverse as the ferns: large ladies'-tresses, rattlesnake plantain, crane-fly, ragged habenaria, the phlox-purple banners of the purple fringeless, and the whorled pogonia, an orchid typically associated with the Cretaceous Hills, are present but not common. Each seep has its unique plant community. The only vegetation common to them all are the orange jewelweed or "touch-me-not," white grass, and the drooping sedge.

In central Illinois, seeps are common along the Illinois and Vermilion rivers, with isolated examples in Peoria, Woodford, Coles, Fayette, and Douglas counties. Like the acid seeps to the south, the central Illinois seeps are less than half an acre in

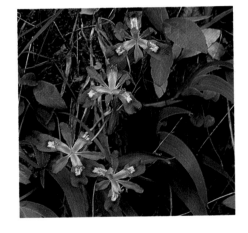

The dwarf crested iris, periodically found near the acid seeps of southern Illinois, is the smallest iris in the state. Only four to six inches high, the leaves have the distinctive, flat-sided appearance of their larger relatives. SP

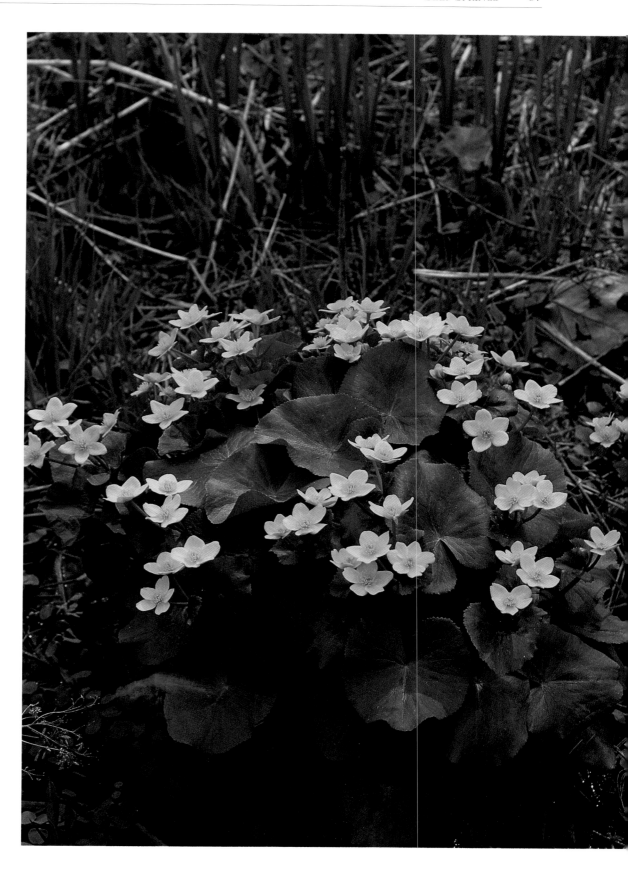

Marsh marigold, a buttercup, often signals the presence of a seep. Forest Glen Seep in Vermilion County is cloaked in yellow by these early spring flowers. SP

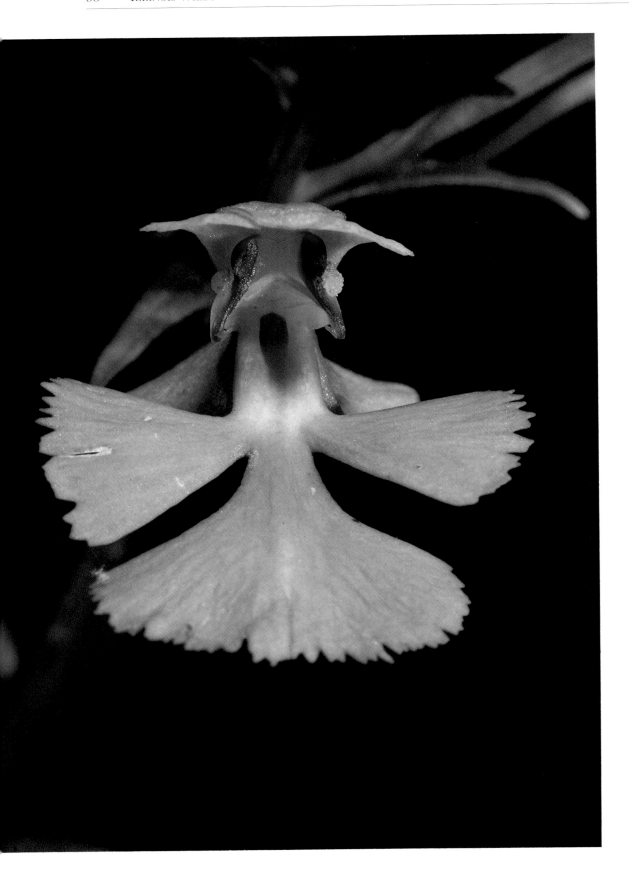

The purple fringeless orchid requires wet, acid soil in sun or partial shade. In addition to the acid seeps, it is often found on the borders of swamps and in wet woods across the southern part of the state. MJ

Cinnamon ferns as tall as a person dot the acid seeps of the Cretaceous Hills Nature Preserve in Pope County. MJ

size, occur near hillsides, and are associated with morainal deposits. These seeps, however, are alkaline, the result of water flowing from a layer of gravel lodged between two layers of clay. The upper layer is perhaps three inches thick and allows some water penetration; the lower layer is much thicker and impervious to water. The ground surface on the north side of hills may be encrusted with deposits of lime and iron up to six inches thick as minerals precipitate from the seepage water. Rare deposits of tufa, a porous rock composed almost entirely of pure calcium carbonate, also form. In 1912, during a University of Illinois field trip along the Vermilion River, an extensive tufa deposit covering over 10,000 square feet was discovered. Slowly the deposit was being redissolved and destroyed by the same spring that had deposited it. In a few years, the tufa was gone.

The seeps of central Illinois share certain plants in common with the Cretaceous Hills—dogwood, willow, touch-me-not, and various sedges, yet the central Illinois seeps also possess flora which is unique to the region. At one time the rare, showy lady's-slipper was reported from this area and still occurs at a single site. Grass-of-Parnassus, bog twayblade orchid, marsh marigold, and skunk cabbage reach their southern and western limits here. Skunk cabbage which grows in the northern

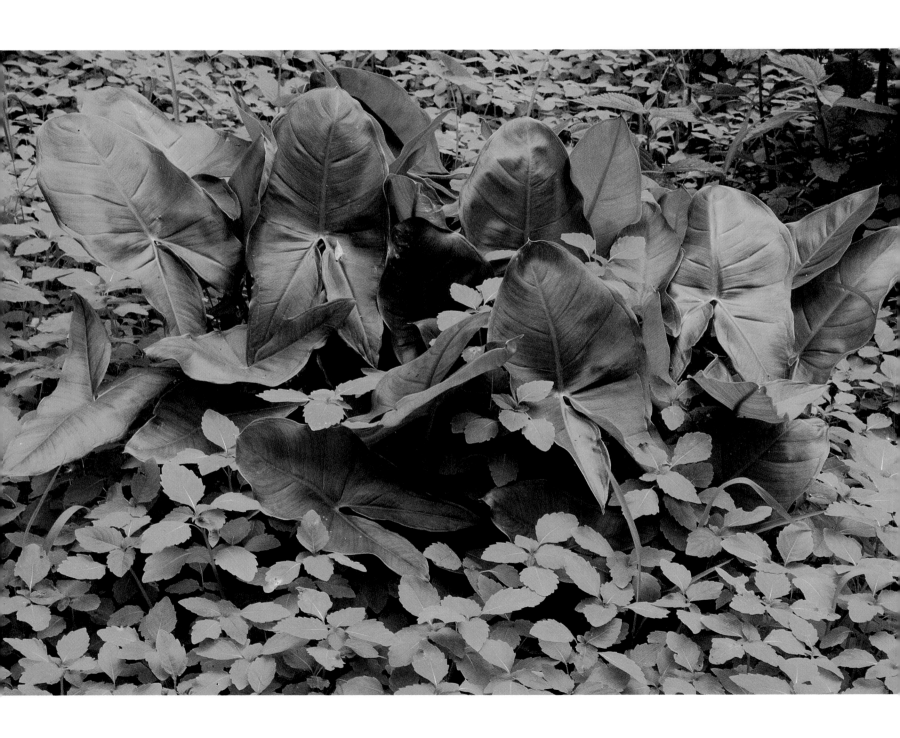

two-thirds of Illinois, blooms in late February or early March. True to its name, all parts of the plant, when bruised or crushed, give off an offensive odor that has been described as a blend of garlic, onions, and decaying flesh. The skunk cabbage's distinctive spathe appears first as a fleshy, purplish-brown protective hood that blends in with the decaying leaves on the forest floor. Enclosed within the spathe is a knoblike structure covered with tiny flowers. During the several weeks when the flowers are open, the plant's internal temperature is maintained at a nearly constant 72° Fahrenheit. This heat, generated by a very high rate of respiration, often enables the spathes to melt their way through an early spring snow. By late spring, when the spathe has wilted, the large leaves unfurl to shade touch-me-not seedlings.

In northeastern Illinois, where glacial topography and wetlands are characteristic, seeps are again common. These seeps are alkaline in composition due to deposits of sand, gravel, and dolomite cobbles. The water here is calcareous, a fact made obvious by the spring runs where calcium carbonates flow out forming marl flats. Very little vegetation grows here. Dominant plants, where they occur, are various sedges and skunk cabbage. Many seeps in northeastern Illinois grade into fens that are found near the edge of moraines.

A visit to the soggy seeps of Cretaceous Hills Nature Preserve in southern Illinois, Forest Glen Seep Nature Preserve in east-central Illinois, or Long Run Seep in northeastern Illinois discloses a wealth of interesting plants, but visitors will need to come clad in sturdy boots. Otherwise the water in the supersaturated soil will likely live up to its habitat's name by "seeping" into and filling up one's shoes.

The plant most characteristic of a seep is skunk cabbage, one of the first plants to bloom each year. Skunk cabbage emerges in late winter, often melting its way through the snow. By midspring skunk cabbage flowers have faded to be replaced by large, caladiumlike leaves that persist the remainder of the growing season. MJ

The vegetation in individual seeps may not be particularly varied, but its lushness is undeniable. Spring Bay in Woodford County has many such luxuriant seeps. This display of arrowhead and jewelweed can be found there. SP

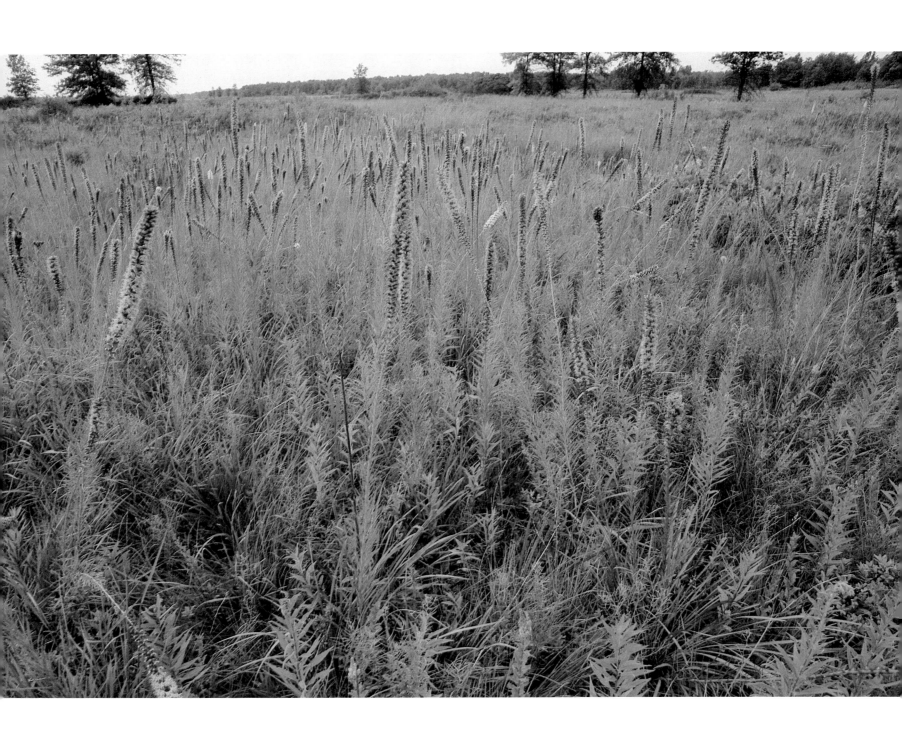

7

I was in the midst of a prairie! A world of grass and flowers stretched around me, rising and falling in gentle undulations, as if an enchanter had struck the ocean swell, and it was at rest forever....What a new and wondrous world of beauty! What a magnificent sight! How shall I convey to you an idea of a prairie?

Eliza Steele on the prairies south of Chicago,1840

TALLGRASS PRAIRIE

Kenneth R. Robertson, Susan L. Post, and Michael R. Jeffords

The Michigan lily may be mistaken for the less common Turk's-cap lily. This perennial prefers moist prairie soil. Its roots were used by Indians as a thickener for soups. MJ

An expanse of blazing-star is typical of a tallgrass prairie in August. Their uncommon white forms intermingle in this Iroquois County prairie. MJ

PRAIRIE! THE MERE MENTION OF THE WORD conjures vivid and varied images. Some may picture settlers in covered wagons, scenes suggested perhaps by an old black-and-white movie or television program. Others recall books with poetic descriptions or striking photographs of the prairie. Many mistakenly think of open grassy areas such as vacant lots and abandoned fields, which are really not prairies at all. A few might even remember promotional brochures that proclaim Illinois as "The Prairie State." Only a handful may be able to call to mind the experience of actually being on a prairie—the day is warm, the sun is shining in a brilliant blue sky, the wind is brisk, birds are singing, and the land is alive with colorful wildflowers and buzzing insects. Oh, those lucky few—for prairies, though wonderful places to visit, are today vanishingly rare in Illinois.

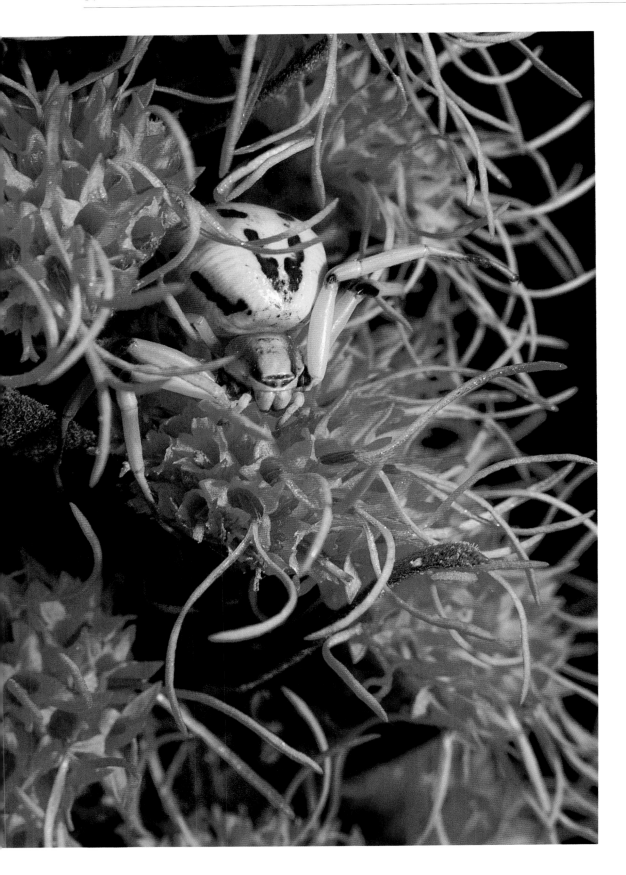

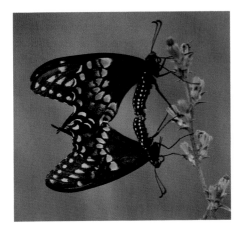

The eastern black swallowtail commonly flies low, frequently alighting on various flowers to feed. Female blacks have more blue on the hindwing and are somewhat larger than males. The attractive caterpillars, called "parsleyworms," feed on members of the carrot family and are considered garden pests. MJ

Goldenrod spiders often change color to match the flowers on which they sit, but only from yellow to white or back again. If one happens to rest on a flower of another color, it conceals its uncamouflaged abdomen within the flower and leaves only the head-on view for potential prey to see. SP

This was not always the case. The first Europeans to see the Illinois country had crossed a vast ocean, snaked their way over a nearly impenetrable mountain range, and forged a path through a thousand miles of dense, primeval forest. They did it with indomitable spirit and by sheer force of will. Yet when they reached the edge of the eastern deciduous forest, today approximated by the Indiana-Illinois border, they stopped in wonder. Here was a landscape so different, their language had no word for it. Later travelers trying to describe the area turned to the sea for analogies, calling the area "a sea of grass" or "a vast ocean of meadow-land." In time, this landscape came to be known as "prairie," a word derived from the French word for meadow.

At the time of settlement, 22 of the 36 million acres that make up the present state of Illinois were in prairie. But this acreage was only part of a much larger region of prairie that stretched from scattered pockets in Ohio and Indiana westward almost to the Rocky Mountains, northward into Canada, and southward as far as Oklahoma and Texas. Prairies differ, because rainfall decreases from east to west. Tallgrass prairie exists in the moister eastern region, mixed-grass prairie in the central Great Plains, and shortgrass prairie towards the rainshadow of the Rockies. Today, these three prairie types largely correspond to the corn and soybean region, the wheat belt, and the western rangelands, respectively.

At first the early settlers avoided living on the prairie. They found the intense summer heat and high humidity of the prairies, the bleak winters, the periodic raging fires, and the hordes of biting insects to be intimidating, almost frightening. Because no trees grew on the prairie, the settlers considered it infertile. This perception, plus the need for firewood and building timber, prompted them to build their homes at the edges of forest groves and along rivers, where trees persisted. Before long, however, the settlers discovered that the prairie soil was not only more fertile than the forest soil, but that it was in fact one of the most productive soils in the world. The prairie sod, with its thickly interwoven roots of prairie grasses and forbs, did not yield to the wooden plows first developed for turning prairie. Discovered only through trial and error, the most effective way to turn the prairie soil proved to be both an art and a science. Using a massive breaking plow, usually 6 to 12 feet long and pulled by several yoke of oxen, an industrious farmer could break one-and-a-half to three acres in a full day's work. The sod had to be turned late enough in the season to prevent regrowth, but early enough to allow time for the grasses to decay before autumn. It was not until 1837, when John Deere invented the self-scouring,

The flaming spikes of blazing-star are one of the most spectacular and familiar of prairie wildflowers. MJ

Overleaf: Historically, lightening from the often violent prairie thunderstorms ignited the landscape of Illinois, causing massive fires that contributed to the formation and maintenance of tallgrass prairie. MJ

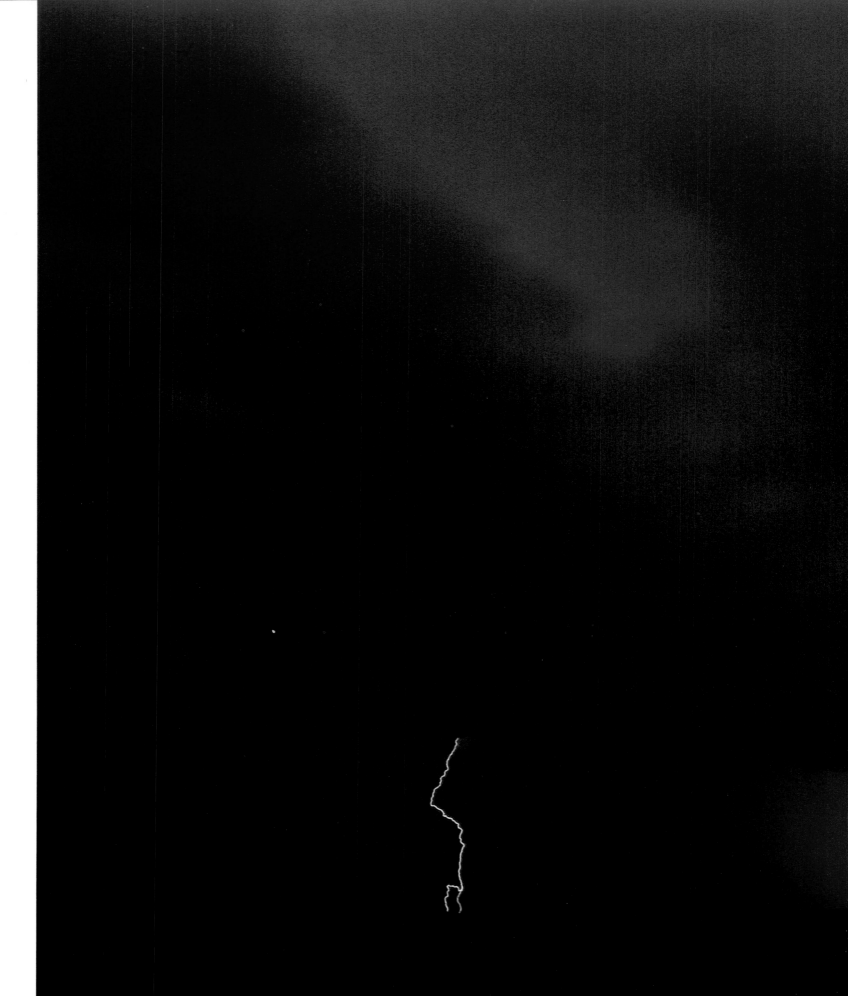

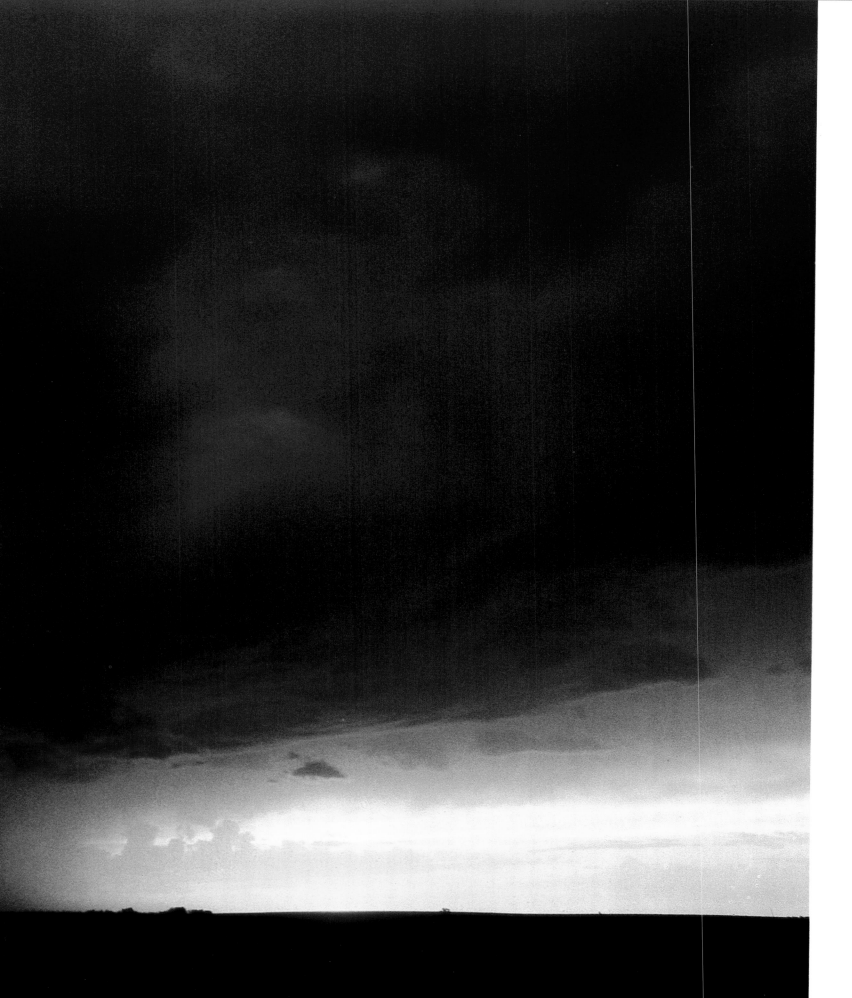

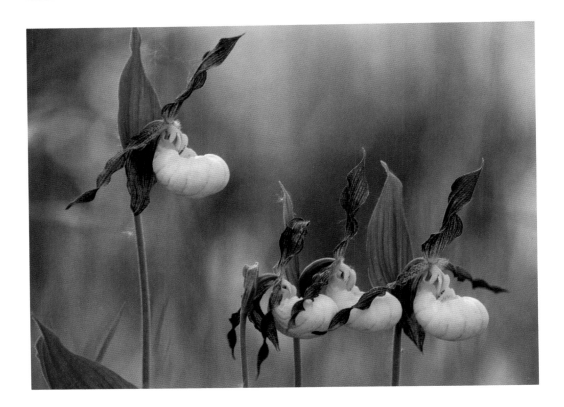

steel-bladed plow in Grand Detour, Illinois, that it became possible to break the prairie sod on a large scale. Then, in a remarkably short period of perhaps 50 years, most of the prairie in Illinois was plowed under and converted for agricultural use. Today, only 2,300 acres of the approximately 22 million acres of original prairie remain in Illinois, less than one-hundredth of one percent.

Illinois lies within the tallgrass prairie region, sometimes called the "true" prairie, where the landscape is dominated by grasses, such as big bluestem and Indian grass, that sometimes reach a height of ten feet or more. Accounts of early settlers tell of being unable to see across the prairie even on horseback, of becoming lost because the horizon could not be seen and trees were of little use as markers. Grasses formed the overwhelming bulk of prairie growth (90% of the foliage), although they usually constituted less than one-fifth of the plant species present. Multi-hued wildflowers would have provided a welcome relief to the infinite expanses of green. Over 200 different species of plants, belonging to 45 different families, are known from Illinois prairies. Although this number is low compared to the number of forest and woodland plants, the diversity of plants within a prairie can be quite large; it is not unusual to find more than 120 kinds of plants in a prairie less than five acres in size.

Sulphur butterflies spend cloudy days on the prairie resting in protected sites, usually at the base of tall plants. MJ

The rare, small yellow lady's-slipper inhabits the wet prairies of the Chicago region. MJ

Katydids are grasshopperlike insects with very long antennae and ears on their front legs. While in all developmental stages they are usually green and well camouflaged, an occasional mutant or "sport" is bright pink and highly conspicuous to predators. SP

Prairies in Illinois are now confined mostly to railroad rights-of-way and pioneer cemeteries. Hoary puccoon, nestled next to an old tombstone, evokes prairies of the past. MJ

Not all prairie plants are noticeable at any given time. Rather, there is a progression of species throughout the growing season. Low herbs, such as prairie violet and blue-eyed grass, flower very early in the spring. In late spring to early summer a rainbow of colors appears: shooting-stars, wild hyacinth, bird's-foot violet, downy phlox, and hoary puccoon. These too are relatively short plants, seldom exceeding one to two feet in height. During the summer, a large part of the prairie is in flower. As the summer progresses, each succeeding forb increases in height to keep pace with the lengthening grasses. By midsummer, the rich beauty of the prairie fully surfaces. The tall grasses bloom and the colors of the forbs explode with dozens of species blooming in a single day. By late summer and early fall the yellows and browns dominate with legions of goldenrod and sunflowers. Flashes of brilliant pink and violet from blazing-stars, false dragonhead, and New England aster punctuate the amber palette. The last plants to flower are the gentians and ladies'-tresses orchids, mimicking the habit of diminutive early spring species by growing in the shadow of the towering grasses.

The soil underneath a prairie is a dense tangle of roots, rhizomes, bulbs, corms, and rootstocks. While the aboveground part of most prairie plants dies back each year, the plants are kept alive from year to year by their underground structures. The roots of prairie plants often extend deeper into the ground than their stems arise above it. The roots of big bluestem, for example, may be 7 or more feet deep, and switchgrass roots more than 11 feet deep. When these belowground portions die, their decay greatly enriches the soil with organic matter. The rich and productive soils of most of the Midwest cornbelt had their genesis under prairies.

The prairie ecosystem is relatively young, having developed about 8,000 years ago after the last glaciation. Hence, few species of plants and animals are restricted or endemic to the tallgrass prairie. Nearly all prairie species occur in habitats other than prairies and in geographical areas other than the prairie region. Most of the spring and early summer plants grow or have related species in the eastern deciduous woods or the northern coniferous forests. The mid- to late-summer and autumn plants often bear resemblance to plants from the southeastern United States. Several prairie species in Illinois, especially those of dry habitats, are also found growing in abundance in the western Great Plains and in the arid areas to the northwest and southwest of the Rocky Mountains.

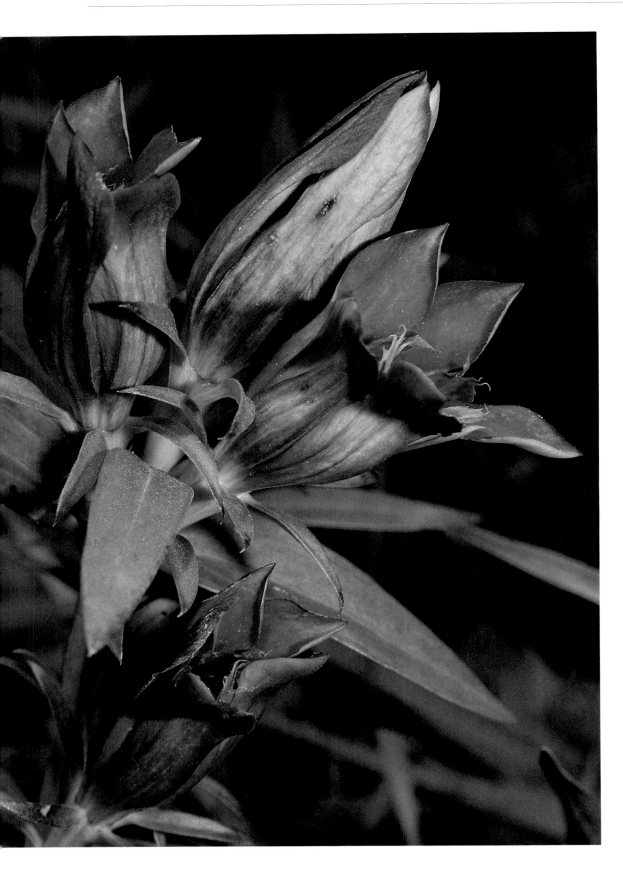

Downy gentians bloom late in the fall, always beneath the towering tall grasses. They prefer drier prairies and rapidly decline when overgrazed. SP

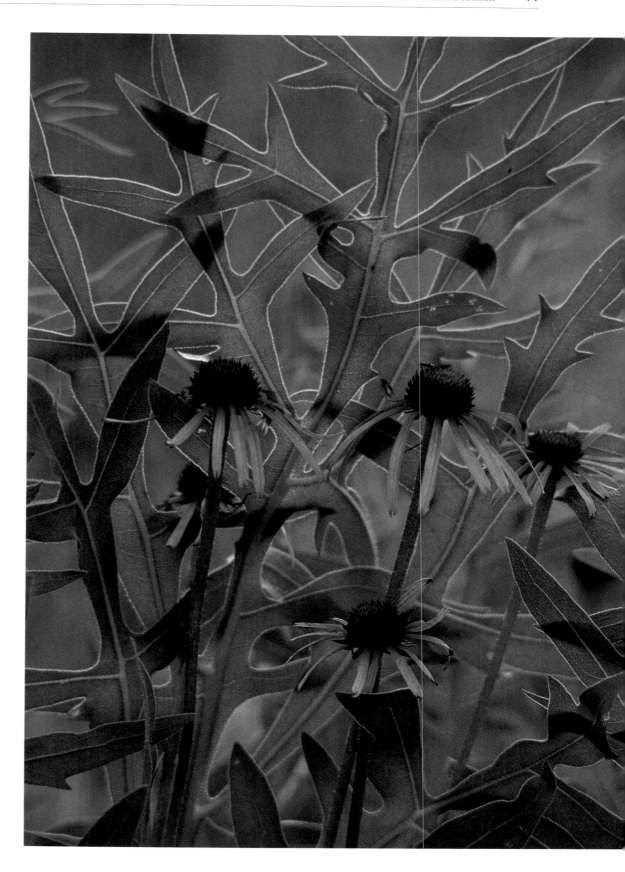

Purple coneflowers are members of the sunflower family and prefer moderately moist to dry prairies. The compass plant received its name from the north-south orientation of its lower leaves. The leaves grow vertically with their broad surfaces facing the rising and setting sun. Tales were frequently told of settlers lost on the prairie on dark nights who found their way by feeling compass plant leaves. SP

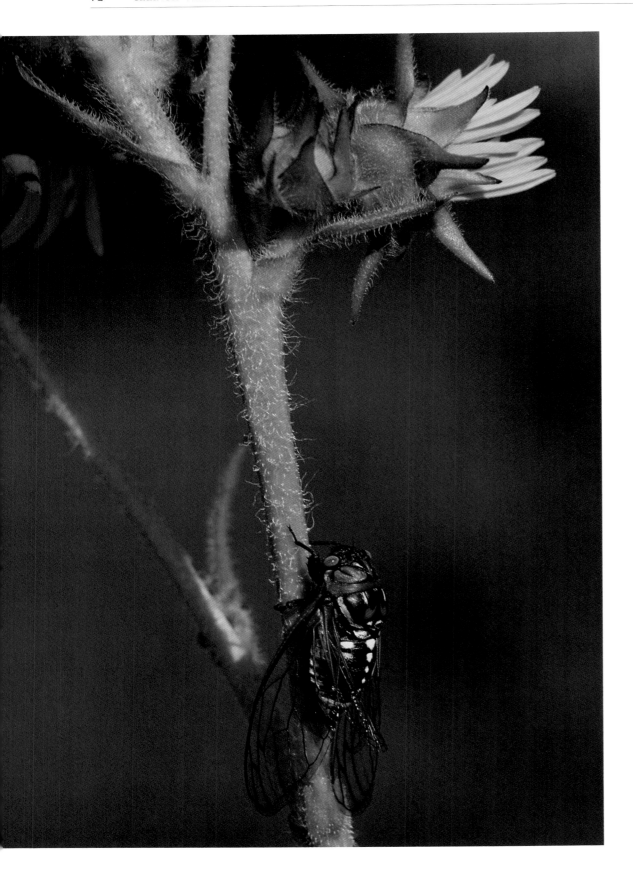

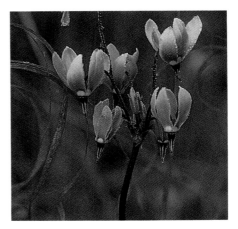

The shooting-star, called "prairie pointers" by early settlers, is a primrose that blooms during spring before the grasses grow tall and shade the ground. In most of the eastern United States shooting-stars are considered woodland plants, but they have taken full advantage of the prairie habitat. MJ

The prairie cicada does not feed as an adult, but its larval form or "nymph" makes up for that by spending up to three years feeding on sap it extracts from plant roots. MJ

Prairie was able to develop because of three major factors: fire, drought, and grazing. Fires were commonplace before European settlement, often set as a hunting tactic by native Americans who arrived in what is now Illinois some 2,000 years before the prairies were formed. Prairie plants are mostly perennial herbs with underground rootstocks and are adapted to endure the roaring prairie fires which kill invading trees. The prairie region is also subject to prolonged dry periods during the summer months, with major droughts that last for several years occurring periodically. The prairie vegetation, with deep roots and the ability to conserve water, withstands these droughts much better than forests. Bison and other large herbivores also maintained the prairie by grazing. Again, the belowground structures of prairie plants enable them to withstand this stress better than trees.

In the early 1830s those who found the prairie habitable were considered part of the lunatic fringe, but by the end of the decade over 300,000 people had settled on the prairie. During the 1850s and 1860s, when the establishment of railroads solved the problem of getting crops to market, the prairies were rapidly settled. By 1860, most of Illinois' prairie had disappeared causing one Illinoian to lament, "What a pity that some of it could not have been preserved, so that those born later might enjoy its beauty also." Although most of the original prairie in Illinois has been destroyed, a number of prairie areas remain. Many of these are former pioneer cemeteries that were laid out on the prairie during the time of European settlement, and others are found along railroad rights-of-way. Several original prairie remnants have been dedicated as Illinois Nature Preserves: Goose Lake Prairie, Weston Cemetery Prairie, Prospect Cemetery Prairie, Loda Cemetery Prairie, Sunbury Railroad Prairie, Searls Park Prairie, and Somme Prairie. While the preservation of these remnants is commendable and worthwhile, it must be remembered that these are small, incomplete prairie ecosystems, lacking the large herbivores and carnivores that once roamed the state.

Because of the rarity of natural prairies, several restoration and reconstruction projects have been undertaken in Illinois. Some of these contain only a few characteristic prairie species, while others are careful representations that greatly resemble original prairie. In fact, one of the best places in Illinois to get the feeling of being out on a prairie is the prairie restoration site at the Morton Arborteum in Lisle, a suburb of Chicago. Hopefully, the combination of preserving remaining prairie remnants as nature preserves and planting prairie reconstructions will make it possible for current and future generations to experience what Eliza Steele did: "the new and wondrous world of beauty"—the Illinois prairie.

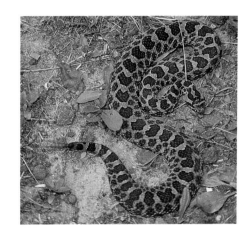

The Massasauga rattlesnake prefers open woods and prairies. It is the smallest of only two rattlesnake species found in Illinois. When disturbed, its rattles sound like the buzzing of a cicada or a katydid. Massasaugas primarily eat small rodents and frogs. MJ

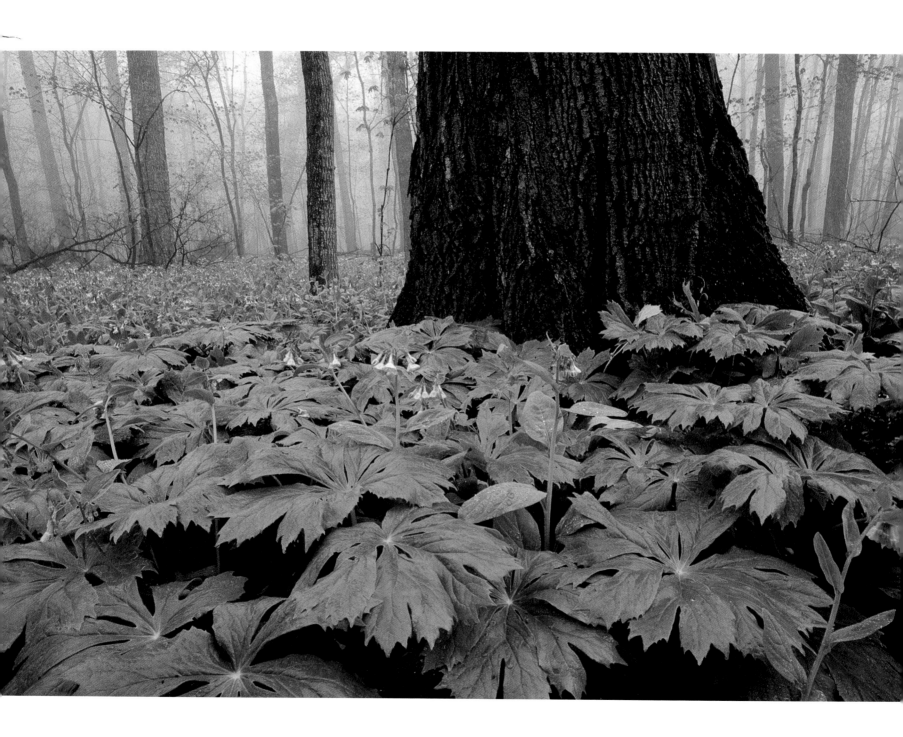

8

Sometimes the woodland extends along this river for miles continuously, again it stretches in a wide belt off into the country marking the course of some tributary streams and sometimes in vast groves of several miles in extent, standing alone, like islands in the wilderness of grass and flowers.

U.S. Government Geologist David Dale Owen, 1839

PRAIRIE GROVES

Michael R. Jeffords

An acorn weevil lays her eggs in developing acorns in early summer. The scar soon heals and the maggotlike grub feeds all summer to magically emerge from mature acorns in the fall. The grub burrows into the soil to pupate, and adult weevils appear the following spring. MJ

A foggy spring morning is an excellent time to view the wealth of life in a prairie grove. May-apples and Virginia bluebells encircle the massive trunks in undisturbed prairie groves and often extend for acres in all directions. MJ

WHEN EUROPEANS BEGAN TO SETTLE THE ILLINOIS COUNTRY, what is now central and northern Illinois was largely prairie, interrupted by forests only on floodplains, on slopes bordering streams, in river bends, and in isolated prairie groves. Many of these groves, completely surrounded by prairie, were miles apart. They were important to the indigenous peoples as landmarks and campsites. The first European settlers chose to live in these groves rather than on the open prairie because they were often near water, offered protection from harsh weather, and provided wood for building materials and fuel. In addition, prairie groves provided a reassuring link with familiar terrain. These early settlers were forest people, unaccustomed to and uncomfortable in a vast expanse of grassland. Today, these groves are surrounded by farmsteads and cultivated fields. Their original sizes and shapes have

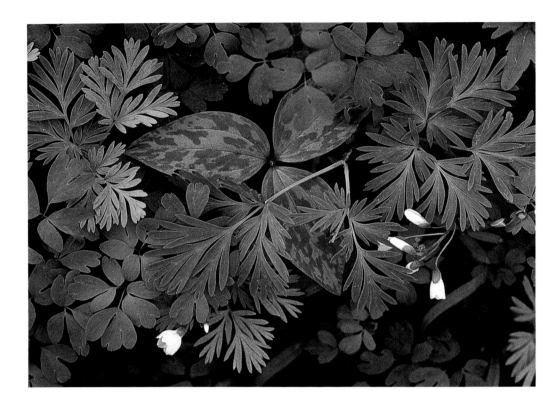

been considerably altered by logging, grazing, and other activities, but they still exist as ecologically resilient islands of life in the midst of the prairie landscape.

The typical prairie grove consists of oak-hickory and maple-basswood forests that support an undergrowth of redbud, pawpaw, prickly ash, and sassafras. The understory vegetation often includes spectacular wildflower displays. Beginning as early as March, the floor of the prairie grove is carpeted with wave after wave of showy wildflowers: several species of trillium, Dutchman's-breeches, Virginia bluebells, and Mayapples, to name only a few. Climax forest herbs such as snow trillium, hepatica, and bloodroot peak very early each spring. As summer approaches, the canopy closes, and the woods become dark. The spring blossoms are replaced by thick patches of stinging nettle, bedstraw, and poison ivy. By late summer, only the uncommon trumpet honeysuckle and abundant jewelweed bloom in the dense shade.

Superficially, prairie groves appear easy to explain. Along streams and rivers, trees were better able to compete with prairie plants because of the increased moisture. The isolated groves were made up of species that had invaded from other forested areas and gained a foothold in the moist prairie sod. Origins are not often obvious, however, and the beginning of prairie groves is no exception.

A common red fox enjoys a brief nap during an Indian summer day. MJ

Early spring leaves of false rue anemone, prairie trillium, and Dutchman's-breeches are just a few of the myriad of wildflowers present in a prairie grove. MJ

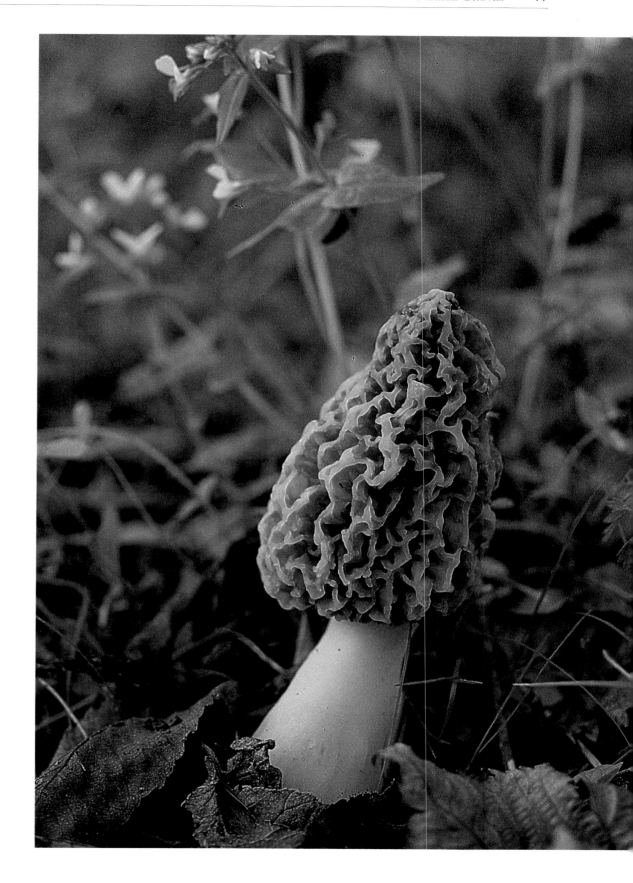

Morels are the object of some of the most passionate collectors in Illinois. Each spring the woods fill with mushroom hunters seeking these choice fungi. MJ

Overleaf: Scarlet and green leafhoppers survive winter in the leaf litter of prairie groves. They become active early each spring and feed on the sap of various plants, often causing them to wither and drop leaves. MJ

To understand the true origins of prairie groves, we must return to the period immediately following the melting of the last glacier in Illinois. The fossil record of pollen from prehistoric plants tells us that about 14,000 years ago, as the Wisconsinan glacier receded, the northern half of Illinois was covered with a coniferous northern forest—an immense dark roof of spruce and pines. About 12,000 years ago large areas of this forest were replaced by a rich, mature deciduous forest of maple, ash, elm, birch, and alder. This forest lasted for only about 1,000 years. When the climate became warmer and drier, the moist forests began to be replaced by oak and hickory, species better adapted to such conditions. About 9,000 years ago major climatic changes occurred, resulting in what is called the "Hypsithermal Interval," a period of very warm temperatures and little rainfall. Within a comparatively short time, perhaps 500 to 800 years, the oak-hickory forest largely gave way to the kind of vegetation we now call prairie. These plants were tolerant of lessened rainfall, regularly occurring droughts, and massive periodic fires. The only trees that survived the Hypsithermal Interval were those protected from fire.

The formation of certain types of prairie groves is closely tied to the interplay of fire and topography. This same phenomenon is true of savannas, a habitat consisting of widely spaced, broad-canopied oak trees with prairie grasses and forbs growing beneath them. In the early prairie landscape of Illinois, prairie groves and savannas were commonly found on the east side of watercourses and marshes that acted as firebreaks. They also occupied the eastern slopes of relatively hilly uplands. Prevailing winds pushed prairie fires in an easterly direction and, because fires burn with greater intensity going uphill than downhill, the eastern hill slopes were somewhat protected. Fire-resistant trees, such as thick-barked oaks, persisted on these downhill eastern slopes of the more hilly areas. The result was a savanna. In 1830 savannas were abundant in northeastern and central Illinois, usually occurring on rolling uplands, while prairie dominated the flat to gently sloping lowlands. Evidence for this means of savanna formation exists in the soil and the tree species found on savannas. The soil is typical of a forest rather than a prairie. Black and bur oaks, both highly fire-resistant species, are dominant. Around 1860, when settlers had converted much of the virgin prairie in Illinois to farmland, the prairie fires ceased. On many savannas, trees that were less fire-resistant sprouted, filled the gaps between the widely spaced oaks, and shaded out the prairie plants. These savannas soon developed into a prairie grove. Primarily for this reason, the savanna habitat has almost disappeared from Illinois.

An uncommon relative of the great white trillium, drooping trillium blooms a few days earlier. It bears its blossoms in a manner much like those of the Mayapple, on a stalk that sometimes dangles the flower below the leaves. SP

Ladybird beetles congregate in protected areas within the woods to spend the winter. Hundreds are often found clustered under bark or in the shelter of a fallen log. MJ

In woodlands on stream floodplains, the dominant spring flower is the Virginia bluebell. Soon after the trees leaf out and the canopy closes, the bluebells disappear completely and are replaced by a thicket of jewelweed and stinging nettle. MJ

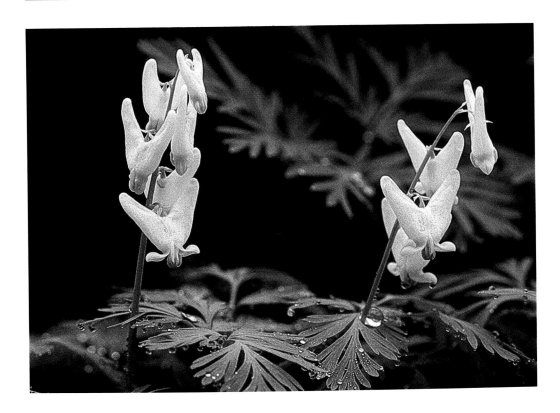

Other evidence supports the argument that certain types of prairie groves, those not formed from savannas, are the last remains of a more extensive forest and not merely islands of colonizing plant species. In these prairie groves, a remarkable number of plant species, especially spring-blooming herbs, are found. The accidental transport of this wide variety of plant life to an island community is improbable. The great distance between prairie groves and the forests from which potential colonizing species might have spread makes their formation by this means unlikely.

Over the decades, these isolated woodlands have undergone serious disturbances and have suffered from the absence of fire. The oak-dominated groves are giving way to sugar maples, while invasive, weedy species outcompete the once-dominant forbs in the understory. Yet the groves continue to exist along major streams and in other protected sites on the prairie. Their square shapes, following surveyed section lines, often lead the uninformed observer to conclude that they have been deliberately planted. Despite the fact that so few stands remain, Funk's Grove, Trelease Woods, and Brownfield Woods in central Illinois still offer sparkles of color after a long gray winter, providing a welcome glimpse of the Illinois prairie grove of 200 years ago.

Dutchman's-breeches, a relative of the wild bleeding-heart of the eastern United States, is perhaps the most fleeting of spring wildflowers. Even so, its lacy foliage and delicate, two-spurred flowers often cover large areas on the woodland floor. The flowers hold nectar deep within. In early spring, bumblebees use their long tongues to reach the nectar through an opening near the bottom of the blossom. Short-tongued bees, however, often bite a hole in the top of the spur to steal the nectar. SP

Redbuds usually put down roots under larger trees or at the wood's edge. Because of their conspicuous flowers, they are prized as an ornamental and probably occur over a wider range in Illinois today than in presettlement times. The typical "pea" or legume flowers are found along the twigs and larger branches and usually appear before the leaves. MJ

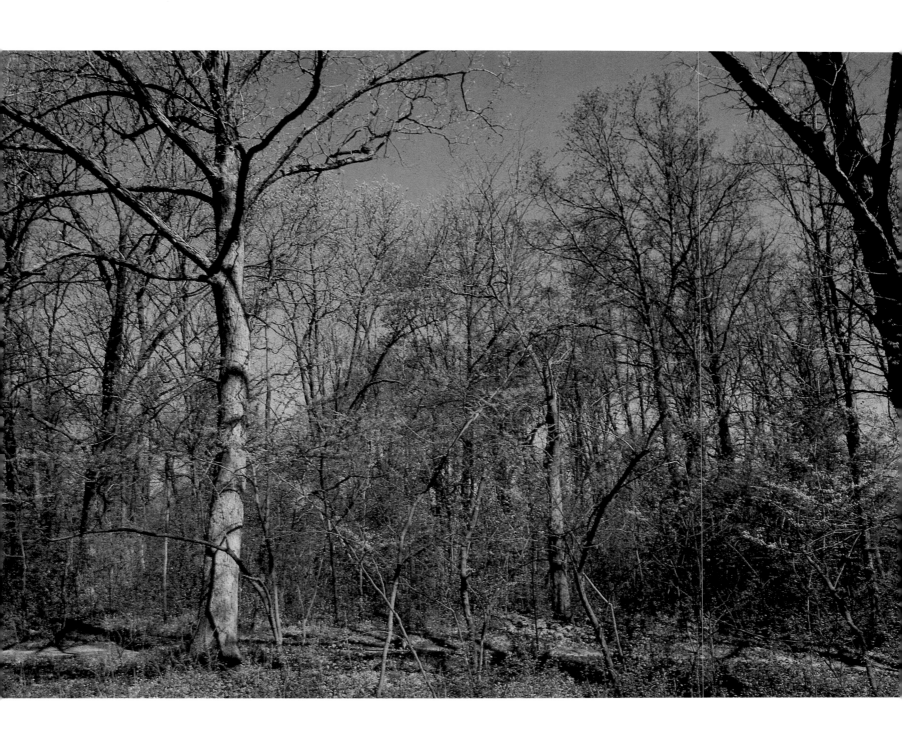

9

By far the most interesting visit was to Devil's Neck, a large wild expanse of blowsand, where we found many interesting things, especially unlimited quantities of Cristatella jamesii *and a few plants of* Lesquerella spathulata, *hitherto known only from northwestern Nebraska and Montana.*

Henry Allen Gleason, Field Notes, 1904

SAND PRAIRIES AND SAVANNAS

Susan L. Post

Spiderworts are well adapted to dry conditions. The narrow leaves curl to resist water loss. Each flower opens in the early morning, but by mid-afternoon the petals have wilted and dissolved into a jellylike fluid. MJ

Spring is the only season that is truly green in the sand prairie as bunch grasses begin to cover the sand. These grasses are deep-rooted because of the limited water supply, and they form bunches to reduce exposure to the wind. MJ

HENRY A. GLEASON, A RENOWNED BOTANIST best known for *The New Britton and Brown Illustrated Flora of the Northeastern United States and Adjacent Canada*, explored the sand areas of the Havana region in the early 1900s while a student at the University of Illinois. The area referred to as "Devil's Neck" is now contained within his namesake: the Henry A. Gleason Nature Preserve in Mason County. Devil's Neck was described in the early 1900s as a great expanse of waste-sand extending east and north for nearly a mile. The bladder pod (*Lesquerella spathulata*, later renamed *Lesquerella ludoviciana*) found by Gleason is a typical species of the great plains and adjacent mountains, more at home in North Dakota or Utah. This site in Illinois is one of two eastern locations; the other is in eastern Minnesota.

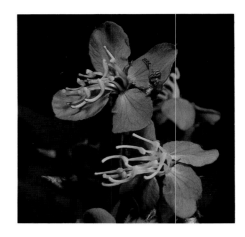

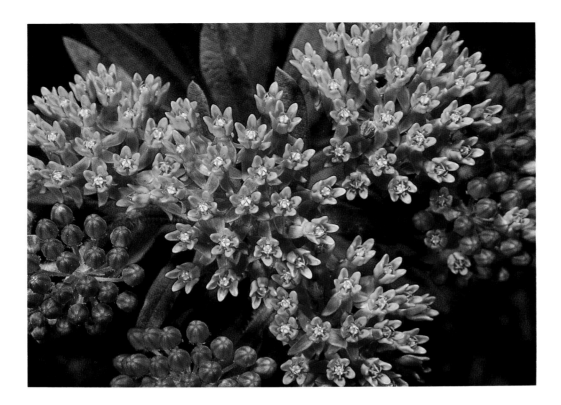

The principal sand areas in Illinois—the Havana deposit, the Hanover-Oquawka region, and Kankakee and Iroquois counties—are located in the northern half of the state. In the south, sand deposits occur only as small local concentrations or as sandbars near larger rivers, but they have never been able to develop and maintain a distinctive flora.

The meltwaters of the Wisconsinan glacier greatly affected the formation of sand deposits and ultimately of sand prairies in Illinois. The Havana deposit was formed as meltwater cascaded down the prehistoric course of the Illinois River. This tremendous flood, known as the "Kankakee Torrent," carried a huge volume of sand and gravel downstream at breakneck speed. At present-day Hennepin the river is narrow and entrenched in bedrock. Here the water lost its velocity, and the sand was deposited in Tazewell, Mason, and Cass counties. The Kankakee and Iroquois county area is the ancient bed of Lake Morris. Lake Morris formed as the Wisconsinan glacier began to melt. The water was restrained by a great rocky barrier known as the Marseilles moraine. When the ancient lake burst its bounds, huge deposits of sand and gravel were left. Another example of sand prairie development is the Hanover-Oquawka region, located in northwestern Illinois along the Mississippi River. Here,

The Virginia meadow beauty is widespread in Illinois, favoring wet sand or peat, but is not commonly found. Note the crab spider patiently waiting for its prey. MJ

Butterfly-weed is certainly the most brilliantly colored member of the milkweeds. Its taproot, once chewed by various native Americans as a cure for pleurisy, is often several feet long, making the plant tolerant of the desert-like conditions of the sand prairie. MJ

the sand prairie occupies an expanse between the bluffs on the east and the Mississippi River on the west. This area is located along the once-western edge of the Wisconsinan glacier, where again sand was deposited by its meltwaters. As water was shed from the glacier's edge, copious streams and long flows of glacial outwash poured down the channel ways. The further from the glacier, the finer the outwash became.

In the early 1900s several thousand acres of sand deposits in nearly "original" condition comprised the largest—and virtually only—areas of natural vegetation in the state. These areas contained virgin prairie that had never been plowed or pastured. The flora of the sand prairie is composed of plants common to the tallgrass prairie of Illinois mixed with plants of open habitat that probably arrived in Illinois over the past 10,000 years. These open habitat plants include sand-loving plants commonly found in the western United States and other species with widely scattered distributions. Western species, such as large-flowered penstamen, migrated east to Illinois during a drier period in the region's history. When the climate became moister, these dry-loving species found refuge in the sands that were conducive to their habitat requirements. Atlantic Coastal Plain plants, such as the sand-dwelling lance-leaved violet, probably migrated down the St. Lawrence River to the Great Lakes and then down the rivers of Illinois. Another group of plants that inhabit sand prairies has by contrast a widely scattered distribution. In some cases, no populations exist between their general range and the Illinois sand prairies. These plants are here because of capricious and far-flung dispersal.

Although sand prairies contain prairie growth, it is strikingly different from that found on the black soil prairie. The differences are due to the special environment provided by sand. Even though the sand areas receive the same amounts of heat, light, rainfall and wind, these areas experience considerable fluctuation in temperature from day to night and from surface to subsoil. There is a relatively constant supply of water because of dew, but the sand's water-holding capacity is low. In open areas, the surface sand is constantly shifting, resulting in an unstable environment that sometimes forms dunes.

To survive in the sand, plants have evolved several strategies. Leaves are narrow or small, thereby exposing a reduced surface to the sun. Leaves may have a protective covering of silvery hairs or scales, giving them a grayish green color. Perennials are deep-rooted in response to the limited supply of surface water and frequently grow in tufts or bunches to reduce exposure to the wind. Plants like prickly pear cactus form mats that grow close to the sand and tend to spread each year over

Blazing-star may be found blooming here and there at Sand Prairie–Scrub Oak Nature Preserve in Mason County during late summer. Fourteen hundred acres of blackjack oak savanna and sand prairie are contained in this preserve. SP

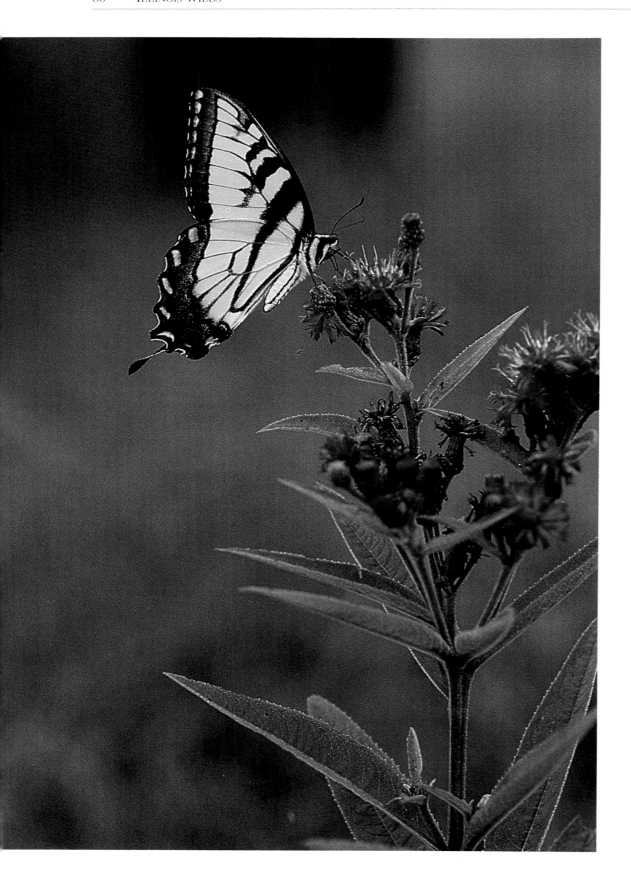

Male tiger swallowtails range freely in open deciduous forests and grasslands. Ironweed provides an abundant late-summer nectar source for this and many other species of butterflies. MJ

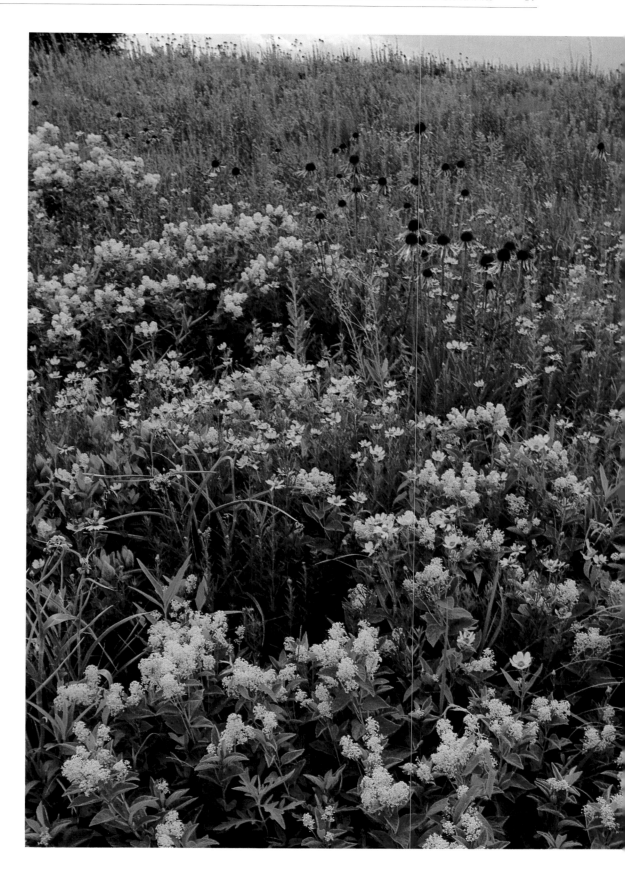

Purple coneflowers and New Jersey tea grow on an ancient dune at Foley Sand Prairie Nature Preserve in Lee County. SP

Overleaf: Prickly pear cactus is found scattered in several habitats throughout Illinois, but is most abundant in sand prairies. MJ

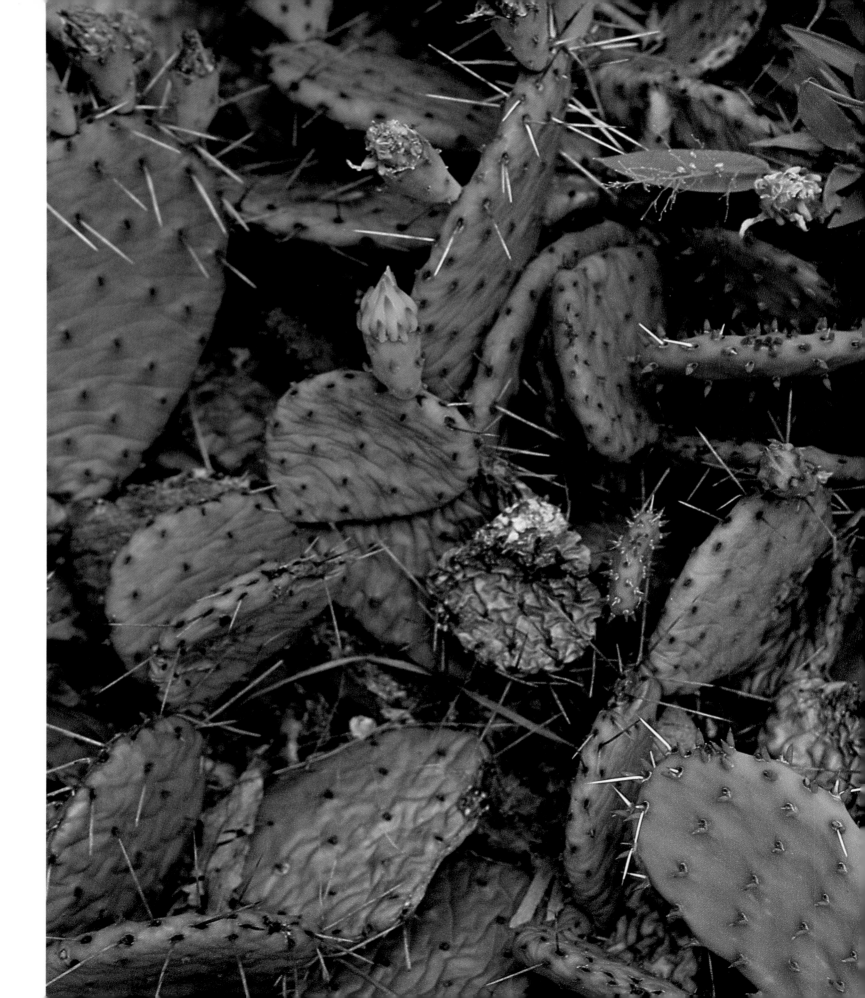

Lupine and puccoon, growing under the young oak of a sand savanna, are typical early season wildflowers. Both species have exceedingly long taproots that often reach to the water table. SP

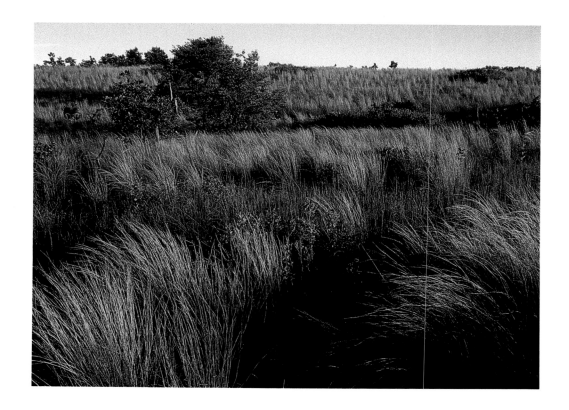

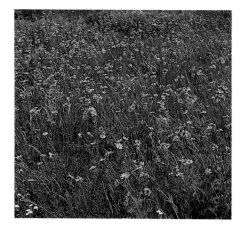

Coreopsis often forms dense stands in sand prairies during late spring. KR

The fall landscape is dominated by brown bunch grasses and the occasional scrub oak growing on an ancient dune. MJ

a larger area. Annuals are slender and frequently have unbranched stems, narrow leaves, and fibrous roots. These appear in late June or July and owe their existence to the mat-forming plants and perennials that bind the sand together.

Spring can come early to the sands, bringing plants that are small and grow in sparse clumps. As a result, the region has a tufted appearance similar to that of a true desert. The first blossoms to appear are the sand phlox followed by the pansylike bird's-foot violet. The flower of this species is a uniform sky-blue color, unlike the bicolored form common in the east. Each succeeding day of spring reveals additions not only to the floral display but to the greenery. The dunes that initially appeared as sand ridges now resemble low glacial hills lightly overgrown with plants. By late spring, the luminous yellow-orange blossoms of puccoon mingle with the varying shades of violet spiderwort, its long, linear leaves helping to conserve necessary moisture. Isolated clumps of lupines are typical sand plants with long taproots probing deep for moisture. By summer the sand prairie is robed in the yellows of dwarf dandelion and black-eyed Susan, variegated by the waxy-yellow blossom of prickly pear and the bright orange of butterfly weed. These plants are scattered through the ever-present June and grama grasses. By late summer, as the sand becomes parched

and the drone of katydids is heavy and oppressive, grasses begin to turn brown and the landscape is broken only by tall, slender pink spikes of blazing-star. Some are so top-heavy they yield to gravity, making perfect arcs in the coarse sand. As the ground cover withers with the coming of frost, the sandy soil becomes visible once more.

Forests grow along the infrequent watercourses where sand lies in disconnected ridges. Forest trees slowly encroach upon the sand, eventually resulting in a sand savanna, a transitional community between forest and prairie. These two-layer communities have a 10 to 80% canopy coverage of trees and a nearly continuous ground layer of prairie species. Sand savannas, like other savanna communities, were maintained by fire in presettlement times but were not overly burned, due to their special topography. The presence of undulating dunes and low, marshy areas controlled the severity of fires and allowed a savanna to develop instead of a sand prairie. The seedlings of only a few species of trees are able to withstand the extreme conditions of the shifting sand, the hot surface layer, and the almost total lack of protection against winter winds. Oaks indicate the early stages of a sand savanna, and to a large extent they determine how the ecology of the forest will unfold. The herbaceous flora consists of such familiar perennials as lupine and puccoon. Where bur oaks are found, bracken fern often flourishes. During presettlement times savannas were among the most widespread and characteristic communities in Illinois; today, sand savannas constitute an overwhelming percentage of the savannas left. These relatively undisturbed remnants owe their continued existence to controlled burns.

A return visit by Gleason to Devil's Neck as late as 1966 still revealed *Lesquerella*, although *Cristatella jamesii* was gone. Gleason remarked, "That same kind of plant, represented by a few individuals, had been sticking it out for so many years and no one knows how many hundreds of years before. This plant had spread eastward during the xerothermic (dry-hot) period, which easily might have been 5,000 years ago." The sand areas today are no longer great expanses of desert-like barrens. Domestic animal grazing has destroyed the annuals; cultivation and irrigation have transformed large areas into truck crop farms. Weeds introduced from roadsides and cultivated fields traverse the sand areas to compete with the native vegetation. Pine trees—though planted by the well-intentioned to control erosion—are non-native and supplant the once-dominant oaks. Despite all this, remnants still exist in nature preserves like the Thomson-Fulton Sand Prairie, Sand Prairie–Scrub Oak, and Henry A. Gleason preserves. Hopefully, they will remain for yet another 5,000 years.

Starry false Solomon's seal, which favors open woods and savanna, blooms in midspring. MJ

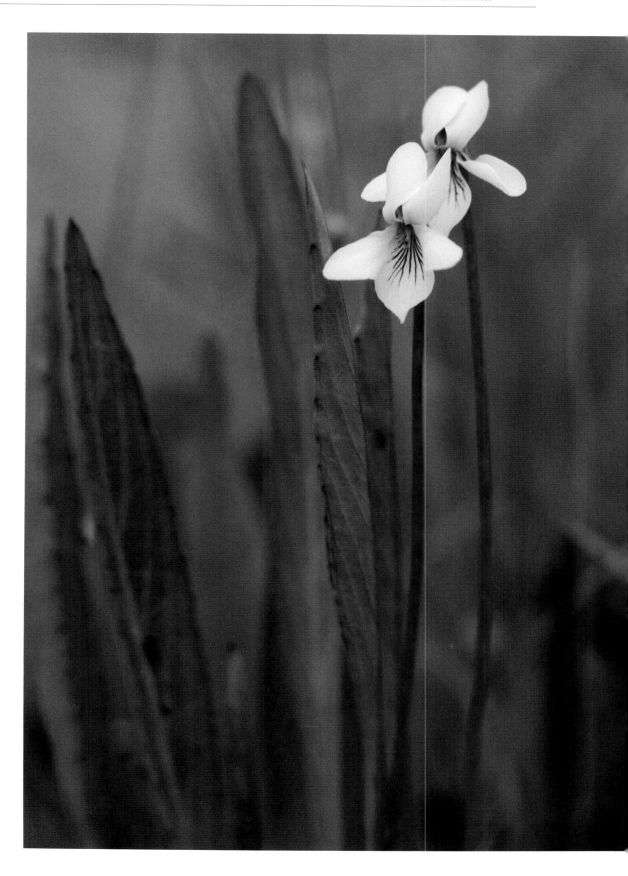

The lance-leaved violet grows only in moist, acid, sandy soils. The petal markings lead insect pollinators into the plant's nectary. MJ

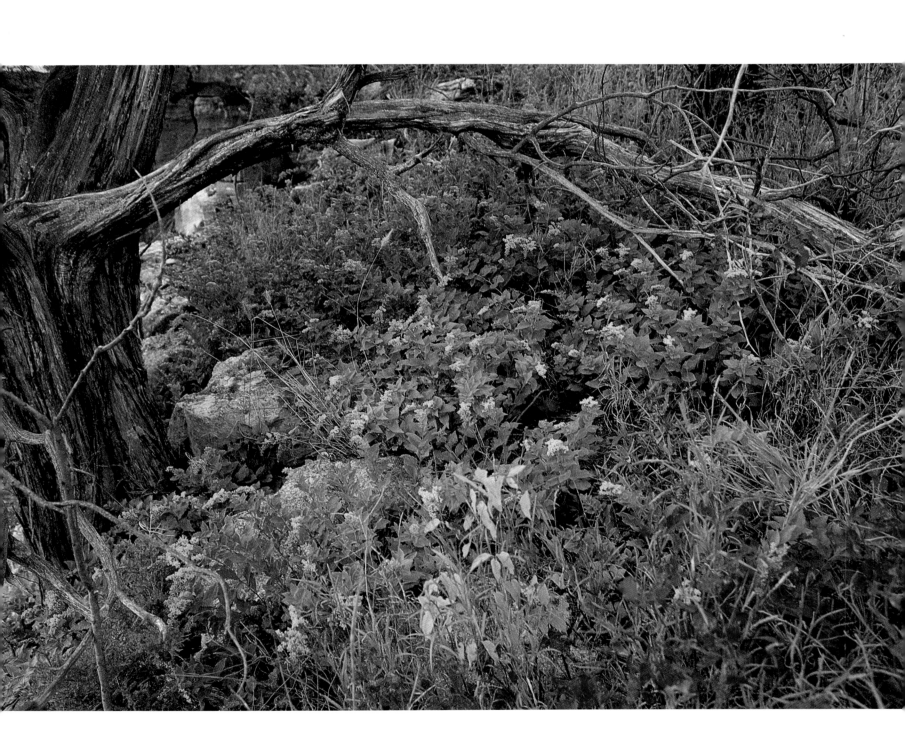

10

HILL PRAIRIES

Kenneth R. Robertson

The gray tree frog lives throughout Illinois, most often in trees near a water source but occasionally amid the dry grasses of a hill prairie. The species is nocturnal and feeds on insects. MJ

Gnarled cedars, some at least 300 years old, share the bluff edges with goldenrod in late summer. MJ

ON A TYPICAL SUMMER DAY IN JULY, with the hot sun beating down and the air temperature at least 105°, we are standing at the base of a crumbling bluff looking at a steep, precarious trail. "You expect me to climb *that*?" says my five-year-old daughter, staring at me in disbelief. After struggling up the trail, through woods and nettle, we are finally rewarded as we emerge onto a magnificent open expanse overlooking the Illinois River. Turning to see the river below with the prairie landscape around us, Amanda can only muster an incredulous, "Wow!" Hill prairies are like that.

Hill prairie vistas are impressive because of their location on steep slopes surmounting bluffs, often several hundred feet above the floodplain of the river below. In Wisconsin such prairies are called "goat prairies" because only a nimble animal could graze them. Upland forests usually abut hill prairies, their sides often falling

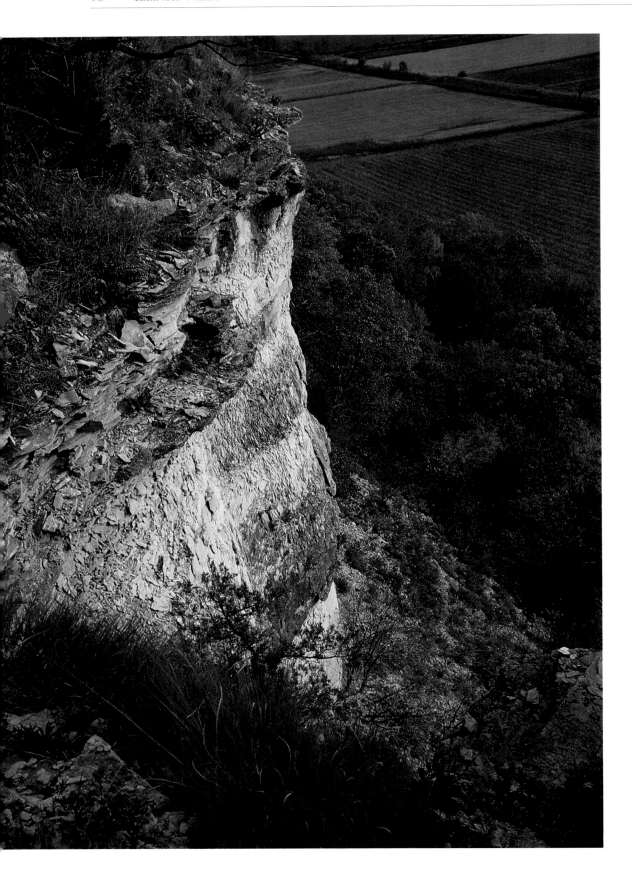

The limestone bluff at Fults Hill Prairie Nature Preserve in Monroe County is covered with wind-blown loess. Many western species are found here, including the coachwhip snake and narrow-mouthed toad. MJ

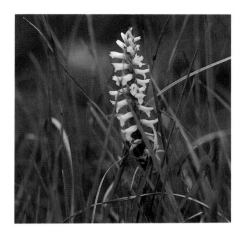

Long-horned beetles look for an easy meal of pollen concentrated in the brown flowerheads of drooping coneflowers. The color pattern of the beetle suggests that of a wasp. MJ

This particular species of ladies'-tresses orchid grows most abundantly on loess hill prairies and occupies the most severe natural habitat of any Illinois orchid. Grazing may actually help this species to develop large colonies. Ladies'-tresses lack the evergreen leaves of some orchids and are one of the last flowers to bloom in the fall. MJ

away to densely wooded ravines. Because of the deeply furrowed uplands above the bluffs, hill prairies occur as a series of spurs, each separated by intervening forest.

A layer of loess blankets the steep slopes. Loess is an accumulation of silt formed of clay and very fine sand which blew in from areas farther west as the last glaciers receded. In places, the loess is more than 70 feet thick and, although easily crumbled, can form nearly vertical cliffs which are stable enough to allow cliff swallows to make nesting holes. Conditions on hill prairies are quite severe. The loam soils developing on the loess are alkaline and so well-drained that the amount of water available to plants is extremely limited. The southwest- or west-facing slopes of the hill prairies bake under the late afternoon sun and are dried by prevailing southwesterly winds. These conditions favor a prairie rather than a forest.

Loess hill prairies exist along the Mississippi River by the western border of Illinois, mostly north of Randolph County, and also along the Illinois River from Putnam County to its juncture with the Mississippi. Fults Hill Prairie, Pere Marquette, and Meredosia Hill Prairie are three examples of loess hill prairies within the nature preserve system. A few others occur along the lower Sangamon River. Revis Hill Prairie Nature Preserve, a noteworthy example located above glacial till instead of limestone cliffs, is the largest hill prairie in the state.

Little bluestem is the most prevalent plant of loess hill prairies. In fall, this three-foot grass is covered with plumelike seeds along stems that turn a beautiful orange-brown. Sideoats grama and prairie dropseed are other common grasses. Prairie dropseed is perhaps the most attractive prairie grass, forming tufts a foot or so in diameter that, like little bluestem, turn a beautiful color in fall. Wildflowers also abound. In spring, the hill prairies are alive with yellow star grass, blue-eyed grass, violet wood-sorrel, bluets, yellow flax, and both fringed and common puccoon. These are followed by pale beardstongue, both pale and purple coneflowers, and scurf-pea. Summer brings blue hearts, purple and white prairie clover, short-green milkweed, and the rare narrow-leaved milkweed, a species restricted in Illinois to hill prairies. Flowering until fall, the distinctively shaped blazing-stars attract a variety of colorful butterflies, as do the aromatic, silky, and stiff asters and the more common heath and sky-blue asters. In late fall, the scented ladies'-tresses orchid casts its heady scent over the hill prairies. Its aroma can be detected long before the small plant is spotted, tucked neatly among the grasses. At Revis Hill Prairie, the showy goldenrod lives up to its name; the bright yellow flower stalks contrast with the deep red leaves.

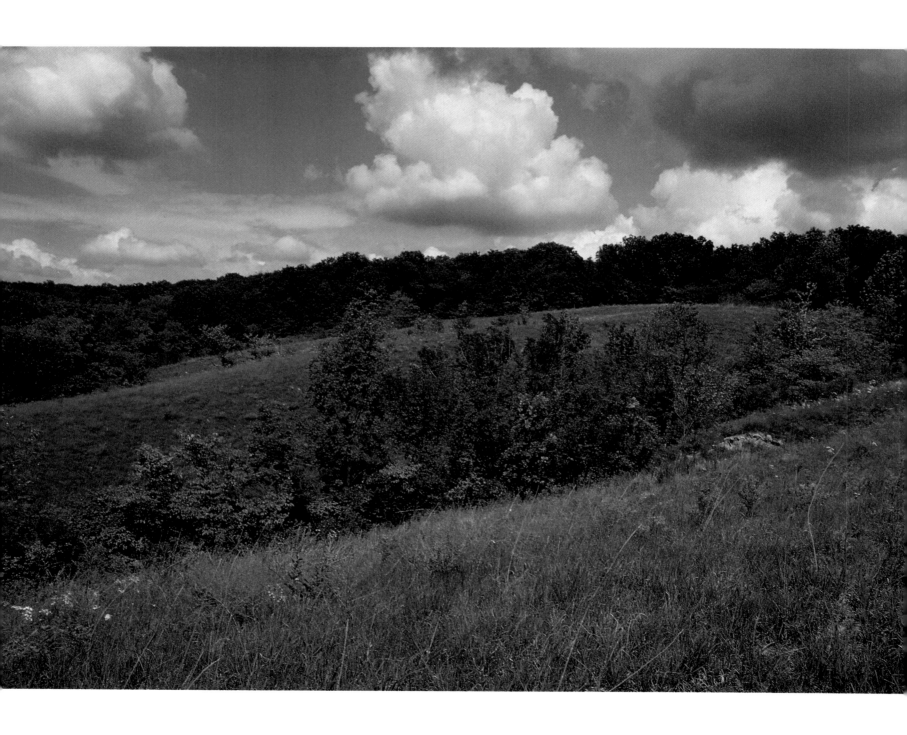

Early in the growing season, coreopsis flowers in great profusion along the bluff edge of Fults Hill Prairie. This species grows in conditions ranging from very wet to the nearly desert-like environment of a hill prairie. MJ

Revis Hill Prairie Nature Preserve in Mason County is the largest hill prairie in Illinois. Its loess-covered hills rise some 250 feet above the Sangamon River valley. SP

Several unusual animals inhabit hill prairies. Most characteristic is the six-lined racerunner, a lizard, which is often seen scampering across bare areas. The Great Plains rat snake, coachwhip, and flat-headed snake are found here, along with the ornate box turtle and the narrow-mouthed toad. Illinois is also home to the plains scorpion, but it can only be found at Fults Hill Prairie, where it feeds at night and usually hides under rocks during the heat of the day.

Glacial drift hill prairies occur along major rivers in central Illinois. They are as exposed as a loess hill prairie but have soil more like that of a gravel prairie. They can be found where a river has cut through an end moraine and created a south- to west-facing slope above the eroding glacial till. Examples are Windfall Prairie, Ridgetop Hill Prairie, Robinson Park Hill Prairies, and Crevecoeur nature preserves.

The vegetation of hill prairies was studied by Robert A. Evers, a botanist with the Illinois Natural History Survey for 30 years. His impressions of Windfall Prairie, written in 1955, can be found in the "Natural Areas" file of the Survey:

In May, Indian paintbrush clothed the prairie with a scarlet hue. Scattered throughout were stems of blue-eyed grass, downy phlox, stargrass, bastard toadflax, puccoon, and meadow parsnip. In June the few

stalks of lead plant showed their dense spike of purple flowers. By July, side-oats grama, mountain mint, pale spiked lobelia, purple prairie clover, purple coneflower, rosin weed, butterfly weed, and yellow flax were flowering conspicuously. In late summer and early autumn, blazing star, partridge pea, tall tickseed, stiff gentian (not abundant in Illinois), goldenrod, several species of asters and gerardias added their colors to the bluff. Seven plants of the hill prairie variant of the ladies'-tresses, an orchid, grew in this prairie.

Since fires have been suppressed, some of those hill prairies described by Evers are today forested, with only the occasional prairie plant providing evidence of their past. Woody plants are encroaching on most remaining loess hill prairies. In the absence of fire, red cedar, blue ash, rough-leaved dogwood, wafer ash, smooth sumac, and hickories have established themselves. Few hill prairies have been plowed because they are so steep. They are, however, sometimes used for grazing livestock, which degrades the natural quality but nonetheless helps to maintain the prairie vegetation. Today, hill prairies are rather transient habitats. Perhaps because they originated during a hotter, drier period some 8,000 years ago, they have only managed to survive on the most extreme sites.

Syrphid flies are notorious mimics of the stinging bees and wasps. This species relies on dark bands across its large fly eyes to simulate the narrow eyes of a wasp and holds its front legs forward to give the illusion of long, wasp antennae. MJ

Plains scorpions hide by day amid the crumbling limestone of Fults Hill Prairie. This small scorpion occurs in Illinois only at Fults, the northernmost record for the species. MJ

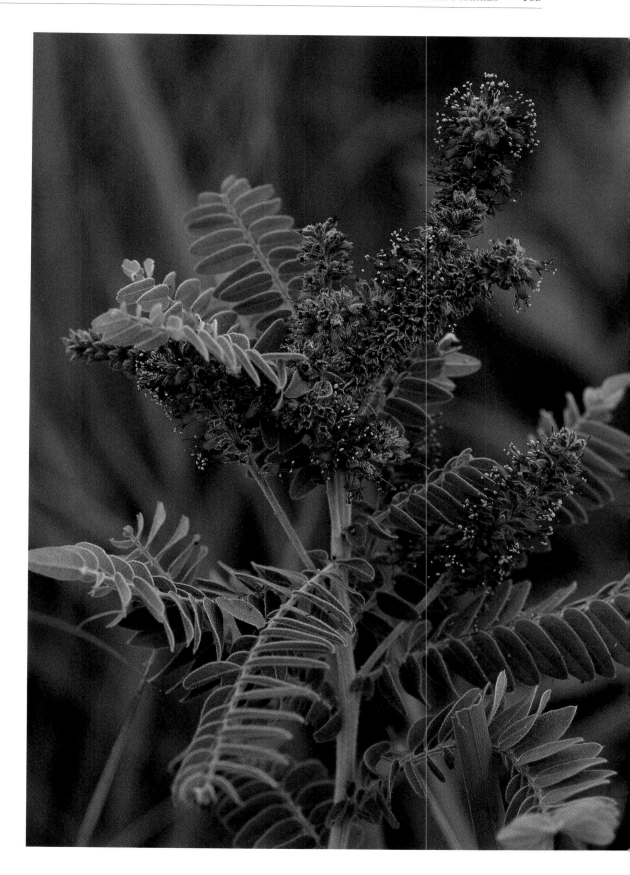

The roots of the shrublike leadplant may reach depths of fifteen or more feet. This legume is one of the most abundant species on upland prairies and a favorite of grazing animals. MJ

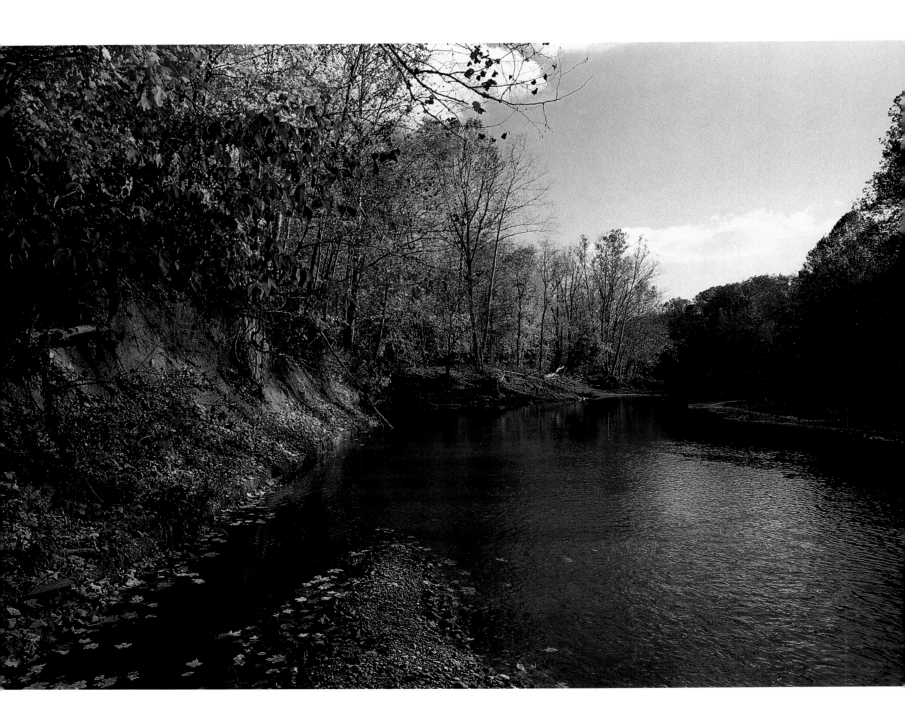

11

EASTERN FORESTS

Susan L. Post

The firepink, so common in the southeast, follows the distribution of the American beech and grows in the upland forests of Vermilion County. The leaves are of a common fern. MJ

The Middle Fork of the Vermilion River is home to threatened and endangered species and is a designated National Wild and Scenic River. MJ

IN PRESETTLEMENT DAYS, THE EASTERN BORDER OF ILLINOIS contained the great trees that made up the last stronghold of the eastern deciduous forest. It was considered by some to be one of the wonders of the world. Although not readily apparent to the casual observer, traces of this magnificent forest still remain in the landscape surrounding the loess-covered hills and bottomlands of the Wabash River, and the valleys of the Vermilion and Embarras rivers. This transition zone between forest and prairie is bordered on the south by the confluence of the Wabash and Ohio rivers, on the east by the line that now marks the border of Indiana and Illinois, and on the north and west by the southernmost advance of the Wisconsinan glacier.

In the south, lowland forests of oak are interspersed with beech and tulip trees, species more typical of the east. The oaks on the floodplains: pin, overcup,

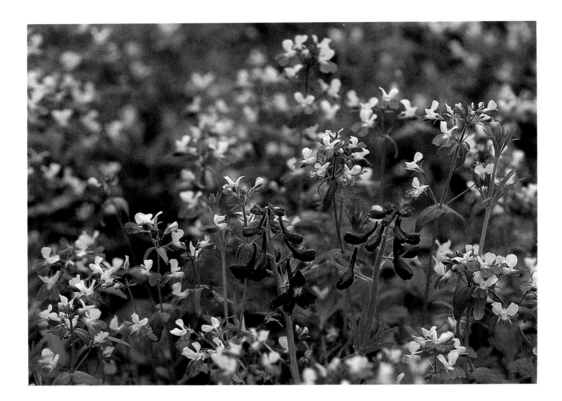

cherrybark, bur, Shumard, swamp white, and swamp chestnut as well as cottonwood, sycamore, and silver maple grow along the stream banks. The understory is composed of poison ivy, large colonies of bloodroot, Mayapple, blue-eyed Mary, and other ephemeral spring flowers. Bedrock outcrops along the river bluffs are few and never form the towering cliffs characteristic of the western border of Illinois.

The upland forests on the loess bluffs are white oak, sugar maple, beech, and sweet gum. Here the understory contains sessile trillium, larkspur, and fragile fern. Along the Vermilion River, where conditions are moist, forests are dominated by white oak, red oak, sugar maple, and American beech, which approaches its northern limit in this region. The forest understory contains brilliant red firepinks and an occasional clump of yellow lady's-slipper orchids. The Wabash River valley supports a great variety of species within its continuous cover of forest vegetation.

The bottomlands of the Lower Wabash contain deep, fertile, well-drained and constantly moist soils—conditions ideal for the very best tree growth. Robert Ridgway, a Smithsonian naturalist, spent much of his time here during the 1870s studying the birds. He particularly noted the richness of species and the immense size of the trees. Through photographs and measurements, he documented the

Stream floodplains become carpets of blue-eyed Mary each spring. The plant is an annual, reseeding itself each year. The vast majority of spring flowers, like larkspur, are perennial and grow from various underground structures. MJ

Colonies of Mayapple dominate the forest floor in Beall Woods and American Beech nature preserves. Each colony is likely to have originated from a single plant, and all individuals are connected by underground stems called "rhizomes." SP

Upland forests along the Wabash River have a higher percentage of oaks than the wetter, flood-plain forests. The rich leaf cover each fall returns nutrients to the soil and serves as a protective mulch to insure a spectacular wildflower show for next spring. SP

extraordinary nature of the bottomlands. According to Ridgway, the lower Wabash Valley consisted of a mixed woods. Within a single area he found trees characteristic of many regions of the United States: beech, sugar maple, and the various oaks of the North; bald cypress and tupelo gum of the South; catalpa and pecan of the Southwest. These woods contained over 90 species of trees, many reaching the furthest limits of their geographic range. The original forest was so dense that trees, competing for sunlight, had to grow upward and many species grew to enormous heights. Undergrowth formed a dense and impenetrable thicket overrun with wild grape and poison ivy. The vines hanging from branches looked like monstrous suspension cables. Flowing between the dense walls of this forest was the Wabash. Ridgway wrote, "If viewed from a high bluff the forest presented the appearance of a compact, level sea of green, almost endless; tree tops swaying in the passing breeze and the general level broken by occasional giant trees which rear their massive heads to overlook the surrounding miles of forest."

These were primeval woods with trees over 130 feet tall and trunks 6 feet or more in diameter. Old sycamores had great white branches as large as tree trunks, stark pale ghosts of perhaps even larger trees before them. Tulip trees vied with the sycamores as the giants of the forest. Evergreens and trees of poor soil, such as post and blackjack oak, were absent. The woods were truly diverse, a great variety of species grew together with no single species dominating. Sad to say, these remarkably huge trees were doomed. By 1876 they had already fallen victim to cutting and were regarded as only a remnant of a once extensive and exceedingly massive growth of forest trees. "The time is not distant when there will scarcely be left a sample of those monuments of centuries of growth," wrote Jacob Schneck in 1876. By 1955 the nearly unbroken canopy of treetops had given way to a ragged line with many openings. Robert Ridgway witnessed the destruction of the Wabash River valley's primeval giants. He saw every example succumb to the saw, the ax, and the plow, each in turn sacrificed to the march of our culture.

Although no virgin stands remain in Illinois, we can once again experience the woods that Ridgway knew. Beall Woods, an Illinois nature preserve in southern Wabash County, consists of 270 acres that line both sides of Sugar Creek. The woods have been used for grazing by hogs and cattle, hunting, mushroom collecting, and the harvesting of walnut, sweet gum, bur oak, and tulip trees. Even so, 74 tree species have been identified here and approximately 300 trees have trunks with diameters greater than 30 inches at chest height. State tree champions include Shumard red

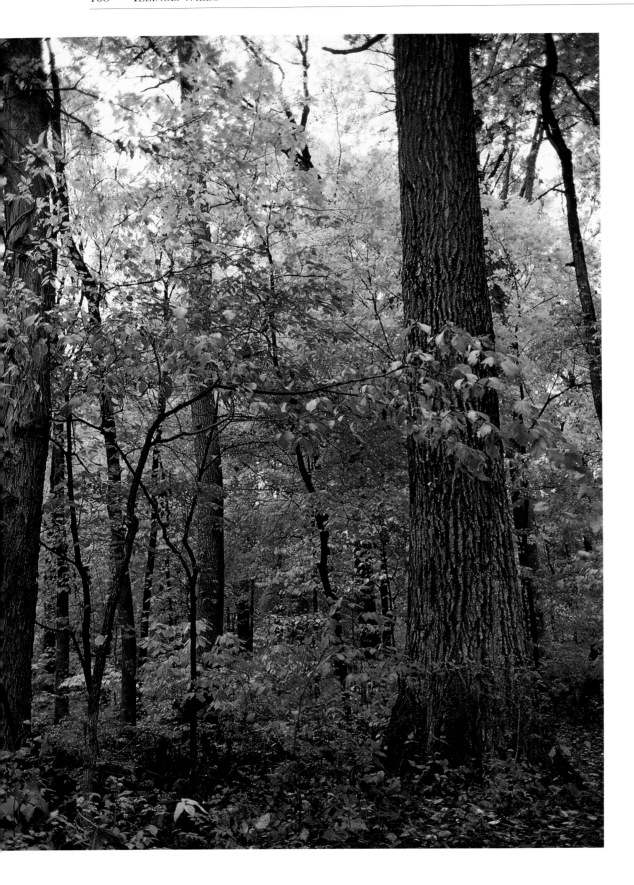

The woods of the lower Wabash valley have over 90 species of trees, including those that often reach prodigious size. In 1872 Robert Ridgway noted, "The largest trees were of course the gigantic sycamores with trunks 25 to 30 feet in circumference." MJ

Yellow lady's-slipper orchids can still be found in isolated woodlands along the Middle Fork, where they bloom in May. SP

Various species of crayfish are relatively abundant but keep out of sight in the small streams of the Wabash valley. Approximately 20 species of crayfish occur in Illinois. MJ

oak, green ash, sugarberry, and sweet gum. In the small visitor's center one is immediately drawn to an immense yellow outline painted on the floor, a representation of a large sycamore trunk. The circle is 17 feet across.

The Vermilion River, a union of the Salt Fork, Middle Fork, and North Fork, is part of the northern Wabash River drainage. About one million years ago this area was drained to the north and west by the Teays River, a predecessor of the Ohio. During the glaciation of Illinois all surface evidence of the Teays was erased. Terminal moraines, caused by the many advances and recessions of the glaciers, resulted in the development of a new drainage pattern south and east to the Wabash. The land became a level, glacial plain carved into deep ravines and valleys by the Vermilion and its branches. The bottomlands were quickly occupied by forests that advanced along the streams; the uplands were colonized by prairie vegetation with occasional savannas developing on well-drained knolls.

Unusual features of the Vermilion River basin include seep springs with their own unique plant life, tulip trees growing in the beech-maple forests of the ravines and adjacent uplands, and occasional hill prairies on west-facing blufftops. These features testify that the Vermilion River and its tributaries lie in a tension zone

between the beech-maple forests of the east and the prairie and oak-hickory vegetation to the west. Plant species from each region are intermingled, but usually to a limited degree. Oak-hickory forests are restricted to the well-drained uplands that were originally protected from prairie fires by their proximity to streams. The beech-maple forest invaded other level uplands to form a climax community.

The Vermilion River basin is also the northeast boundary of a great coal field in Illinois. By 1925, extensive areas had been strip-mined for coal, leaving the ground bare and all vegetation destroyed. Today, these striplands are covered with bottomland forests of sycamore, soft maple, bur oak, and walnut, and many of the mining scars are beginning to heal.

Of the three prongs of the Vermilion River, the clear, gravel-bottomed Middle Fork is unequaled in its water quality and species diversity. Inhabitants such as stoneflies, hellgrammites, unionid clams, hogsuckers, and six species of darters attest to the purity of the water. The bluebreast darter occurs in Illinois only in the Middle Fork and the Salt Fork. The ravine forests of the Middle Fork contain a rich herbaceous community with many uncommon plants that make them distinctive in Illinois. Species here that are restricted to rich forest habitats throughout Illinois include squirrel corn, Gleason's trillium, hepatica, and green violet. Other species scarce in Illinois but found here include squaw-root, yellow lady's-slipper, and beech-drops—a parasite of the American beech. Although the flat upland forests are second growth and grazed, they remain significant because of their diversity and the number of uncommon plants and animals. Refuges are maintained in Kickapoo State Park and Forest Glen Preserve.

The dry to somewhat moist forests of the southern uplands are found between the bottomlands of the Wabash and Vermilion rivers. The woods contain occasional sandstone outcrops that support northern vegetation such as wild sarsaparilla, a plant from glacial times. Rocky Branch Nature Preserve, situated along a small tributary of Big Creek, is a steep-sided ravine and valley cut from the sandstone bedrock. Here is found one of the few sandstone outcroppings in close proximity to the prairie. Many of the plants growing here are at the extreme edge of their ranges and offer an unusual combination of southern and northern species: beech and tulip trees from the South, partridge-berry and sphagnum moss from the North.

Robeson Hills Nature Preserve is a mature beech-maple forest with many large trees in deep ravines. American beech, tulip tree, and sugar maple are common inhabitants, with the rare sessile-leaved trillium in the understory. Beech trees often

The pileated woodpecker is bested in size only by the ivory bill of the southeastern United States, a species which is probably extinct. These giant woodpeckers are frequently sighted among the large trees of Beall Woods Nature Preserve. MJ

cluster together because they grow from the surface roots of neighboring beeches as well as from seeds. In some areas of the preserve more than 50 beech trees can be sighted within a relatively small area.

To appreciate this region of Illinois today requires a sense of the past. Here was the home of giant trees and lush vegetation, the last citadel of the eastern deciduous forest before the onset of the endless prairie. Although the area has been strip-mined, cultivated, and grazed, the few remnants which stand today help to recapture a sense of the forest first seen by our ancestors.

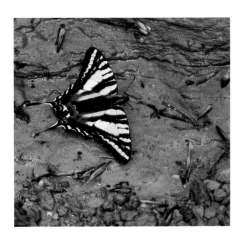

A lone zebra swallowtail butterfly pauses for a drink on the moist surface of a rocky streambed. MJ

The forests along the Wabash River are truly diverse. Though small in size, Beall Woods (270 acres) contains five times as many tree species as the much larger Yellowstone National Park (2.2 million acres). SP

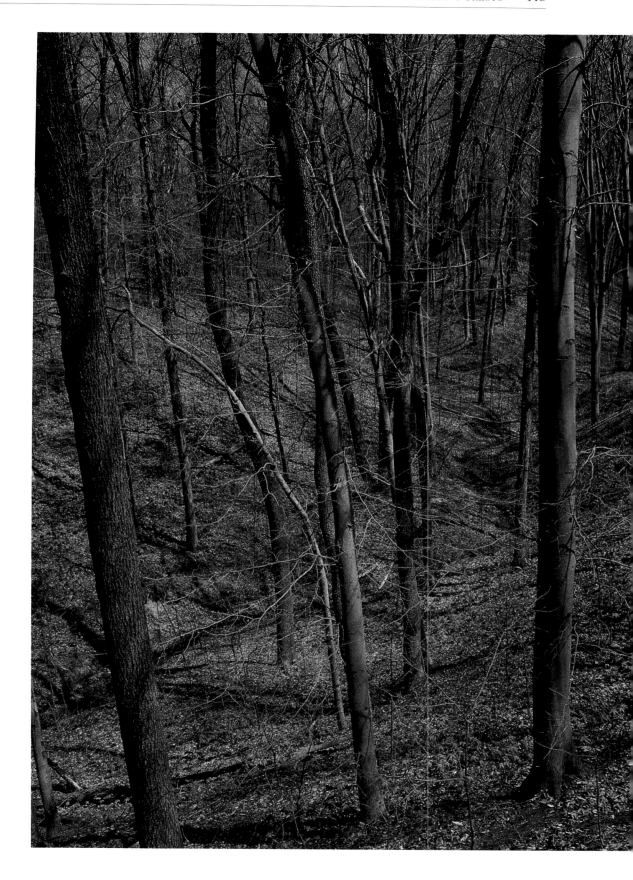

A beech-dominated forest stands out from other forest types because of the contrast between its distinctive gray bark and the bark of other species. MJ

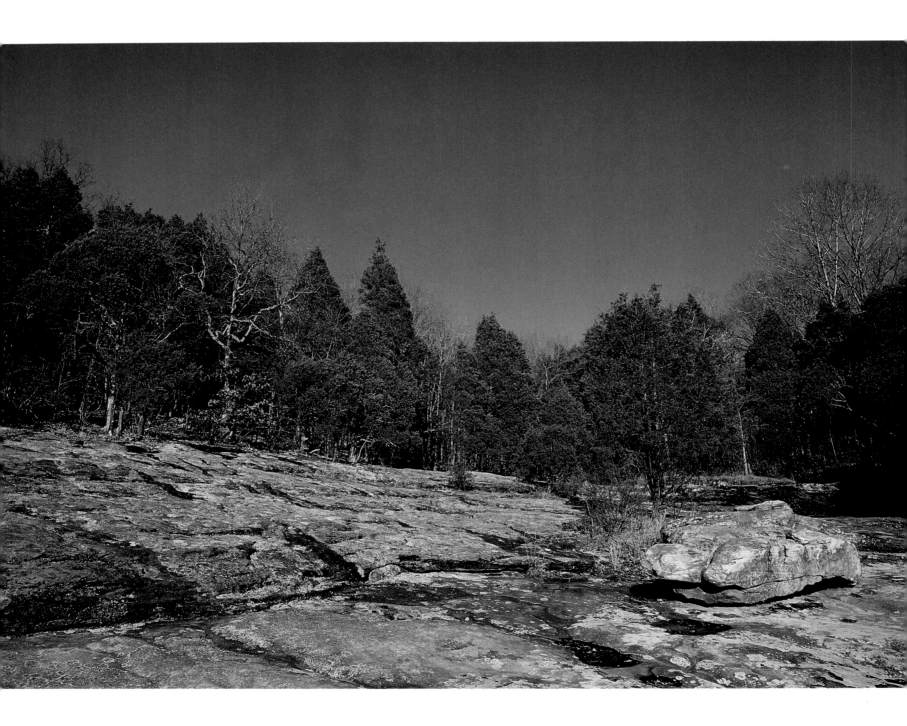

12

ROCK LEDGES

Michael R. Jeffords

In April, orange-tips are the most abundant butterfly in the vicinity of the rock outcroppings. This species prefers open woods and forest edges. Only the male has wings tipped with orange. MJ

Surrounded by dry upland forest, an expanse of sandstone at Hayes Creek Canyon is nearly devoid of life. MJ

THE ILLINOIS PORTION OF THE ANCIENT OZARKS boasts two major types of cliffs: protruding sandstone knuckles that undulate in an east-west direction across southern Illinois, and limestone escarpments that occur chiefly along the great rivers—the Mississippi to the west and the Ohio to the east. These bluffs are often topped by bare ledges of rock, more often sandstone than limestone because of its weather resistance. Both types of outcrops share many of the same plants. In glades and hill prairies, limestone is commonly found near the surface where many typical prairie plants root in the broken, decaying rock. Glades turn a rusty gold color in fall because of the bluestem and Indian grass and form one of the rarest ecosystems in Illinois. Well-developed rock ledges are found in La Rue–Pine Hills Ecological Area,

Ferne Clyffe State Park, Bell Smith Springs, and Hayes Creek Canyon—all located in the Shawnee National Forest.

Sandstone ledges are windswept, inhospitable places for much of the year. Scorched by the midsummer sun, the bare rocks have surface temperatures that regularly exceed 120° Fahrenheit and are often 40° higher than the air temperature only a few feet above. Cliff-top vegetation is extremely sensitive and attuned to violent fluctuations in moisture. Consequently, most rock ledge plants grow and flower in spring when rainfall is relatively plentiful. Few plants are restricted to this habitat; most have been recruited from the surrounding area. The cliff-top flora, though inevitably sparse, is surprisingly diverse. Many plant families are present but are represented by only one or two species. The long growing season and the mild winters place this area of southern Illinois well within the range of many upland southern and coastal plain species.

On the bluff edges of the taller cliffs, only hardy lichens and a few scattered cushions of black moss grow on the fully exposed rock. Where the cliffs are relatively short, trees rooted in the rock debris at cliff bases may extend above the ledges. Moss grows on portions of the ledges shaded by these trees. On large ledges, patches of thin soil accumulate in slight depressions in the rock or in cracks and at junctions between the rock layers. This soil is deposited during heavy rainstorms as it is washed down from the upland forests that skirt the ledges. Caught in cracks in the rock faces, this soil may be removed or redistributed by subsequent rains and thus forms an extremely short-lived habitat. Other organic matter which finds its way into the depressions along with the thin layer of soil is contributed mostly by the common eastern red cedar. This tenacious, scrubby tree somehow finds footholds in the rock cracks and junctures.

In some areas blankets of moss and lichens insulate the rock against the extremes of heating and cooling. The moss cushions help to retain moisture, thus reducing the rock temperatures. Light-colored lichens reflect the harsh sunlight and prevent rapid heat loss when temperatures fall. In this way, the fracturing of the rock by expansion and contraction is lessened and its breakdown into soil considerably slowed.

In spring, bluets, false garlic, and yellow star grass appear frequently in shallow depressions and at borders where the sandstone slips beneath the soil of the open oak forest on the blufftops. In most years orange-tip butterflies, more typical of the western United States, are abundant here. In their relatively short life the adult

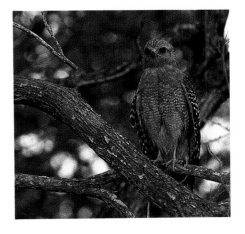

Once the most common large hawk in Illinois, the red-shouldered hawk is now rare and nests only in southern Illinois. MJ

Where moisture is adequate, mosses and lichens carpet the rock to a depth of several inches. Mosses accumulate leaves and other plant materials that eventually decay to form soil, ultimately burying the rock. SP

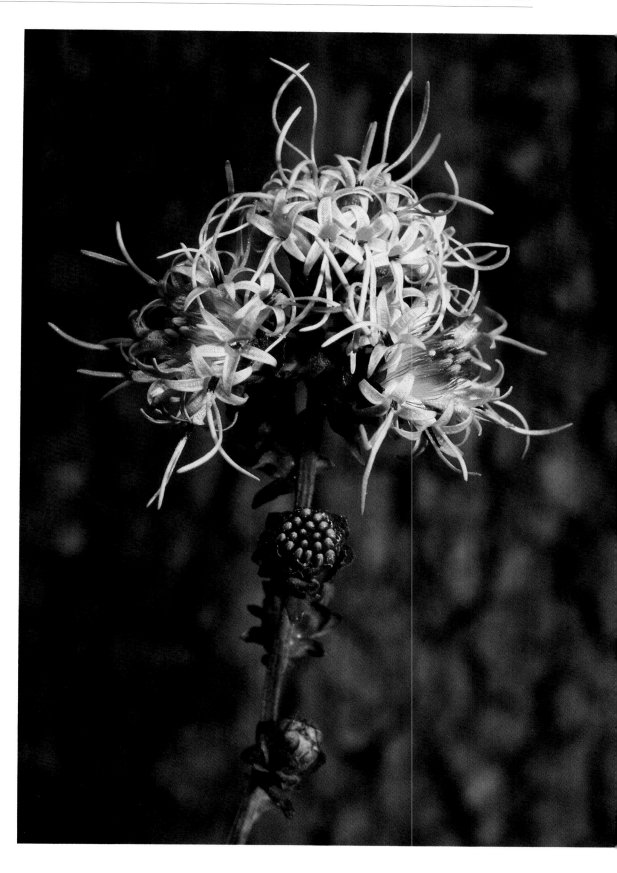

Lichens and mosses cover a shaded blufftop on a sandstone escarpment in the Shawnee Hills. MJ

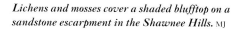

Often the only color found near the rock ledges in early fall is that of the blazing-star. This species does quite well under the extremely hot and dry conditions of the sandstone. MJ

Overleaf: Burden Falls plunges into a deep canyon each spring, but dries to a trickle by mid-summer. MJ

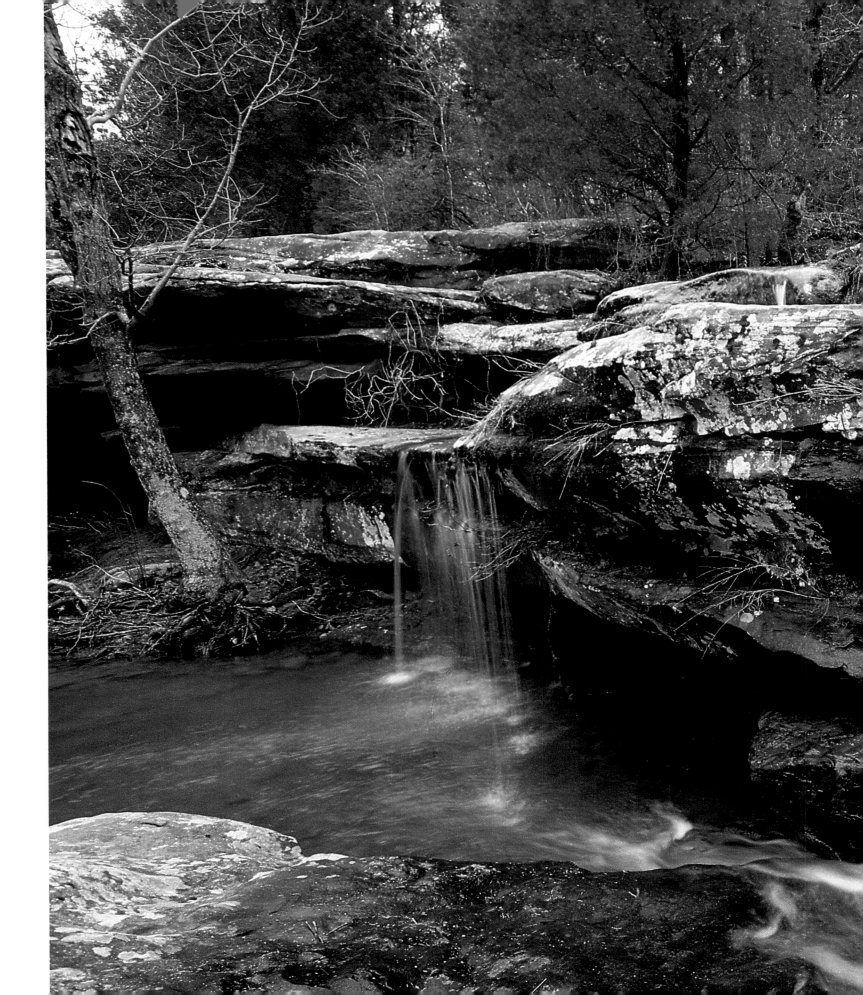

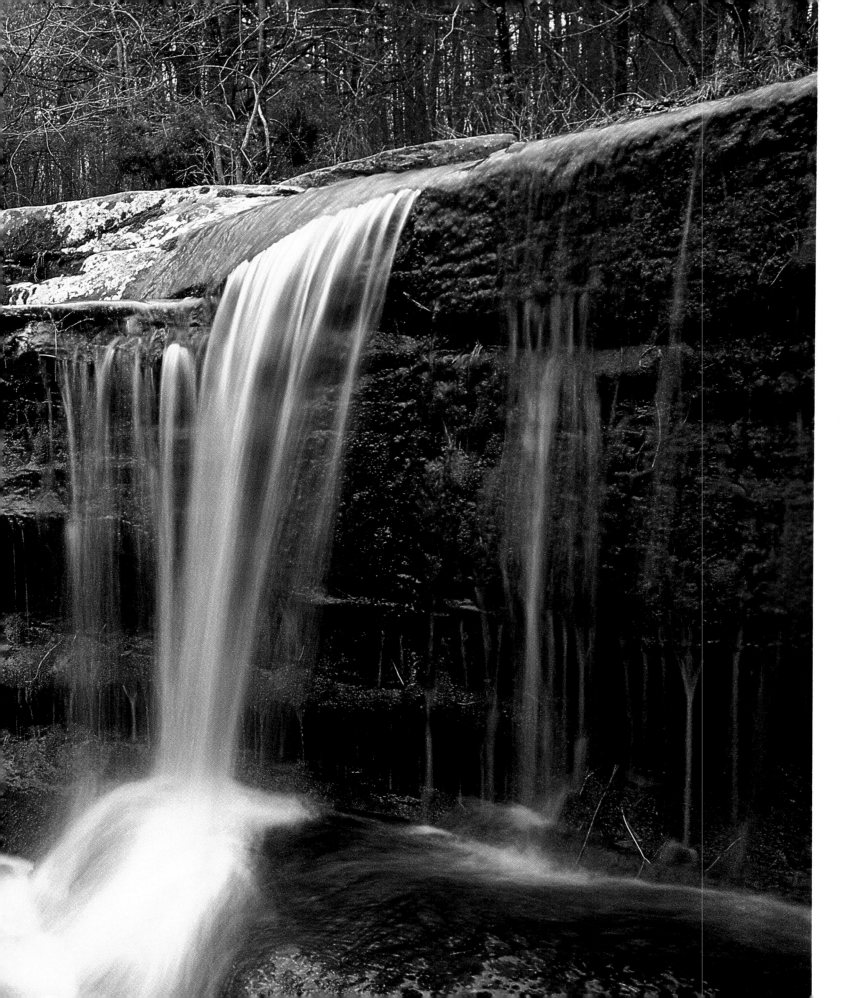

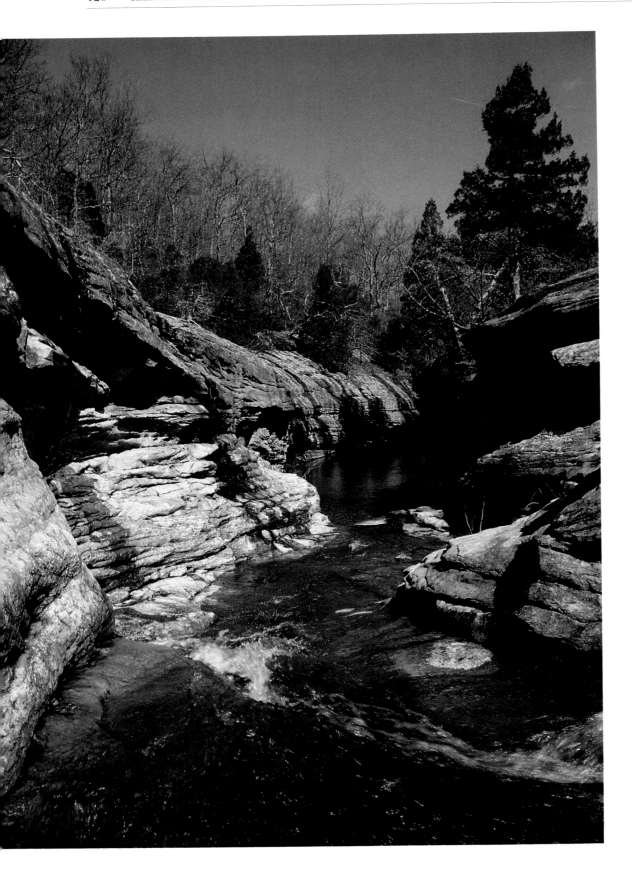

On the dripways, a male crane fly defends a female from other males while she lays eggs on the moist rock surface. MJ

Water flowing across the soft sandstone eventually carves steep-sided canyons that support permanent streams. SP

Pockets of soil that have accumulated in rock depressions support colonies of bluets in early spring. MJ

Eastern fence lizards are common on the rock ledges; they are most often seen on lichen-encrusted tree trunks near the forest edge. Male lizards have a bright blue patch under the throat. MJ

butterflies have a practical way of mating. They pair overnight, remaining in the open, exposed to cool damp air. In doing so, they lose little water and conserve energy. Their larvae feed on toothwort and other mustards that grow in the adjacent oak woods.

The soil-rock borders of ledges are transition zones, constantly reshaped by the action of wind and water. Dripways originate here and water flows down the gently sloping rock ledges forming algae-covered wet streaks. In spring, these dripways become a proving ground for delicate, long-legged crane flies, insects that are far more familiar at porch lights in midsummer than here in early spring. Large, writhing masses or "leks" of male crane flies roll back and forth across the moist ledges, pausing only when they encounter overlapping ridges of rock that cause a change in direction, or when a female happens along and dives into the throng. After a brief but intense struggle within the lek, the female emerges, attached to a large male. Mating ensues rapidly; the male uses his six spindly legs to form a cage over the female. This strange pair walks to the nearest dripway, and the female, still en-trapped by the male's legs, begins laying eggs on the wet algal mat. For the duration of the egg laying, which can take several minutes, the male wards off other males that attempt to reach the egg-laying female by bumping them with his slender body,

never relinquishing his claim. Within a few weeks, the eggs hatch into tiny crane fly larvae that travel down the dripways to newly-formed pools carved in the rock, or over the ledge to be washed into other aquatic habitats where they can complete their life cycle. Within weeks the dripways become only dark, dry streaks on the sandstone, concealing the unique relationship they hold with the crane flies.

Although no one plant seems to be particularly characteristic of the rock ledges, one notable insect may well be: the lichen grasshopper or rock-loving locust. Restricted to the larger sandstone ledges of the Ozark hills in southern Illinois, this grasshopper is at the northern limit of its range. In the dramatic setting of bare rock encrusted with a patchwork of mottled lichens, this grasshopper flashes by, pale yellow hindwings shining, and settles to become part of the landscape. Its dark brown, green, and whitish markings mimic the lichens on which it spends most of its time. By habit it is sluggish and unsuspicious, flying only a short distance when disturbed. Its confidence in its disguise appears unshakable.

The forests bordering the ledges and enclosing the limestone glades are dominated by post oak, blackjack oak, and red cedar. Trees only eight to ten inches in diameter may be 150 to 300 years old, stunted by lack of moisture. The open understory supports the prairie shooting-star, wild columbine and, in late summer, blazing-star. Occasional wet, soil-covered slopes are blanketed with spongy moss mats containing various mushrooms and the scarlet British soldier's lichen.

Many cliffs in southern Illinois that face east or north have only narrow bands of exposed rock or are completely covered with vegetation growing in a moderately thick soil layer that formed quickly, induced by the moisture and shade of the sandstone. It is the bare south- and west-facing rock surfaces that are incredibly harsh habitats. Because of the continual assault of wind and water, they are subject to constant, often violent, change. Only where soil can accumulate and endure for an appreciable period of time do plants colonize, multiply, and ultimately cover the bare rock.

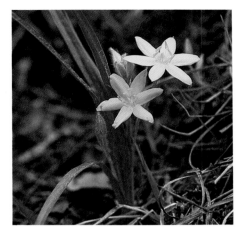

Yellow stargrass, an amaryllis, grows widely in rich prairies throughout Illinois, but it is also found in soil-filled cracks on the sandstone. Without its distinctive flower, this species is often mistaken for a grass. MJ

The coloration of the lichen grasshopper is a nearly perfect match for the lichens found growing on the sandstone of its habitat. The grasshopper does not eat the lichens but feeds on a great variety of other plants. This curious species inhabits a narrow region of southern Missouri, Illinois, and Indiana. MJ

The rock outcroppings of Old Stone Face in Saline County support the early blooming serviceberry, a common resident of the Shawnee National Forest. MJ

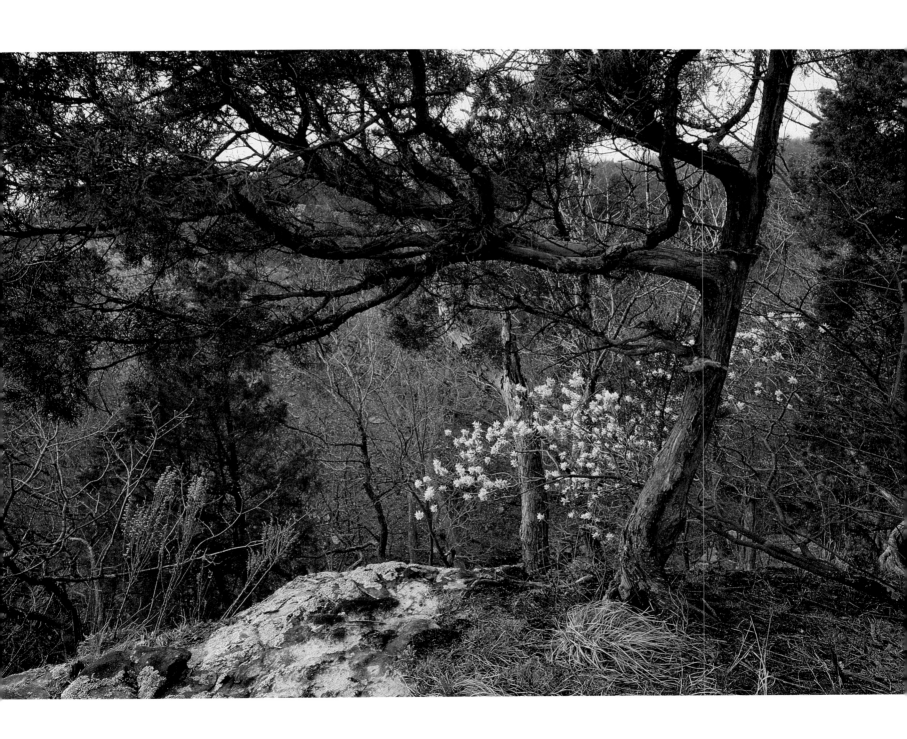

13

Southern Ravines

Michael R. Jeffords

Fern fronds unfurl in early spring. The fiddle-heads of some species are considered to be delicacies and are sold as vegetables. MJ

The Pomona Natural Bridge is a spectacular sandstone formation located near Carbondale. SP

JUST SOUTH OF WHERE THE ILLINOIAN GLACIER STOPPED, the massive sandstone and shale escarpments of the Shawnee Hills stand ancient, weathered, and exposed. Most prominent is the Pennsylvanian sandstone, deposited by a warm sea some 270 to 310 million years ago. The rock outcroppings survived burial by glacial soil and gravel deposits that filled in much of the landscape to the north. The land remained untouched by the ice, but not unaffected. Lusk Creek Canyon in Pope County and many others were quickly incised by the run-off from glacial meltwaters some 200,000 years ago. Over time the winding course of clear, rock-bottomed streams widened and deepened the ravines. Shelves and steps were formed, and so-called "caves" or shelter bluffs were eroded into the canyon walls. These long, shallow caves are actually undercuts in the sandstone with large over-hanging ledges forming the ceilings.

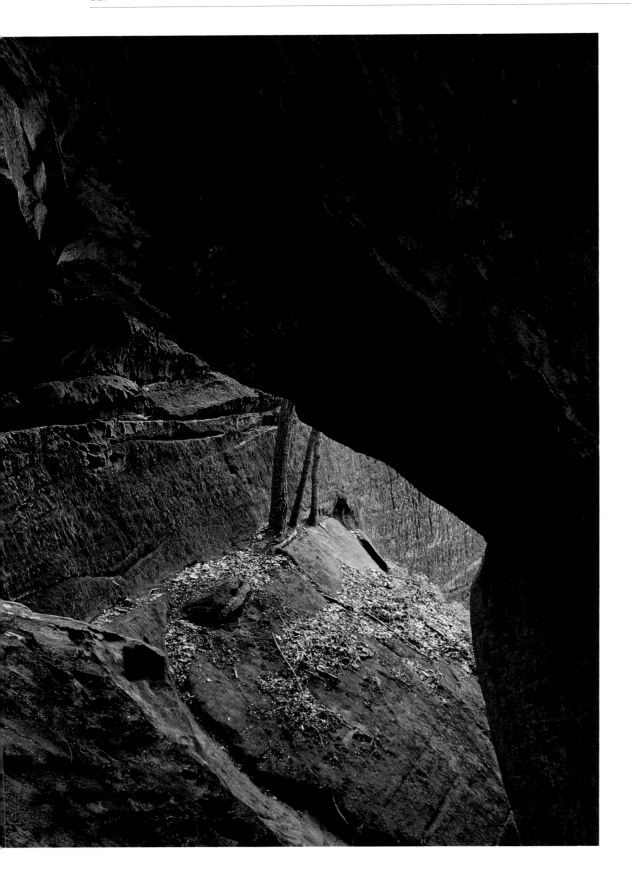

Over time, water dissolves the soft sandstones of southern Illinois, creating curious and intricate patterns in cliff faces. MJ

Large blocks of sandstone have detached from the bluff walls and form dark passageways as they slide imperceptibly toward the valley floor. SP

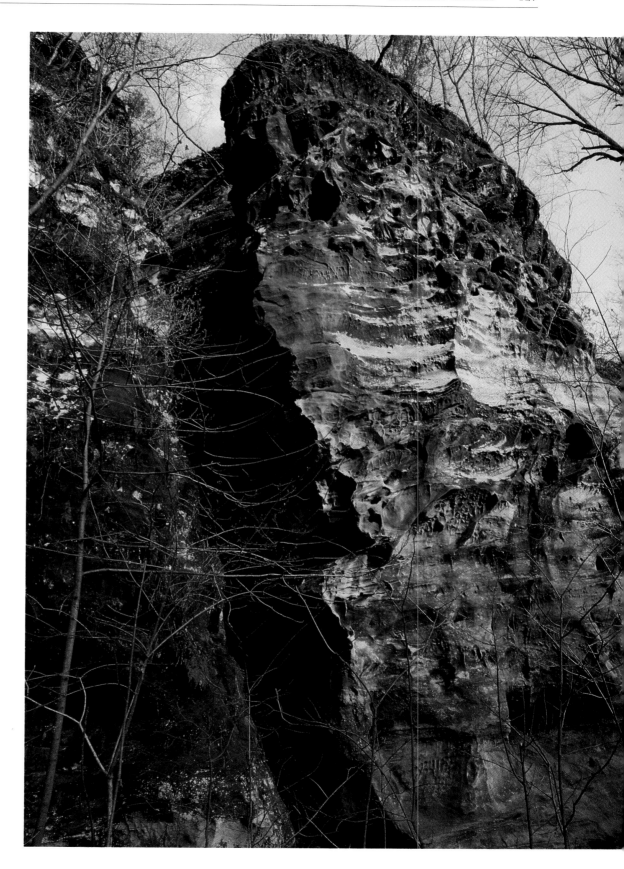

Early morning light shows the highly eroded surface of a massive sandstone bluff at Ferne Clyffe State Park in Goreville. MJ

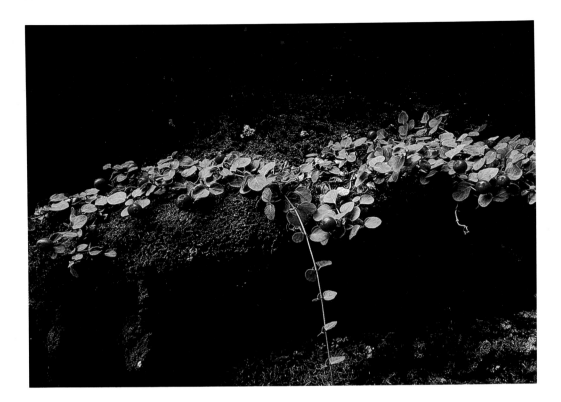

Dry now, these cave-like undercuts make excellent snake dens. During the first half of the twentieth century, this region was notorious for its exceptional snake population. Five-foot rattlesnakes, copperheads, and cottonmouths, as well as non-poisonous snakes, hibernated by the thousands among the rocks. On warm sunny days in April, the snakes would break from their dens. Overcollecting by enthusiasts and other causes have greatly reduced their numbers. The brown rippling wave of snake migration which once flowed continuously from the dens is evident today only by the remains of a few dendritic patterns in the fine dust.

The lushly green, damp jungles of the ravines shelter some of the rarest plants in southern Illinois and also contain fabulous collections of more common species. Lusk Creek Canyon alone holds thirteen species of wild orchids. North-facing shelter-bluffs provide a habitat for one of the most unusual and restricted plants in North America, the filmy fern. Its pale green fronds are but one cell thick and require the moist, shaded area found within the overhangs. In botanical terms, the forested ravines are curious mixtures of intraneous and extraneous plants. Intraneous species, such as wild columbine and bloodroot, are entirely within the limits of their geographic range and are typically found living under a variety of

Partridge berry grows on inaccessible ledges of the bluff face. The berries, despite their name, appear to be rather unimportant as food for wildlife. SP

These wooded slopes at the base of the sheer bluffs are an oak-hickory forest with numerous outcroppings of rock and partially buried boulders dislodged from the cliff. MJ

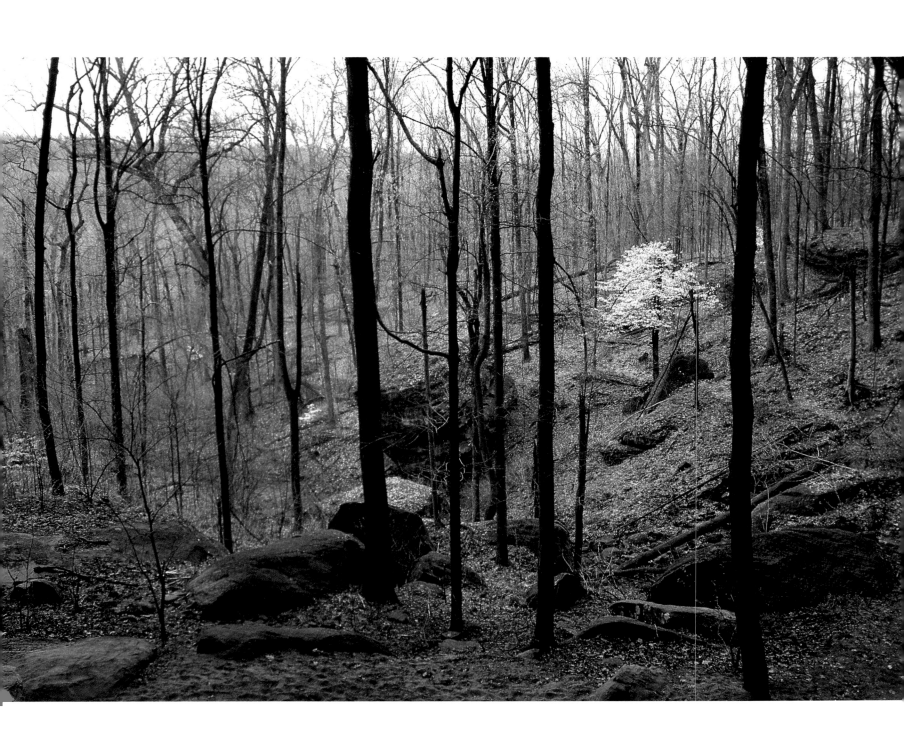

conditions. Extraneous plants existed commonly in earlier geological times but to-day are confined to particular habitats, such as the ravines, and live near the limits of their present ranges. Starry false Solomon's seal and sphagnum moss, for example, occupy only cool moist sites, and have their origins in the north.

The relatively broad, flat-bottomed ravines, enclosed by high bluffs and shaded by a dense forest canopy in summer, are sheltered from climatic extremes and support the most luxuriant vegetation in southern Illinois. The growing season is nearly two months longer than that of extreme northern Illinois. Summers are cool and moist, winters are moderate with temperatures seldom falling below 0° Fahrenheit. The climate is officially classified as humid subtropical, with the emphasis on *humid*. Many distinct habitats occur, ranging from the perpetually moist sandstone canyon walls to sandy streambeds. Vegetation which grows along the stream edge and in the streambed is profoundly affected by the scanty, sterile soil and periodic flooding. Flood-tolerant sycamores, willows, jewelweed, and the occasional yellow pond lily live here.

The woods adjacent to stream-carved ravines have stabilized the soil and allowed sugar maples, elms, and black walnut seedlings to persist, eventually replacing the once-dominant sycamore and willow. The shrub and herb layers are often sparse, probably because of the subdued sunlight that reaches the valley floor. Further upslope in floodplain woods, beech, sugar maple, and tulip tree often reach and overtop the bluffs. Unlike the more disturbed stream habitats, these woods support a dense understory of seasonal shrubs and herbs typical of many Illinois woodlands. Early spring brings yellow trout lily, spring beauty, larkspur, and trilliums; late spring, spiderwort and Solomon's seal; summer, the uncommon Michigan lily and crane-fly orchid; and fall, asters, goldenrod and ladies'-tresses.

Large sandstone blocks have separated from the canyon walls, creating blind alleys and narrow passageways within the forest. Many are open to the sky only through narrow clefts and are always dark and gloomy. Each imperceptibly slides toward the valley floor, assisted by gravity, the push of freezing ice, and growing tree roots. The tops of these blocks are isolated, untrammeled islands. Here miniature forests of waterleaf, spring beauty, bellwort, phlox, and Christmas fern densely carpet the surface. Christmas fern, an evergreen, was named in pioneer days when it was used as seasonal greenery.

At the base of sheer bluffs, shallow soil is interspersed with rock outcroppings and ledges. This rough terrain supports an often sparse forest. One is rewarded,

The pawpaw is a common tree of moist ravines. It may reach 30 feet in height, but occurs most frequently as a shrub in the understory. KR

In spring the fertile alleyways between large boulders are transformed into corridors of wildflowers. Dutchman's-breeches and squirrel corn's lush leaves form cushionlike beds covering large areas in Round Bluff Nature Preserve during April. SP

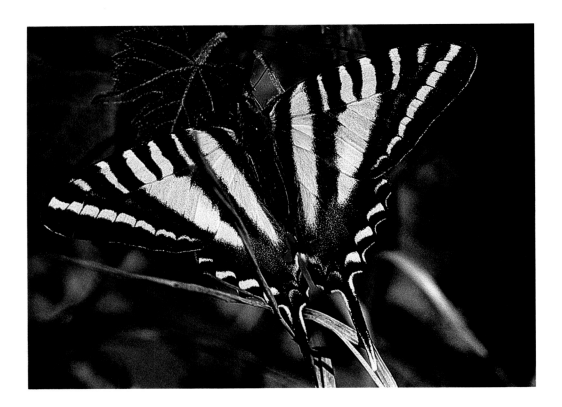

however, in spring, when celandine poppy, false rue anemones and other gloriously colored wildflowers arrest the eye. Squirrel corn covers the forested slopes with lush, green, feathery foliage. Under the overhanging cliffs, where drip-line moisture is assured, French's shooting-star grows. This rare relative of the common shooting-star, named for George Hazen French, an early biologist at Southern Illinois University, was originally thought to exist in a regional band only ten miles wide across southern Illinois. Isolated populations have since been found in Indiana, Missouri, Arkansas, and Kentucky. This plant is smaller, requires less light, and has twice as many chromosomes as its more familiar cousin of dry woods and prairies.

The sandstone bluffs that form the ravine walls vary greatly in height but frequently top 100 feet. Waterfalls form in damp weather and often persist deep into the summer. Eventually they become mere trickles. The water brings life to the sandstone; north-facing vertical cliff faces may be draped with sphagnum moss, characteristic of northern bogs, or moist tangled mats of ferns and club mosses. A thin layer of debris clinging to vertical surfaces or nestled on narrow ledges can support the common polypody, walking, and hay-scented ferns. Spring water often seeps from beneath layers of shale at the cliff bases, staining the exposed rocks with the

This formation is called "Liesegang" rings and is caused by the precipitation of salts within the sandstone. MJ

The bold pattern of the zebra swallowtail butterfly actually camouflages it as it flies through the sun-dappled woods. Zebra swallowtail caterpillars feed on pawpaw. MJ

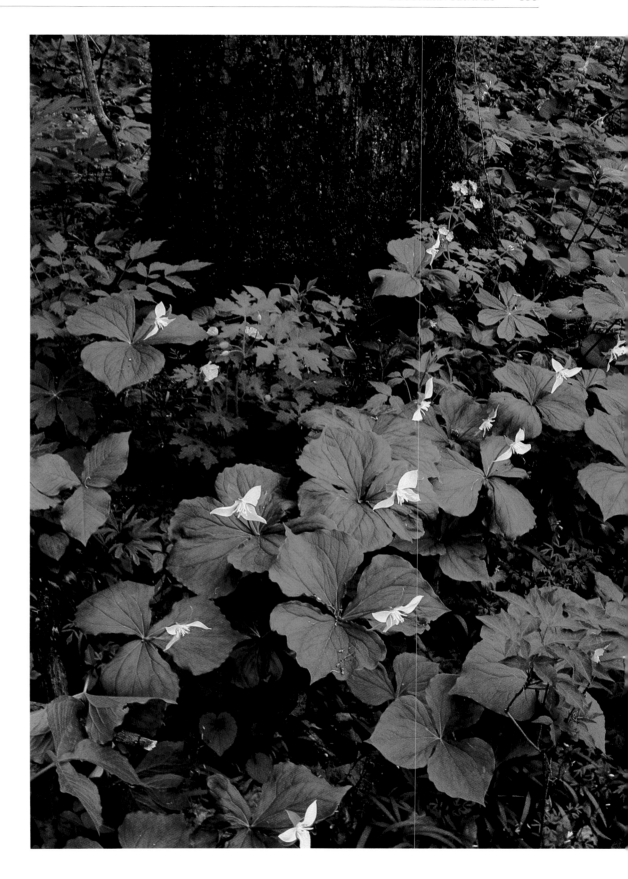

Fern Rocks Nature Preserve in Giant City State Park supports legions of drooping trillium and celandine poppy in early May. MJ

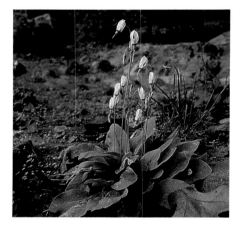

French's shooting-star grows under the drip-line of overhanging bluffs. Once thought to be found only in southern Illinois, isolated populations have been discovered in similar habitats in nearby states. SP

Beech-maple forests are usually found in ravines, often extending to the base of the bluffs. SP

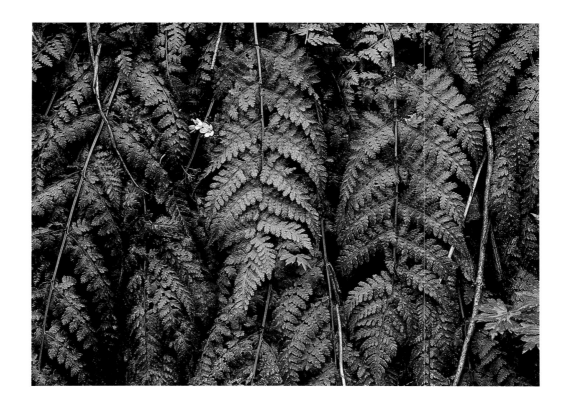

rich reds and browns of iron sulfate or other minerals. The water escapes the rocks in a tranquil, almost imperceptible flow. In tiny, sheltered alcoves where the sandstone is pitted and ridged by erosion, unusual plants such as early saxifrage and closed gentian gently grow.

On occasion, the streams expand and fill the entire canyon floor. Rainfall penetrates the soil only with difficulty and often causes severe run-off and spring flooding. Uprooted plants lodge in head-high tangled mounds amid the streamside growth, a testament to the potentially violent character of the waterway. Such floods must nevertheless be considered beneficial, for they bring nutrients to the valleys. Floods have also made cutting and pasturing near the stream highly impractical, and most likely account for the preservation of these remarkable areas.

Ferns are the most conspicuous plants of moist cliff faces and give these ravines the appearance of a luxuriant rainforest. MJ

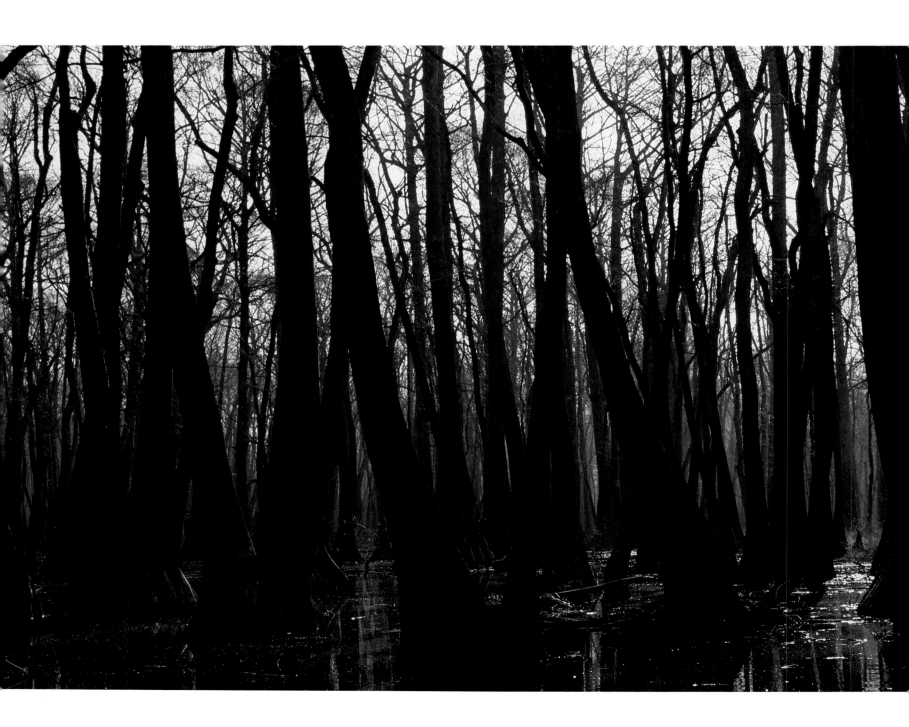

14

SOUTHERN SWAMPS

Susan L. Post

The red iris, a common flower of Louisiana, extends its habitat range to extreme southern Illinois. It is found on the edges of swamps and more frequently in wet, roadside ditches. SP

The water level in a floodplain swamp may fluctuate by several feet from year to year. Without such changes species like the bald cypress could not reproduce, for its seedlings require dry ground early in their development. MJ

IN THE STRANGE, SILENT, PRIMEVAL WORLD of the southern swamps, the only sounds one hears are created by people or birds: the groan and creak of the floating boardwalk underfoot, a pileated woodpecker hammering on a long-dead snag, a prothonotary warbler chortling as it feeds its young, and the startled cry of a wood duck fleeing through the trees. Cypress trees, in a seemingly vast stand, support upon their "knees" little colonies of plants—islands in miniature. The surface of the pond is covered with several species of duckweed. This thick green blanket is broken only by a fallen cypress needle, the black ribbon of a swimming cottonmouth, or the delicately embossed outline of a floating frog. In the quiet and stillness, the bayous of Louisiana come to mind.

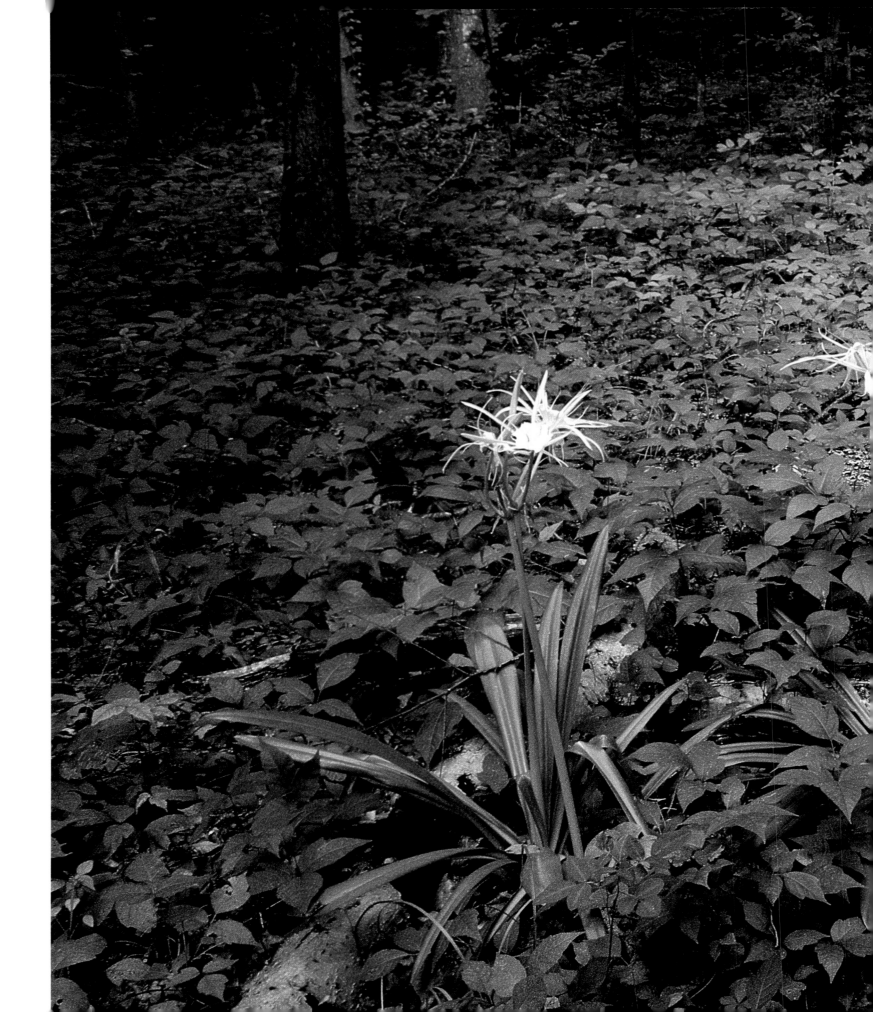

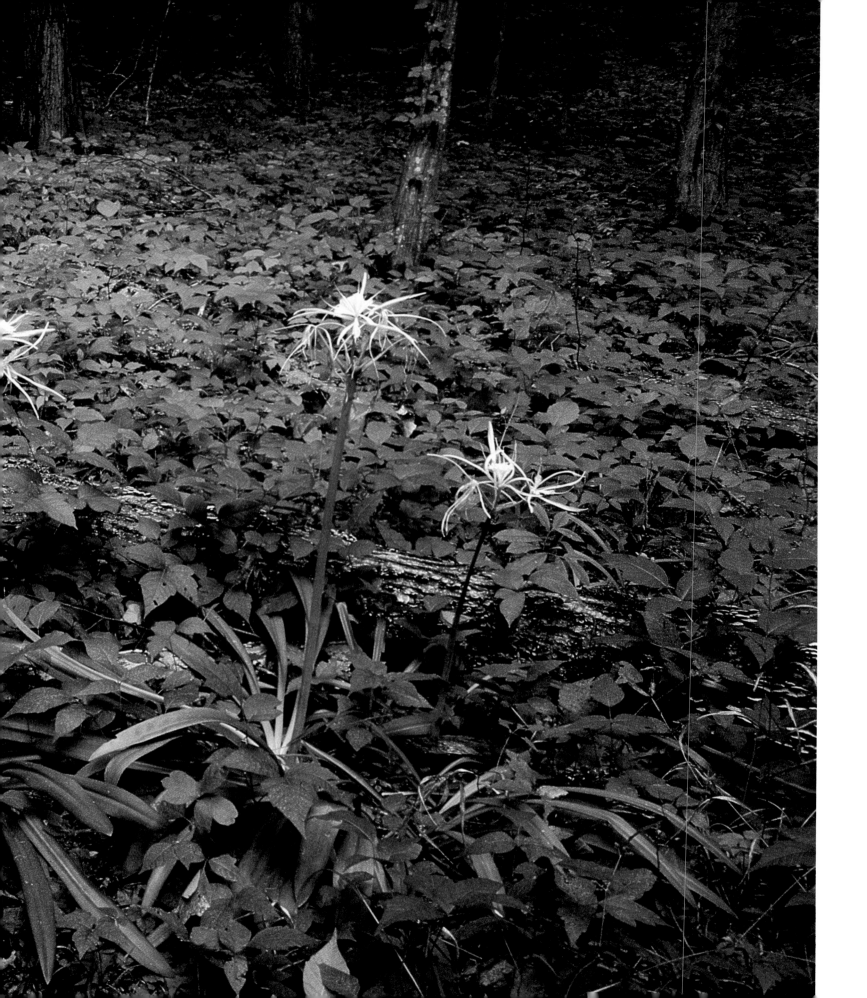

This area was originally described by an English journalist in the 1860s as "a forest of dead trees, their ghostly leafless arms over buried trunks like plumes over a hearse—a cheerless miserable place, sacred to the ague and fever." Other early visitors described it as a place where your first and only thought was "how shall I get away again" or simply, "the pit of hell." These descriptions of the swamps of southern Illinois, of plant life more typical of Mississippi, Alabama, or Louisiana, were made by individuals viewing the landscape without the luxury of a boardwalk.

Swamps are areas where the soil is saturated or covered with surface water for most of the growing season and where woody vegetation is dominant. In Illinois there are deep swamps that have surface water throughout most of the growing season and shallow swamps that are inundated for only short periods of time. In deep swamps the dominant plants are trees, flaring at the water line with swollen or buttressed bases and projecting "knees." The trees and shrubs which dominate shallow swamps have trim silhouettes. Swamp vegetation, typical of the Southeastern Coastal Plain, reaches its northern limit in Alexander, Pulaski, Johnson, and Massac counties, located in extreme southern Illinois. Long before human records were kept, this strip of southern Illinois bordered the shoreline of a much larger Gulf of Mexico. Though the seas retreated, the coastal plain of Illinois still resembles plains which surround the present-day Gulf.

Although untouched by major glaciations, these southern areas of Illinois were influenced by glacial floodwaters and sediment deposits. The area known today as the Cache River Basin was the prehistoric river valley of the Ohio. During the Wisconsinan period, when the final glacier was slowly melting its way back to the Arctic, massive torrents of meltwater flowed south and west. The giant river that was to become the Ohio cut across southern Illinois leaving behind sediments up to 180 feet thick. As the glacier continued to retreat northward, the water level slowly dropped and the nearly flat glacial mud left by the ancient Ohio blocked its own tributaries to form a series of swamps, wetlands, and small lakes called "scatters." These areas were low-lying and flat. The Lower Cache, a sluggish stream, meandered through, making any hope of drainage impossible.

"This river is hidden," said a French adventurer credited with naming the Cache River, when he spotted its log-jammed mouth on the Ohio in 1702. His words are even more true today. The Cache River watershed, a result of thousands of years of geologic action, is naturally divided into three parts: the Upper Cache River, the Lower Cache River, and the Cache River Basin itself. The Upper Cache River flows

Often mistaken for the cottonmouth, the yellow-bellied water snake is a common resident of Heron Pond. Its favored foods are amphibians and fish. MJ

Overleaf on previous pages: The woods surrounding a cypress swamp may have several notable species, including the southern spider lily. Not a lily at all but an amaryllis, the species is at the northern limit of its habitat range and is much more familiar in southern Florida. SP

*Telltale sinuous paths of black water in the thick
duckweed betray the passing of a cottonmouth.* MJ

through the high hills of the Ozark mountain uplift into the Cache River Basin. The Lower Cache River flows out of the River Basin. The Cache Basin crosses southern Illinois, extending to the Ohio River on the east and the Mississippi River on the west. It marks the geographical point where the last invasion of the sea reached its northernmost limit, and lies only a few miles from the southernmost extent of the continental glaciers. The Basin is referred to in the original United States Land Survey as "inaccessible, a drowned land." Here stood the vast cypress–tupelo gum swamps of southern Illinois.

The Cache River has been dredged, diverted, and generally tampered with for decades. In 1916 the Post Creek Cutoff near Karnak was completed. The cutoff, designed to alleviate the flooding of adjacent farmland, cut the river in two, thereby allowing a portion of the Upper Cache to drain directly into the Ohio River instead of the Lower Cache. Deprived of its source, the Lower Cache has become a sluggish trickle that even flows backwards upon occasion! Despite these human interventions, the Cache remains the only river in Illinois with two National Natural Landmarks along its banks: Heron Pond–Little Black Slough and Buttonland Swamp. Heron Pond, so named because it formerly served as a rookery for the great blue

Small frogs of various species overrun the swamp by midsummer. When disturbed, they dive into the water and slowly float to the surface, constantly alert for danger. SP

The humid, lush forests bordering Lime Kiln Slough along the Cache River are a haven for many species of fungi. MJ

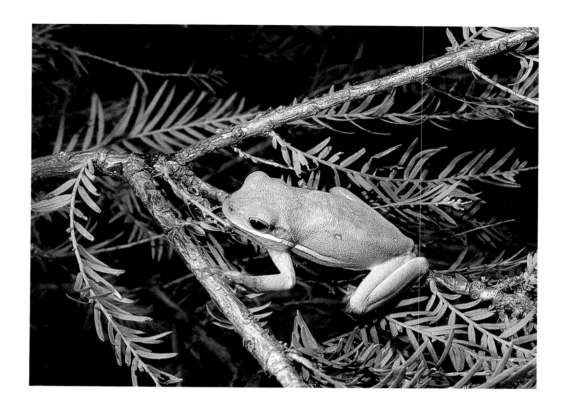

heron, is part of a larger parcel of swampland called Little Black Slough, which is itself part of the Cache River State Natural Area. Little Black Slough is dominated by bald cypress and tupelo gum trees; approximately 200 acres are covered with water throughout the year. Within the larger Cache River State Natural Area, thousands of additional acres of high-quality bottomland hardwoods and cypress–tupelo gum swamp are also protected from timber harvest.

Heron Pond may not have survived, had it not been for the major part canning jars played in its history. In 1898 the Main brothers settled in the Cache River valley and began logging the cypress and tupelo gum for boxes in which to ship glass jars. The brothers discovered they could buy timber for $2 an acre, or timber and land for $3 an acre. Before they sold their business, they had accumulated almost 28,000 acres. They cut few trees on their own land; people were willing to sell them other timber and their philosophy became "why cut ours? We'll need it some day." Fortunately for future generations, Heron Pond and Little Black Slough were two of their tracts.

Buttonland Swamp, an area 10 miles long bordering the Cache River, is one of the few remaining examples of the landscape that once covered much of southern

Illinois. Its name comes from the buttonbush, a water-loving shrub that grows there in profusion. Here are bald cypresses over 100 feet tall and a thousand years old, the sequoias of the Midwest. The miserable conditions of mud, water, mosquitoes, and summer heat made logging difficult and expensive. As a result, this one-of-a-kind area was preserved.

Several species of plants and animals that bordered the ancient Gulf of Mexico have remained, including the spider lily, red iris, green tree frog, cottonmouth, and the two dominant swamp species: bald cypress and tupelo gum, which make up nearly half of the plant composition. Bald cypress, unlike most conifers, loses its needles in the fall, giving the tree its naked appearance. The cypress bears a cone with seeds that need special growing conditions. First, they must germinate on dry soil. Then, they must reach a height greater than that of the next high-water level if the seedling is to survive. The fruit of the tupelo gum is a dark-skinned, purple, plumlike fruit with very sour flesh. When the fruits reach maturity, they fall into the water. They are either eaten by wildlife, or float to shore where they germinate. Both trees share an unusual feature: they develop swollen or buttressed bases and "knees." Buttresses develop in response to aerated water; the greatest swelling occurs where aerated water is present for the longest time. Knees are also reactions of exposure to water. However, they have no bearing on respiratory gas exchange, as was once believed. The height of a knee corresponds to the average high-water level for the locality. Knees, distinguished from stumps by their smooth, conical shape, are not produced on unflooded lands or on soils continuously inundated by water, but on land that is subject to alternate flooding and drying.

Originally, cypress-tupelo forests in southern Illinois covered about 250,000 acres. Extensive timber cutting, land clearing, and drainage for agriculture have altered most of the area's natural character. Nonetheless, some of the oldest and largest trees in Illinois and the United States occur in and along the floodplains of the Cache River Basin and the Lower Cache River. This distinguished group includes the largest tree in Illinois (a bald cypress), and the oldest living stand of trees east of the Mississippi River. Though the southern swamp, with its midsummer heat, humidity and mosquitoes, has rightly been dubbed "the pit of hell," there are sights which soften this unfortunate description. Great blue herons can still be seen stalking their prey along roadside ditches, and bright patches of red iris with their coppery petals give color to the still, green landscape.

A pair of green darner dragonflies rest in the "wheel position" near the edge of a cypress swamp. By clasping the female behind the head, the male assures that a successful mating will occur while protecting himself from becoming his partner's next meal! MJ

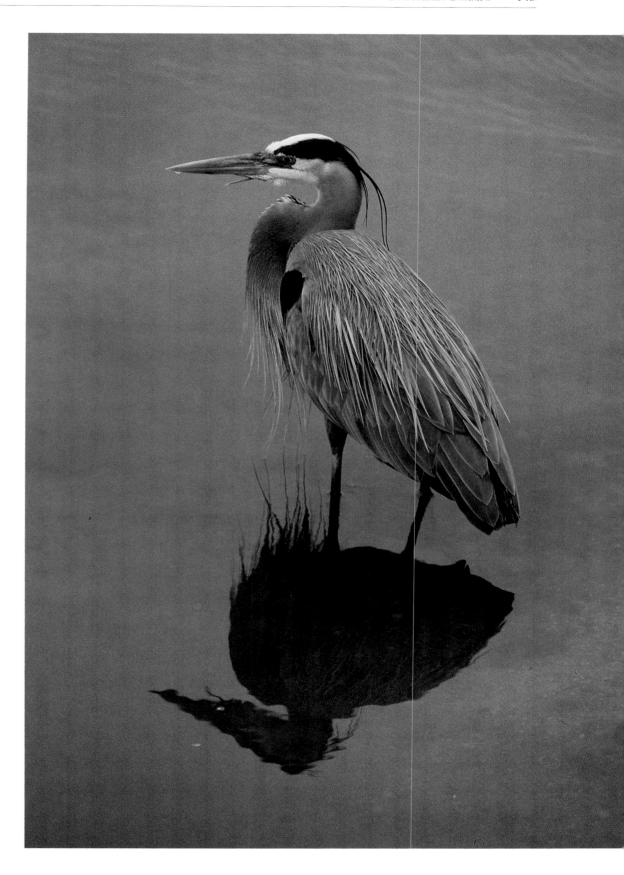

Great blue herons can still commonly be seen in the valley of the Cache River even though their rookeries have been severely reduced in size. MJ

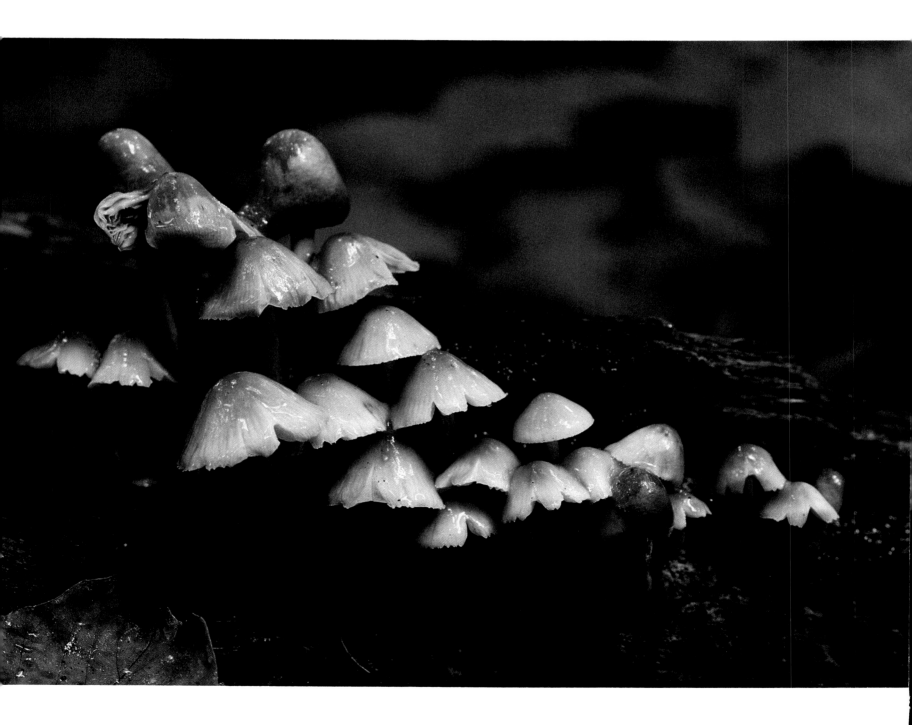

15

COASTAL PLAIN FORESTS

Michael R. Jeffords

SOUTH OF THE SHAWNEE HILLS the land flattens, the drainage is poor, and frequent flooding occurs. The broad plain of alluvium, consisting of the Cache, Ohio and Mississippi river bottoms, is broken only by the gently sloping knolls and ridges of the Cretaceous Hills. Prior to the great glaciers, the Cache River valley was occupied by the Ohio River. The present-day Ohio River valley contained the Cumberland and Tennessee rivers. Only in relatively recent times, probably since the retreat of the Wisconsinan glacier, has the Ohio River occupied its present more southern location.

This area of far southern Illinois has perhaps received more notice for its early history than for any notable landscape features. The French built Fort Massac here in 1757, and here George Rogers Clark and his small band of patriots left the Ohio River to travel overland in their historic trek to Kaskaskia to defeat the British

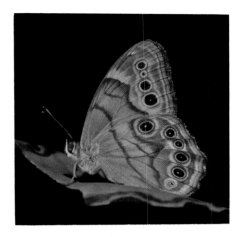

in 1778. Early descriptions of the river bottoms were provided by Henry Engelmann in 1866: "They have a warm, light sandy soil of inexhaustible riches, but the principal drawback to their more extensive cultivation is the malaria from the adjoining swamps...the bottoms are heavily timbered throughout, and at some points the timber attains a prodigious size." Engelmann also noted that most of the creeks emptying into the Ohio assumed the appearance of slow-moving southern bayous. That southern appearance was no accident. Portions of Alexander, Pulaski, Massac, and Pope counties are the northernmost extension of the coastal plain that stretches from southern Illinois to the Gulf of Mexico. A distinctly southern flora is present here with bald cypress, tupelo, willow oak, water hickory, water locust, and water elm present in considerable numbers. Herbs characteristic of these low-lying and periodically wet areas include cardinal-flower, lizard's-tail, and even sea oats.

Several distinct habitats are found as a result of both Pleistocene glaciation and more recent flooding by the Ohio River. Typical floodplain forests have a border of black willow along the stream, and are backed by cottonwood, silver maple, ash, elm, sycamore, and pin oak. Wild grape, greenbriar, and trumpet creeper form a dense tangle of vines, making areas in the floodplain virtually impenetrable. Mistle-

Pearly-eye males will alight on any projection and use this perch to defend a territory by madly dashing at other butterflies that come too close. Its caterpillars feed on various kinds of grass. MJ

The cross-vine inhabits low, moist woods. Its extensive root system allows it to climb trees, often of great height, to reach the sun above the canopy. The flowers are usually seen only if the wind happens to dislodge a section of the vine so that it dangles from the canopy, or when the spent blossoms appear, as if by magic, on the forest floor. MJ

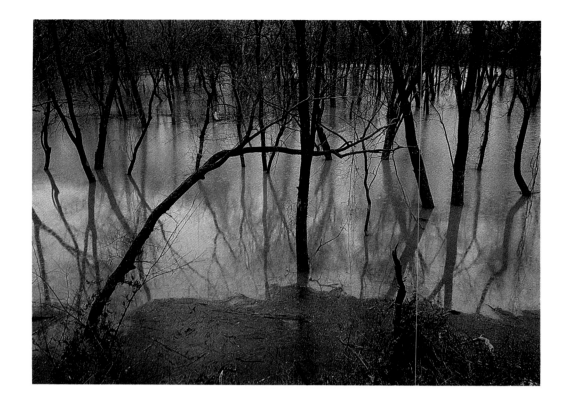

Spicebush caterpillars cling to nearly every sassafras tree in far southern Illinois. After hatching, the caterpillar resembles a bird "dropping," but as it grows larger it assumes the appearance of a rough green snake which deters predators. In its adult state, it is the most common large swallowtail throughout much of Illinois. MJ

Forests along the Ohio River must endure periods of prolonged flooding. Southern species of trees, such as bald cypress, willow oak, and water hickory, are common inhabitants of floodplain and flatwood forests. MJ

toe, a parasitic vine of many trees, often snakes far overhead while green herons and wood ducks nest in the dense forest below. The silverbell tree, a common inhabitant of the Appalachian Mountains far to the east, reaches the northwestern limit of its range and grows in moist ravines along streams. Its white, bell-like flowers hang in clusters of two or three and cover the ruddy twigs; often the young green leaves can scarcely be seen. When the blossoms first appear they are small, flesh-colored, and inconspicuous, but with the warming temperatures of spring, the tree seems to burst into bloom overnight. Appearing after the blossoms, the fruit resembles tiny, green-winged lanterns.

The slopes of river terraces support a rich, moderately moist forest of red and white oak and shagbark hickory with occasional examples of the rare white basswood. All lowland areas and even some of the terraces must endure annual flooding. In these areas a silver maple community dominates, with thickets of hawthorn in the understory. Wildflowers are not uncommon but are usually localized and often grow in short narrow strips. Seven-Mile Creek in Massac County supports a lush understory of wild ginger and bloodroot along its banks.

The relatively common leopard moth, although large and conspicuous, is usually seen only at night when it is attracted to lights. Its handsome caterpillar feeds on plantain. MJ

Lizard's-tail, the only member of its botanical family found in Illinois, occurs in swamps and along shaded stream banks. MJ

Forests growing on hardpan, clay soil that is very moist in spring and very dry and hard in summer are called "flatwoods." Willow oak grows in the flatwoods of Illinois, as do the common herbs smooth phlox, Missouri ironweed, and groundnut. The 1806 land survey notes "open woods, level and second-rate land" and the relatively small size of the timber. The appearance of these flatwoods is probably much the same today as it was then, for trees do not live long in a flatwood forest. When the trees reach a certain size, they inevitably blow down because of their shallow root penetration in the clay soil. Every 150 to 200 years, there is a new cycle of tree growth.

In southern Pulaski County, a series of hills, ravines, and bluffs border the Ohio River; in a few places the bluffs rise nearly 160 feet above the river. The upland forests contain cucumber magnolia, beech, red oak, and sugar maple. This area, known as the "Chestnut Hills," once supported the only stand of American chestnut native to Illinois. Elderly residents here still remember that in their youth chestnut trees grew "wild in the hills of Pulaski county." In all likelihood their recollections refer to a single grove on a small hill near the present-day town of Olmstead.

The Chestnut Hills Nature Preserve near Olmstead is significant for its population of wintering bald eagles, several species of rare or endangered plants, and the dusky salamander. The dusky salamander is common in the East, but the Illinois subspecies, the spotted dusky, has a very limited range of habitat and is found in small, gravel-bottomed, spring-fed streams. Great horned owls and wild turkeys are common, as are the two-lined salamander, ginseng, and the occasional stand of Indian pink. Native Americans discovered that the root of Indian pink was a remarkable cure for intestinal worms. This use was adopted not only by the early settlers but also by Europeans. As the demand for the root grew, the gathering and selling of Indian pink became an important source of income and brought the plant close to extinction in some areas.

In summer the forests of the coastal plain area of Illinois are hot, humid, and mosquito-infested. The understory is a tangle of jewelweed and poison ivy vines. The generally inhospitable environment makes one appreciate the toughness and perseverance of the individuals who, with George Rogers Clark, forced their way north through this dense and verdant barrier so many years ago.

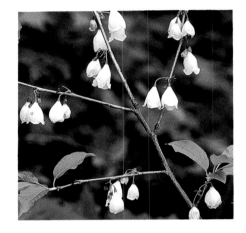

Of the three species of silverbell, only one grows in Illinois, and that only rarely in a few ravines along the Ohio River near the city of Metropolis. MJ

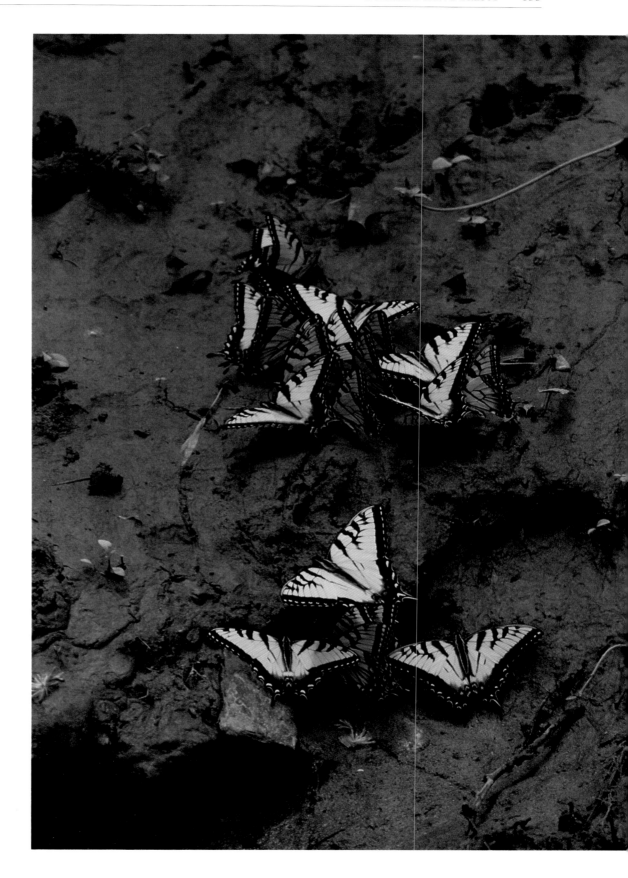

Gatherings of male butterflies, called "puddle-clubs," occur on the dense soil of the flatwoods. Puddleclubs form around food sources, and are often confined to a single species, such as the tiger swallowtail shown here. MJ

GLOSSARY

adventitious arising or occurring in unusual locations; often refers to plants that grow roots along the main stem or branches

algific refers to conditions on rocky slopes that retain ice below the surface throughout most of the summer and are thus colder than the surrounding terrain

alluvium clay, silt, gravel, sand, and other material deposited by flowing water

biome a major type of ecological community, such as a grassland or desert

calcareous containing calcium carbonate; chalky

chert a variety of rock that resembles flint

climax forest the final stage in ecological succession that results in a stable community achieved over time through adjustment to a particular environment; climax community

corm a rounded, thick underground plant stem base with scaly leaves or buds that allows the plant to reproduce without producing seeds

dolomite a sedimentary rock resembling limestone that is rich in magnesium carbonate

esker a long narrow ridge or mound of sand, gravel, and boulders deposited by a stream that flows on, within, or beneath a decaying glacial ice sheet

forb an herb other than a grass, especially one growing in a field, prairie or meadow

humus the organic part of soil formed from partially decomposed plant or animal matter

hydrophytic water-loving; plants that grow in water are called "hydrophytes"

kame a short ridge, hill, or mound of material (drift) deposited by glacial meltwater

knee an abrupt, woody projection that rises from the roots of various swamp-growing trees

loess a windblown deposit of yellowish brown, fine-grained material

mesic moderately moist

moraine an accumulation of earth and stones carried and deposited by a glacier

outlier something that occurs separate from the main body or distribution, such as organisms that occur far from their normal range or distribution

physiographic pertaining to natural occurrences or events

rainshadow a dry landscape produced when moisture-laden winds deposit most of their precipitation on the ocean-facing slopes of mountains, leaving little moisture for the other side

relict a surviving remnant of a kind of organism or species which is otherwise extinct in that particular area

rhizome a long, underground plant stem that is often thickened by extra food material and is capable of producing shoots above and roots below

rookery a breeding ground or area of birds, which tend to group together with others of the same kind, such as herons, egrets, or cormorants

saprophytic obtaining nourishment from dead or decaying organic matter

slough a creek in a marsh or other wetland, usually filled with deep mud or mire

spathe a large sheath that encloses a cluster of flowers

swale a low-lying, wet stretch of land, usually between slightly higher regions

talus rock debris at the base of a cliff, often forming a slope

till glacial deposits consisting of an unconsolidated mixture of clay, sand, gravel, and boulders

xerophytic dry-loving; plants that need only a small amount of water are called "xerophytes"

REFERENCES

The authors used between 500 and 1,000 references in writing this book. The following are the works specifically cited in the text.

BENTON, COLBEE C. 1833. Journal to the far-off West. In *Prairie state: Impressions of Illinois, 1673–1967, by travelers and other observers*, ed. Paul Angle. Chicago and London: University of Chicago Press, 1968.

DARWIN, CHARLES R. 1899. *Insectivorous plants*. 2d ed. New York: Appleton.

DICKENS, CHARLES. 1842. In *Prairie state: Impressions of Illinois, 1673–1967, by travelers and other observers*, ed. Paul Angle. Chicago and London: University of Chicago Press, 1968.

ENGELMANN, HENRY A. 1866. Surface configuration and timber of Pulaski, Massac and Pope counties. *Geological Survey of Illinois* 1:410–12, 429–434.

EVERS, ROBERT A. n.d. Unpublished personal field notes. Illinois Natural History Survey Natural Area Files, Champaign, Illinois.

GILMAN, CHANDLER R. 1836. *Life on the lakes: Being tales and sketches during a trip to the pictured rocks of Lake Superior*. Vol. 2. New York: George Dearborn.

GLEASON, HENRY A. n.d. Unpublished personal field notes. Illinois Natural History Survey Natural Area Files, Champaign, Illinois.

HENDERSON, HAROLD. 1980. The hidden river of Illinois. Part I. *Illinois Times*, Springfield, IL. 19 June.

KEATING, WILLIAM H. 1843. *Narrative of an expedition to the source of St. Peter's River, Lake Winnepeek, Lake of the Woods, etc., etc., performed in the year 1823*. Vol.1, Ch. 5: 175–242. London: George B. Whittaker.

MOHLENBROCK, ROBERT H. *Guide to the vascular flora of Illinois*. 1986. Carbondale: Southern Illinois University Press.

OWEN, DAVID D. 1844. Report of a geological exploration of part of Iowa, Wisconsin, and Illinois made under instructions from the Secretary of the Treasury of the United States, in the autumn of the year 1839. Washington, D.C.

PAGE, LARRY M. AND MICHAEL R. JEFFORDS. 1991. Our living heritage: The biological resources of Illinois. *Illinois Natural History Survey Bulletin* 34(4):357–477.

PEPOON, HERMAN S. 1909. The cliff flora of Jo Daviess County. *Illinois State Academy of Sciences Transactions* 2:32–37.

———. 1917. The primrose rocks of Illinois. *Illinois State Academy of Sciences Transactions* 10:159–62.

RIDGWAY, ROBERT. 1872. Notes on the vegetation of the lower Wabash valley. *American Naturalist* 6:658–65, 724–32.

RISSER, PAUL G. 1984. Bibliography of Illinois vegetation. *Illinois Natural History Survey Biological Notes* 121. 51 pp.

RUSSEL, KENNETH. 1969. *Henry County surface water resources*. Springfield, IL: Illinois Department of Conservation, Division of Fisheries.

SCHNECK, JACOB. 1876. Catalog of the flora of the Wabash valley below the mouth of the White River and observations thereon. *Geological Survey of Indiana Annual Report* 7: 504–579.

STEELE, ELIZA R. 1844. *A summer journey to the West*. New York: J. S. Taylor.

TRELEASE, WILLIAM. 1917. The chestnut in Illinois. *Illinois Academy of Sciences Transactions* 10:143.

ACKNOWLEDGMENTS

Considerable use was made of the Natural Areas File at the Illinois Natural History Survey. This file, based on the notes of Robert A. Evers, also contains numerous proposals for the dedication of preserves and master plans for their management that were prepared for the Illinois Nature Preserves Commission. These documents were written by a number of people, and we extend our gratitude to them all. Data from the Illinois Natural Areas Inventory have also been helpful. For assistance with field work, we thank John K. Bouseman, Marlin L. Bowles, Randy R. Heidorn, Jeanine E. Karnes, Alfred C. Koelling, William E. McClain, Daniel L. Nickrent, Randy W. Nÿboer, and John E. Schwegman. John Taft and Mary Kay Solecki provided stimulating discussions on natural areas. Monica Lusk provided invaluable assistance in finding reference material. We thank Paul G. Risser, former Chief of the Illinois Natural History, for encouraging this project in its initial stage and Lorin I. Nevling, present Chief, for his support during subsequent stages. Audrey S. Hodgins contributed much to the improvement of this manuscript.

This book was designed and produced by Debra Bolgla.
The type is composed in Caslon.

Manuscript Editor: Katherine Kuper
Art Director/Managing Editor: Evelyn C. Shapiro
Proofreader: Margaret Chambers
Production Assistance: Gretchen Hoenes

The Illinois Natural History Survey staff offered their support
throughout the course of this project.